ARTFUL WATERCOLOR

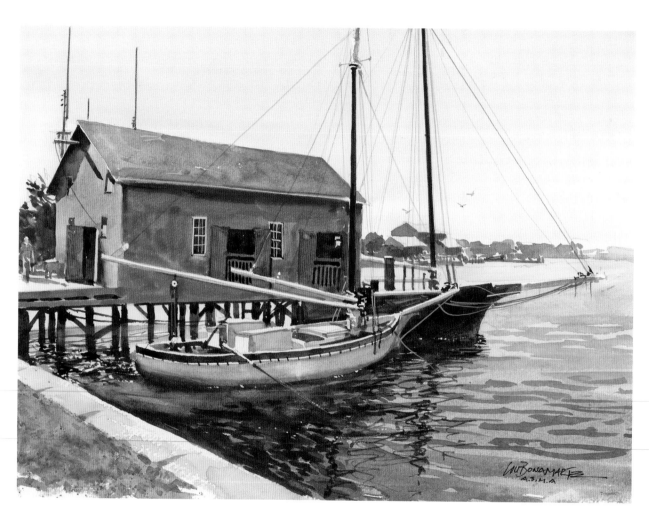

Oyster Shack

ARTFUL WATERCOLOR
Learning to Use the Secrets of Light

Lou Bonamarte
and Carolyn Janik

STERLING
New York

STERLING
New York

An Imprint of Sterling Publishing
387 Park Avenue South
New York, NY 10016

ISBN 978-1-4027-5409-8 (hardcover)

Library of Congress Cataloging-in-Publication Data
Bonamarte, Lou.
 Artful watercolor : learning to use the secrets of light / Lou Bonamarte and Carolyn Janik.
 pages cm
 ISBN 978-1-4027-5409-8 (hardback)
 1. Watercolor painting--Technique. I. Janik, Carolyn. II. Title.
 ND2420.B66 2012
 751.42'2--dc23
 2011048542

Distributed in Canada by Sterling Publishing
c/o Canadian Manda Group, 165 Dufferin Street
Toronto, Ontario, Canada M6K 3H6
Distributed in the United Kingdom by GMC Distribution Services
Castle Place, 166 High Street, Lewes, East Sussex, England BN7 1XU
Distributed in Australia by Capricorn Link (Australia) Pty. Ltd.
P.O. Box 704, Windsor, NSW 2756, Australia

For information about custom editions, special sales, and premium and corporate purchases,
please contact Sterling Special Sales at 800-805-5489 or specialsales@sterlingpublishing.com.

Manufactured in China

2 4 6 8 10 9 7 5 3 1

www.sterlingpublishing.com

PRODUCED BY
AUTHORSCAPE INC.

To my son Adam, who makes me proud,
and to my co-author Carolyn, who suggested we do this book.
—Lou Bonamarte

For CeeCee Martin and Jeanne Fredericks, who gave this book the push that got it rolling!
—Carolyn Janik

CONTENTS

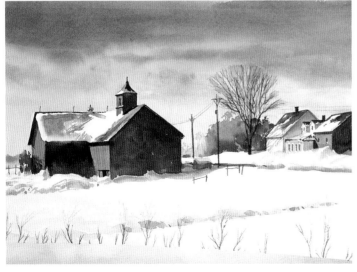

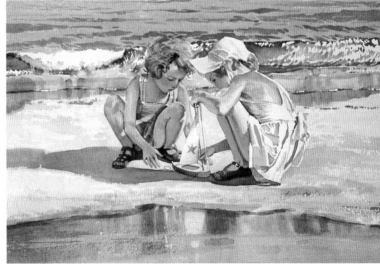

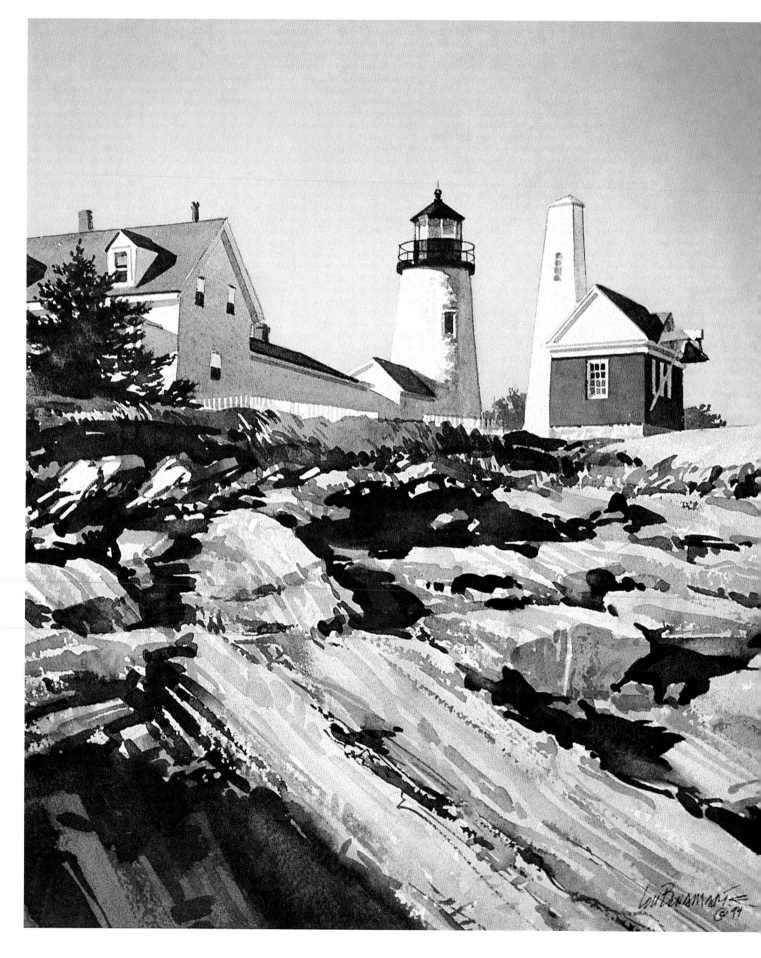

Why do people paint? I've heard many answers: to communicate, to decorate, to illustrate, to capture a moment, to create. Watercolor painting can do all those things. For me, painting is a celebration of life, in all its vastness and wonder, and learning to paint is a process that continues for a lifetime.

Some time ago I came across the following passage (I wish I could remember where I found it). I copied it and it has survived among my class-preparation materials. Now it seems particularly appropriate as we begin this book.

To be an artist is:

• To recognize that we never stop learning, whoever we are, whatever we do.

• To do the best our current ability allows, at whatever level, without regret or self-pity.

• To recognize that we all begin at the same beginning and that where we go and what we do from there is our own responsibility.

• To applaud the achievements of every fellow artist, acknowledging insight and improvement, regardless of whether he or she is a beginning, intermediate, advanced, or professional artist.

Opposite: Detail from *Pemaquid Point Lighthouse, Maine*

• To understand that learning and progress come from doing—painting, drawing, studying—and that we get from it what we put into it. There is no shortcut to experience.

• To realize that each one of us shares the same gift, from the same giver, and that we are companions in the same struggle, the same dream.

• To paint, draw, or create from the heart, rather than from the ego; the true artist is the creator within us.

Join me now on this journey into my favorite world, where light and color play together each and every day that the watercolor artist picks up a brush. Let's get started!

—*Lou Bonamarte*

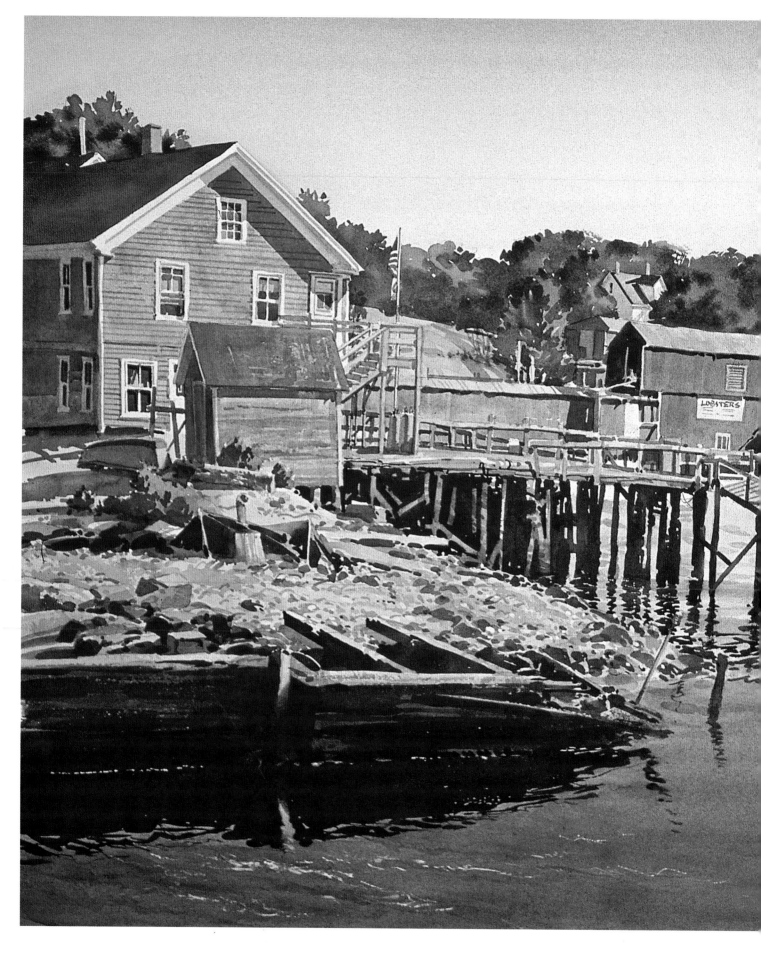

Welcome to Lou Bonamarte's studio! For over forty years, Lou has taught students like you and me. Virtually all of us have other jobs and/or identify ourselves as something other than an artist. In this high-tech world, only a few of the millions of people who study fine art can aspire to become professional artists and to support themselves with painting and teaching as Lou does. But all of us want to paint—and to paint *better*!

Better, more enjoyable, and more successful watercolor painting is what studying with Lou Bonamarte is all about. The approach to painting that Lou teaches is called *traditional realism*. It is based on the classical concepts studied by just about every major artist since the Renaissance. Yes, it's the very same foundation that supports the work of Rubens, Renoir, Monet, Picasso, Sargent, Homer, Cassatt, O'Keeffe, the Wyeths... the list could go on and on. This book is focused upon the most important of the traditional realism concepts: light. You will learn to understand how light affects—and even determines—color, form, and composition.

"Hold on!" you say, "I'm not in competition for wall space in a museum. I just want to do a few good paintings. Do I really need to study 'classical concepts'?"

Yes, if you want to paint well consistently. *Yes,* if you want to feel satisfied with your work. *Yes,* if you want others to appreciate your paintings. *Yes,* if you want the freedom to see things differently

and then express your perceptions in an aesthetically pleasing way.

More than any other artistic means of applying color to a two-dimensional surface, watercolor is the medium of light and luminosity. Well-executed watercolor paintings can appear magical, mystical, and sometimes even awe-inspiring. But the medium is not easy. Perhaps you've seen books or course offerings about learning "Watercolor in Five Easy Steps." These often promise an art form in which you can wave your arm across a sheet of paper and the brush and paint will leave behind something beautiful. This approach is supposed to work like the wand in a Disney film—a simple wave of it touches and transforms. Touching white paper with a wet, paint-laden brush will indeed transform the surface, but will you like it? Will anyone else like it?

Undisciplined strokes, no matter how graceful they may be, do not consistently and repeatedly produce satisfying and attractive art. Lou believes... no, let me change that... Lou *knows* that learning

Opposite: Detail from *Fishing Port in South Bristol, Maine*

to paint takes work. The effort required can be eased somewhat by a teacher, someone who will walk you through the required basic information and then help you put it to use. But the best, most carefully organized knowledge and guidance in the world, even when presented by the best teacher in the world, won't be magic enough to do away with that work requirement. To paint well you must paint often. Translation: *Practice! Practice! Practice!* To learn to paint well is to learn by doing.

That *doing*, however, must be based upon knowledge. I am a nonfiction writer by trade, and I've discovered that learning to paint with watercolor is surprisingly like learning to write. Before you can touch a keyboard and begin producing a fine essay or story, you must learn grammar, sentence structure, paragraphing, description, characterization, dialogue, plot structure, tone, and voice (to name just some of the basics). Similarly, before you can produce truly fine paintings, you must understand light, value, color, composition, brush techniques, and a whole lot more.

Whether it's writing or painting, you must learn both the concepts and the techniques before you can successfully develop your skills to create art. Those with the greatest artistic potential always need the strongest foundation. Why? Because the greater one's aptitude, the more creatively he or she can build upon that foundation.

"Are you talking about *talent*?" you ask.

Yes, in a way. The dictionary definition of talent is "a natural, innate aptitude for something." Of course, every person's natural aptitudes differ, but a good foundation in artistic concepts can help the student learn new painting skills and develop new attitudes and perceptions toward space, value, line, and color. In other words, it can help develop a person's talent.

Of course, every person has a slightly different idea of what talent is. Perhaps, after study and effort, it's really the ability to become completely unmindful of the conventions, limitations, and rules within which you must work, while at the same time using all of those conventions, limitations, and rules effectively and, in fact, building upon them. Talent is also the ability to see what others don't see and then to organize and present that vision in a way that leads the viewer or reader to share your vision. No matter your "natural, innate aptitude" for art, studying watercolor techniques will enhance your talent.

Perhaps the poet Robert Frost said it best in a short poem called "The Pasture." In it, he talks about some chores he must do and then tells the reader, "You come too." Those words are an invitation to see his vision, to share his world.

Every painting makes the statement "You come too." When you allow another person to view your work, you are sharing your unique perception. If you want your viewer to understand and appreciate that perception, it is best to create it based upon the time-proven concepts and conventions of art. In other words, use the knowledge that has worked for centuries. And then go beyond that knowledge when Inspiration and Insight come to visit you.

You may be thinking, "I'm a free spirit. I want my work to express that spirit. I don't need to know all that stuff artists used to go by."

Well, you can indeed express your free spirit to your heart's content in watercolor. But if you want

your viewers to appreciate your work and perhaps to understand it, you will need to know something about light, value, color, and composition. These concepts do not feel binding to the creative artist. They do not squelch artistic freedom and development. Rather, they support it.

The classical precepts of traditional realism are the foundation of Lou Bonamarte's work and his teaching. He believes that if you take the time to learn artistic concepts and techniques, your talent will then have the opportunity to grow and to flourish. In other words, once you know *how* to put a painting together, you can indeed put a painting together.

I have studied with Lou for five years now. I began with lollipop trees and cotton ball clouds and I thought I was pretty good. How my work has changed! During the process of learning to paint in watercolor, I have shed a few tears, walked out of class, sulked, and sworn that I was never going back. I have also felt the pride of watching hard edges become soft, of mixing exactly the right color, of creating a vibrant focal point, and of having my paintings admired.

During this five-year period, I have tried studying with other teachers. But again and again I have returned to Lou Bonamarte's studio. The almost magnetic attraction is his immense artistic knowledge, his love and understanding of light and color, his high standards of excellence, and his clear, step-by-step teaching procedures. Not to mention his charisma, sense of humor, kindness, and patience. Lou is a teacher who makes the challenge of learning easier. He not only shows the way, he also helps you travel it.

This book is an invitation from Lou to share his knowledge. The process is a journey that begins with the most basic understanding of the importance of light in a watercolor painting. Once you master these basics, you will be able to choose your own subjects, capture your particular visions, and develop your unique talent. This journey is not an easy one. Along its pathways, you will stumble upon setbacks and switchbacks. But you will also feel the pride of accomplishment.

Look—here is Lou, standing at the start of the path right now, saying, "You come too."

—Carolyn Janik

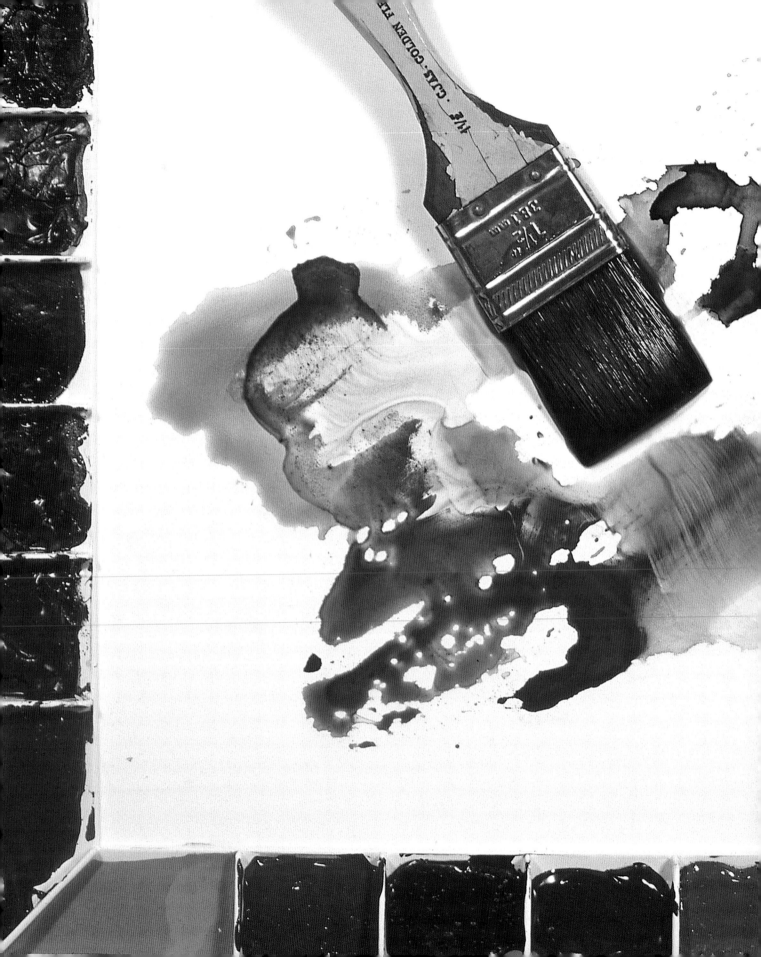

TOOLS AND SUPPLIES

CHOOSING TOOLS AND SUPPLIES

The problem for the beginning watercolor artist today is not where to find the tools and supplies, it's how to choose the right materials. You certainly don't need one of everything. So before you can become a member of your local artists' community, you are faced with questions: *What do I really need? When do I choose quality over quantity? And how do I tell the difference?*

Rather than use up your time with an extensive evaluation of every brand and product, I'll brief you on what has worked for me in my thirty-nine years of painting and teaching. Be aware, however, that there are many more options available. As you increase your knowledge and develop a style of your own, you'll want to try out other materials. What follows is a supply guideline for beginner and intermediate students.

HERE'S A TIP

The first thing you will need is a watercolor palette. The best, as far as I'm concerned, is the John Pike palette. Next, you'll need paint to put into your Pike palette. The colors aspiring watercolor artists should begin with, in addition to ivory black, are:

Winsor & Newton
• Winsor blue (green shade)
• Winsor green (blue shade)
• Winsor red
• New gamboge yellow

Grumbacher Finest
• Burnt umber
• Burnt sienna
• Alizarin crimson
• French ultramarine blue

Then, of course, is the noble brush! I recommend buying two Winsor & Newton "Sceptre" brushes (numbers 12 and 14), one Loew Cornell 7020 (number 6), one rigger (number 4), and a one-inch flat brush (also known as a skyscraper). See the following section for an explanation of each type of brush, along with images.

Now you just need some good quality watercolor paper to use all the paint and try out the brushes. I prefer Arches cold-pressed 140 lb to 300 lb paper. It comes in 22-inch by 30-inch sheets, pads, or blocks. Of course, there are other papers out there, but I've been using Arches for about thirty-five years and it continues to be consistent in quality.

Previous page: The best type of palette for watercolor is the John Pike palette.

Brushes

Traditionally, prevailing opinion has favored buying the very best brushes you could afford (or even not afford). In the watercolor world, "the best" meant Kolinsky sable. Today, however, synthetic brushes are well made and work nearly as well, with the bonus that they cost a fraction of the price of sable or other natural bristles.

Now, don't run out to the dollar store and buy up all their brushes. You'll be disappointed. Art supply stores and the art supply sections of big chain stores are good places to look. You don't have to buy the most expensive brushes, but you do need good brushes.

One way to test brushes is to take a small covered jar of water along on your shopping trip. When you see a brush that seems to be a size and shape that fits your needs, dip it into the water, swirl it around to get the sizing off (sizing is a substance added to papers, textiles, and brushes to act as a protectant), take the brush out, and then flick it with a quick snap of your wrist. In a good brush the hairs will return to their original shape and position. To stay out of trouble, first ask the department manager or storeowner if you can wet the brush to test it. Most good salespeople won't object.

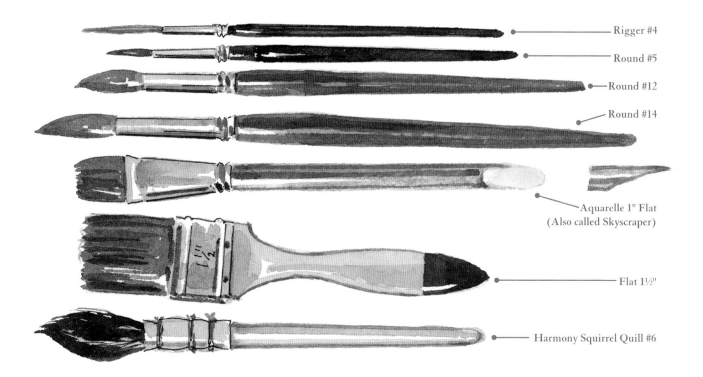

Rigger #4

Round #5

Round #12

Round #14

Aquarelle 1" Flat (Also called Skyscraper)

Flat 1½"

Harmony Squirrel Quill #6

There are many types of paintbrushes that can be used for watercolor painting. Remember, you don't have to buy the most expensive materials, but you do need good materials. Stay away from dime and dollar store specials. (Brushes not at actual size.)

FLAT BRUSHES

The hairs of flats have a square or rectangular shape. They come in a wide range of sizes, from ¼-inch wide to 4 inches wide. In your early watercolor paintings you are not likely to need either extreme. I generally recommend a 1-inch flat aquarelle (a flat watercolor brush with a special wedged end) for your starter set. It is sufficiently large for flat washes, where large surfaces must be covered evenly with one color, and sufficiently small to make a sharp corner when needed. If you want an additional size, buy a flat brush that is 1½ to 2 inches wide.

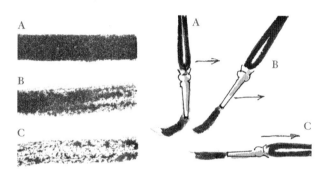

A. Holding brush vertically, moving slowly
B. Holding brush diagonally, moving quickly
C. Holding brush horizontally, moving quickly

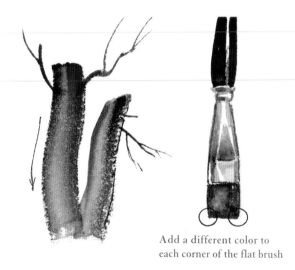

Add a different color to each corner of the flat brush

The effects of various strokes with a flat brush.

Flats have many other uses beyond the traditional wash. By sequentially touching the paper with the end of the brush, for example, you can create the illusion of blades of grass. The edge of the brush will also make swirls and dots, and can be applied in one movement from top to bottom to make a perfect square. If you like to paint wet-on-wet, you can use a larger flat for wetting down a sheet of paper before applying a wash. You can also use semi-dry flat brushes to create more pronounced brush marks.

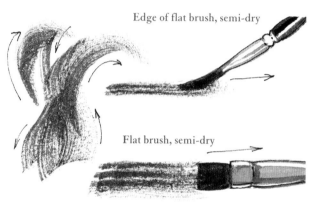

Edge of flat brush, semi-dry

Flat brush, semi-dry

Semi-dry brushes create more pronounced brush marks.

ROUND BRUSHES

Rounds are the brushes most people think of when they envision watercolor painting. They are bulbous in shape, come to a point, and hold a lot of water. They come in an immense array of sizes, which varies from manufacturer to manufacturer. Some companies sell size 000 brushes (the smallest size available), most sell sizes 0 to 14, and Robert Simmons goes all the way up to size 36. I usually suggest that students buy a #8 and a #12 round. These two brushes will hold enough water and pigment to cover large areas quickly, but their tips can also be used for more detailed work. If you can't do a painting without detail, also buy a #5 round.

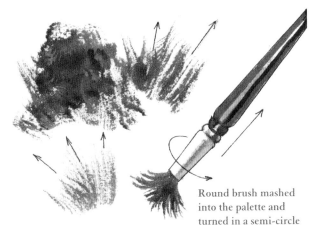

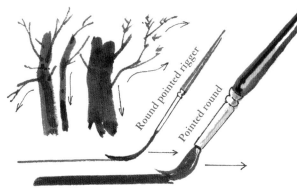

Round brush mashed into the palette and turned in a semi-circle

The effects of various strokes with a round brush.

RIGGER BRUSHES

Imagine you're a watercolor painter in the age of sailing ships. How would you paint the rigging of a ship? Enter: *The rigger*. This brush has very long bristles, but very few of them. It holds a large quantity of paint for its size and is used for making long, fine lines.

Riggers come with a flat tip, an angled tip, or a pointed tip. Try all three types and then decide which you prefer. Or you can wait—owning a rigger is not really necessary as a beginning painter, but if detail is your forté, you might want to buy one at the beginning. With a steady hand, you'll be able to paint lines as thin as a cat's whisker. (Think

telephone lines, the stamen of flowers, thread, fishing line, eyelashes . . . you get the idea.)

FAN BRUSHES

Fan brushes are shaped just as their name implies, with the bristles forming a semicircle. Like the rigger, a fan is not necessary for your start-up box of tools. If you like to experiment, however, they are good to use when painting hair, grass, and wood grain, and for feathering out paint and other special effects. Many artists use them to drag dry-brush paint across the painting surface, creating a series of fine lines that are a unique watercolor effect.

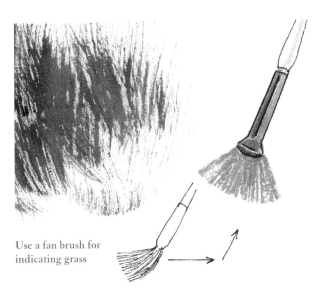

Use a fan brush for indicating grass

The effects of various strokes with a fan brush.

MOP BRUSHES

No, these mops are not the type found in the broom closet! The mop is similar to the round, but thicker. They are used for covering large areas with water or a wash. It's not necessary to spend the extra money to include this kind of brush in your start-up box.

Paper

Because the watercolor medium must be applied to an absorbent surface, it requires specially prepared paper. There are many manufacturers of watercolor paper and the range of quality is great. However, there are three types of watercolor paper texture: rough, cold-pressed, and hot-pressed.

There are three types of paper texture: rough, cold-pressed, and hot-pressed.

TEXTURE

Rough paper is highly textured, meaning it has many bumps and indentions. In the art world, this is called "tooth." It is easier to make a flat wash on rough paper because the pigment evens itself out in the indentations between the bumps. But, as you might expect, it is more difficult to paint fine lines and details on toothy paper.

Cold-pressed paper is rough paper that has been weighted down during the drying process. This step smooths out the texture to some degree. With cold-pressed paper, the pressing process affects one side of the paper. To know which side it is, look for the watermark that appears in the corner of the paper. If you can read the watermark (also known as embossing) you have the cold-pressed side.

Cold-pressed paper is a good all-purpose watercolor surface and probably the best choice for learning the watercolor medium. When you use it, you will inevitably learn that the semi-smooth surface causes water to puddle rather than spread out among the tooth. When the paper dries, you can sometimes see the darker edges of the puddle, which is referred to as a *backrun* or *bloom*.

Hot-pressed paper is exactly that: rough paper that has been hot pressed. In other words, it is ironed with a metal plate. The resulting paper surface is very smooth, but I don't recommend that a beginning artist start out on this texture. The pigment is hard to control and backruns are even more likely to occur than on cold-pressed paper.

Disappointment is inevitable when using a surface that is hard to manage. That disappointment can lead to defeat and resignation. Hot-pressed paper is tricky; many would say it is temperamental. So why would anyone want to struggle with hot-pressed paper? The answer: pure and transparent color. Texture causes shadows in the valleys of rough paper, which affect the clarity of the applied pigment. Since hot-pressed paper is very smooth, it does not have that issue. Many professional artists choose to work on hot-pressed paper for a particular effect.

WEIGHT

Besides texture, watercolor paper is also sold by weight. And, like the karats in a diamond, weight is positively correlated to price; cheaper papers are lower in weight and less desirable. You may be wondering, however, what those printed weights actually mean. The watercolor pad you find in

the store is described as 140 lb (or less) on the cover, but you *know* it doesn't weigh a hundred and forty pounds! And, of course, it doesn't—the weight printed on a pad or block of paper is the weight of a *ream* (500 sheets) of paper. The heavier the weight listed on the package, the thicker the paper stock.

PROBLEMS

Potential problems to be aware of in watercolor paper include buckling (when areas of the paper swell and wrinkle when wet), heavy sizing, and mechanical finish. Some artists make efforts to correct these problems in lighter-weight papers (under 200 lbs) by soaking each sheet in water and then stretching and stapling it before allowing it to dry.

Today, heavier papers are made to counter buckling. The heavier the weight, the more rigid the paper and the less likely it will buckle. Any paper over 300 lbs will stay flat no matter how much paint and water you apply. However, 300 lb paper is not only expensive, but also more difficult to work upon. It is hard to "cut an edge" on rough paper ("cutting an edge" refers to the sharpness of the edge of a brushstroke of paint).

Most artists, and especially beginning artists, prefer the more flexible 140 lb paper. If purchased in a *block*, with glued edges and a hard backing, stretching is not necessary, as the glued edges keep the paper straight and flat. Blocks are more expensive, however, than separate sheets or spiral bound pads.

If you paint on cheaper paper (90 lb for example), you will need to stretch each sheet before starting a painting. Because lighter-weight paper is prone to wrinkling when it gets wet, if you don't first wet it, stretch it, and then let it shrink, you will discover (and have to deal with) bumps and wrinkles as you paint. Those bumps and wrinkles may or may not be permanent.

I recommend that you start on quality 140 lb cold-pressed paper. The art of painting is an interplay between the mind, the hand, the paint, the brush, *and* the paper. In exploring what this quintet can do, you'll be disappointed much less often if you work consistently on quality paper. When using 140 lb cold-pressed paper for exercises and sketches, feel free to turn the paper over and use the other side for another exercise since it's durable enough to withstand buckling.

Heavy sizing, common on cheaper watercolor papers, can interfere with the clarity of color and the ability to move paint freely. It is generally better to invest in high quality, 140 lb cold-pressed paper, than to go through the process of soaking and stretching to remove the sizing. In other words, you should be painting rather than working on improving paper quality!

Pigments

Watercolor pigment comes in two forms: liquid in tubes and solid in cakes. Pigments also come in an almost endless array of hue and quality. Eventually, picking paint will become a very personal choice. For the time being, however, I think you should begin your watercolor education with just a few "old reliables."

I prefer working with watercolor in tubes. In a given tube, the paint squeezed out onto the mixing surface is always the same color. When using color in small cakes, it is very easy to accidentally put a dirty brush on a clean color. Then it is difficult to get the color clean again.

Paint can be kept fresh in the wells by covering the palette. If a pigment becomes dry, it can be renewed using the mister.

For beginners, I suggest stocking a palette with the following nine colors:

Alizarin crimson
Burnt sienna
Burnt umber
Ivory black (optional)
New gamboge yellow
French ultramarine blue
Winsor blue (green shade)*
Winsor green (blue shade)*
Winsor red*

*I recommend Winsor & Newton brand for these colors.

"Why so few colors?" you ask. "That's like starting out with a basic crayon box."

Yes, in a way it is, and there's a very good reason for that. Each watercolor pigment has a complex personality. For example: Is it staining or nonstaining? Is it warm or cool? Transparent, opaque, or translucent? Is it granular? How well does it mix with other colors? If you start out with too many pigments on your palette, you will get confused and sometimes you will end up making mud (well, mud-colored paint at least). It's far better to get to know a limited number of the most commonly used hues and then gradually add more to your palette.

Last, but most important, do *not* buy so-called "student grade" pigments. The colors can be inconsistent from tube to tube or cake to cake; they frequently dry to shades different from what you expected; they often fade; and they can be granular. If you learn to paint in watercolor with poor quality paints, you will have to un-learn many things before you can produce aesthetically pleasing work. So buy "artist grade" (also sometimes called "professional grade") and get a step up on becoming an artist. There are many fine brands of watercolor pigment on the market. I like Winsor & Newton and Grumbacher. You can start with those, but you will also surely find others that you like.

The Palette

There are hundreds of types of palettes on the market. In fact, most pre-packaged painting kits come with a cover that doubles as a palette. If that space seems like it would be too small, you're in the majority. Experienced artists usually want more surface area on which to mix colors, as well as individual wells to hold and separate paint that has been squeezed from tubes.

There are many palettes, both large and small, that have mixing space and paint wells; I personally prefer the John Pike palette or something similar. The Pike palette has a large, empty center space that allows you to mix paint without running into obstacles; you can also use the cover as a mixing area. The pigments are kept in individual wells around the outer edge of the palette. I won't hold you to buying a Pike palette at first since they're rather pricey, but I do recommend spending the extra few bucks to get a palette with a tight-fitting cover to keep the paint fresh when not in use.

If you are economizing, you can mix watercolor pigments on any nonporous surface, but ceramic and plastic work best. The surface should be white so that you can accurately see the hue with which you are working. You can use chipped plates or old ashtrays, or you can purchase inexpensive plastic palettes with wells and mixing areas in your local crafts store.

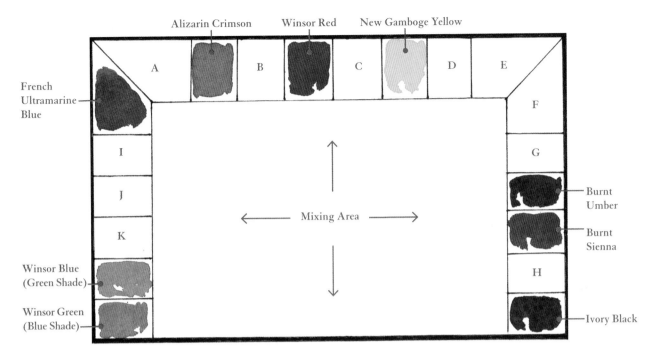

This is how I arrange my colors out on my palette. Wells A–K are for additional colors as you become more confident with this limited number. For example, Well D could be filled with Winsor yellow or Well K could hold cobalt turquoise.

The Work Surface

If you read art catalogues, you will see many watercolor easels that allow the artist to somewhat control the angle of the work surface advertised. However, I do not recommend that you buy one as a beginner, unless you are absolutely set on working outdoors. A decent easel is invariably expensive and can actually make learning to paint more difficult.

Although outdoor watercolor painting does require an easel, working on an easel usually means working on almost vertical paper. The upright angle of the paper increases the difficulty of handling the watercolor medium by tenfold, especially for a beginning watercolorist. Washes are harder to control and colors run more easily.

So, I have another suggestion: Instead of making it *more* challenging for yourself by hiking out to the field to paint, learn the fundamental techniques of watercolor initially by painting indoors. You can use still-life arrangements, or you can work from photographs. Some artists object that using photographs is not the artistic ideal since you are not painting directly from real life. And yes, there are some limitations to using photographs—you won't

HERE'S A TIP

Most artists prefer their painting surface to be set at a slight angle. Some even choose an almost vertical surface. Most beginning watercolorists, however, will feel more comfortable working on a flat, horizontal surface. Do whatever works best for you.

If you are painting outdoors, you will need a portable easel.

Necessary Odds & Ends

Because nothing is as simple as we'd like it to be, your watercolor painting satchel will have to include a number of extra items to help transform your ideas and efforts into aesthetically pleasing paintings. Think of this section as a checklist that you might use to pack for a trip.

WATER JARS

You'll need two water containers, one for clean water and one for cleaning off brushes. (That one will very shortly become dirty water.) Any kind of glass jar or plastic container will do. I prefer containers that are relatively short and squat. The most important thing is that the container for the clean water be *clean*. Keep in mind that you should *never* keep brushes standing on their hairs in water—they will become misshapen.

You might also want additional empty jars (taller than the water jar) to hold the brushes that you are using. To store your brushes between painting sessions, clean them with warm water and then stand them on their ends in a dry jar with the hairs pointing up, or in a brush case. It is very important to make sure your brushes are clean and all the pigment is removed. The gum arabic found in watercolor pigments can dry and break the hairs of your brush.

be able to observe the play of light and atmosphere as easily, but you will be able to learn the concepts and essentials of the watercolor medium with less stress and difficulty.

Later, prepared with a good artistic and watercolor foundation and some experience, you can venture outdoors. For outdoor painting, I recommend using a watercolor easel.

When painting indoors you can use a piece of plywood or Masonite as your painting's support surface. Have it cut to a size you find comfortable for the work you will be doing and use white artist's tape or clasps to attach your paper to it. You can also use Homasote (a ½-inch thick fibrous composite board). It comes in 4- by 8-foot sheets and is available at lumberyards and home maintenance outlets. Many of these stores have smaller "scraps" in various sizes for sale. Paper can easily be stapled to Homasote.

HERE'S A TIP

The water jar used for cleaning off the brushes will soon get mucky. However, it can be useful when mixing dark, muted colors. The clean water is for clean, clear color mixing.

A BRUSH CASE

Convenient both for storage and for holding brushes while painting, canvas brush-carrying cases are widely available in art catalogues, art supply stores, and online, and they are not outrageously expensive, ranging between $10–$25. You don't have to run out and buy one, but they do make a good item for your birthday wish list.

PAPER TOWELS

You may be thinking: *Wow! He's getting pretty basic, isn't he?* Yes, I am. But paper towels are important because they quickly absorb excess water on the paper or from a brush. Absorbing is important when you want excess water or pigment removed, not simply moved around. Definitely buy the most absorbent towels you can find.

You will also want paper towels that do not decompose and shed lint onto your painting or into your brushes. The bits and pieces may be very small but they can wreak havoc with a flat wash or cause a bump on a fine line, so pay the little bit extra for better quality paper towels. Personally, I prefer Viva brand.

A HAIRDRYER

If you are very patient and have time on your hands, you don't actually *need* a hairdryer, but it sure does make twenty-first–century watercolor painting easier. Hairdryers will cut down on time spent waiting for your painting to dry. It's important to know when the paint is dry. For example, we usually paint from light to dark (light colors first, then darker, then darkest) and, instead of waiting for the light wash to dry naturally, you can carefully dry it with a hairdryer, avoiding unwanted problems.

Most hairdryers found in pharmacies and discount and department stores will do the job. Usually, a hairdryer has more than one speed, so I use low-to-high. Using the low setting, keep moving the dryer slowly, left to right, about four to five inches away. When the paint begins to appear dull, switch to the high setting, still moving from left to right. Don't leave the dryer aimed at the painting for too long—you don't want your paper super-heated. You will be able to tell when the area is dry because it will lose its shine.

Keep in mind that if you hold it too close the hot air blowing from the dryer can actually move the wet paint. Also remember to keep the paper completely flat when drying, or else you end up with wrinkles.

TAPE OR STAPLES

Unlike oil painting, in which the canvas is already attached to a board or on stretchers, the watercolorist must find a way to attach the paper to a work surface. There are several options.

Some artists use tape to attach the paper to the work surface, as well as to create a "frame" around the painting. Although masking tape seems to work, I don't recommend it. If you are painting wet-on-wet and using a lot of water, the tape will not hold consistently. Also, as the wet paper shrinks in the drying process, it will tend to pull up the tape and prevent it from sticking properly. Instead, use white artist's tape, which comes in a variety of widths. I recommend 1-inch, with half the tape sticking to the paper, and the other half on the mounting board. Artist's tape is sticky enough to hold paper in place and can take a little water without coming detached, but when you peel it off it, it will not damage your paper. Always remove tape slowly.

Avoid the blue painter's tape sold in the paint departments of home maintenance stores. Although it actually works very well, the blue border will influence and react with the colors you choose to put into your painting.

As I mentioned earlier, when using a Homasote work surface, you can use staples to attach your paper. If you are working on a sheet of plywood, you can also attach paper with a lightweight upholstery stapler. You should staple the paper about ¼-inch from the edge of the paper, with the staples at 2- to 3-inch intervals. Remember, however, that you will have to pry the staples up with a screwdriver or staple remover when your painting is finished. Also, make sure that your mat covers the staple marks on your final product. If you don't plan on matting your painting when it's done, you'll want to make sure to leave enough margin space to be able to cut away the staple marks and still maintain the border you desire.

PENCILS AND AN ERASER

Most painters lightly sketch in major masses and forms before starting a painting. Although the lines can easily be erased, many painters just leave them in as an aesthetic detail. However, you should erase pencil marks from any white shapes that will remain on the finished painting.

Some abstract artists and some very confident realist artists begin their work by putting paint directly on the paper. I am not comfortable with that approach and prefer to make preliminary sketches and value studies before I start painting. (A value study is a sketch that shows the dark and light areas of the scene that will be painted. I will discuss value studies in more detail in Part III.

Once I have an idea of what my finished work will look like, I transfer the idea to my painting surface in pencil.

Although I don't just pick any pencil, I also don't go to the art supply store for specialized pencils. The commonly used no. 2 pencil (the same as an HB drawing pencil) is really the best pencil for sketching your work on the painting surface because it is neither too hard nor too soft. Soft pencils like 4B or 6B can leave graphite on your paper, which can mix with applied pigment and dull the hue. Hard pencils (any pencil with an H, like 3H or 5H) will score your paper with just a little pressure. Those score lines are difficult to get rid of and can show in the finished work.

After the work of painting is complete, some artists like to erase the sketch lines. Some, however, just leave them as a part of the work. I personally prefer to erase as many of the pencil lines as possible, especially on white paper. If you choose to erase, use only soft erasers such as kneaded, soft gum, or plastic.

A STRAIGHT EDGE OR RULER

You can use a ruler or straight edge to guide your hand when straight lines are essential. Most artists also measure their paper and the working area for appropriate size.

MASKING TAPE AND MASKING FLUID

White artists' tape can be used to cover a large area when doing a flat wash, such as a barn against the sky. It will keep the water and pigment from staining the area, allowing the pristine white paper to show through.

Masking fluid can be used to keep a smaller area white, such as a church steeple or the mast

of a boat, while doing a wash. Art masking fluid is actually a liquid rubber that can be painted on in any shape you wish. However, do *not* use your good artists' brushes to apply it; it could ruin them. You should use disposable children's brushes, craft sticks, or toothpicks instead. Masking fluid can be purchased at most art supply stores or online. After you have finished painting around the area you have masked out, wait for the paint to dry and then peel or rub off the liquid rubber.

A SPONGE

Both artificial and natural sponges can also be used to scrub out pigment from an area of the paper.

A RAZOR, A PALETTE KNIFE, A CREDIT CARD, AND MAYBE A SPATULA

You'll be surprised what a little ingenuity using everyday tools can do. Single-edged razor blades can be used for scraping or scratching paint up from paper. You can also lift paint with a palette knife or, believe it or not, with a torn-apart credit card. And the edge of a spatula can create the illusion of tall grasses.

A MISTER

No, not a man—I'm talking about a pump-style spray bottle that creates a fine mist.

Long ago, before the days of self-steaming irons, people commonly sprayed mist over the surface of a piece of cloth to help get wrinkles out. Such bottles are now hard to find in the housewares section of stores (most of the spray pumps you'll find don't produce a fine enough mist), so most of my students purchase plant misters, the bottles used for spraying the leaves of indoor plants. You can find them in garden supply stores and the gardening section of home goods stores.

You can also find them (at a somewhat higher price) in art supply stores and catalogues.

If you are wondering *why* you need a mister, think a moment. The medium is watercolor. Often, you may want to wet or re-wet a section of your work surface. You can also use a mister to refresh tube paint that has begun to dry on your palette.

INTANGIBLES

It takes a willing human being and some pretty important intangibles to create a painting.

Let's talk about *courage*. No one likes to make a fool of himself/herself, especially in front of others. But when you touch a brush to paper you are going to leave something on that paper and it won't always be what you intended. Will you make a "fool" of yourself? No, so long as you are not afraid to laugh, or crumple the paper, or start again. Learning to paint is a process, and it doesn't always go step-by-step.

Overcome your fears. I've seen so many paintings fall short because the painter was afraid to try something new or different. So many beginning (and even sometimes experienced) painters are afraid to "wreck it." When that dark cloud rolls in, students often leave a work just short of complete, sometimes just short of awesome. Call upon your courage. Experiment!

And while gathering intangibles with your tools and supplies, don't forget to store up plenty of *perseverance*. In other words, don't give up. Keep trying! Keep studying! Learn from your failures; take joy in your success.

Finally, your eyes: keep them open. Notice things. There is awesome beauty everywhere, even in what appears to be not so beautiful. Your eyes and the intangible magic of aesthetic conception are the most powerful tools you have.

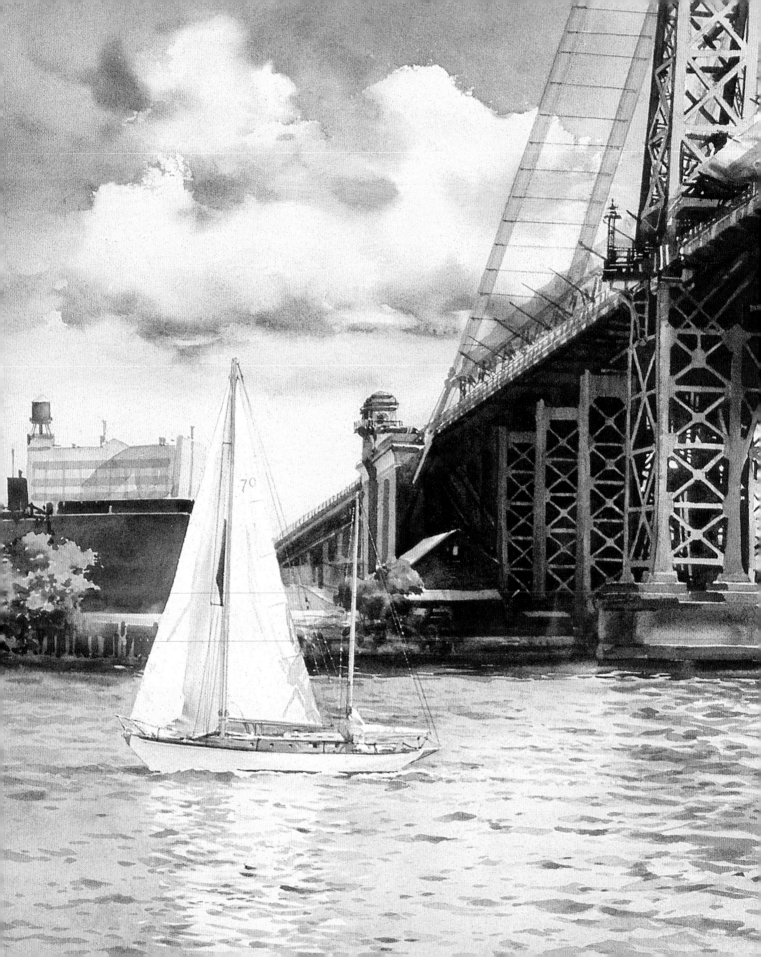

PART II
LIGHT

LESSON 1
LIGHT IN YOUR LIFE

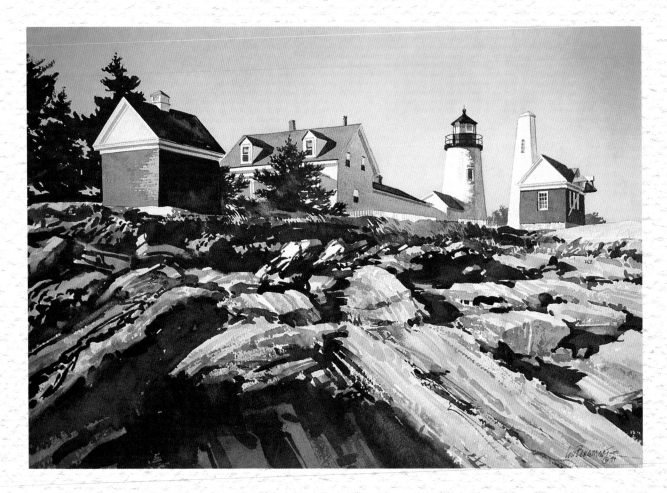

Pemaquid Point Lighthouse, Maine

A work of art is above all an adventure of the mind.

—EUGÈNE IONESCO (1909–94), Romanian-French playwright

Previous page: *The Williamsburg Bridge*

Can you imagine life without light? Think about no dew-drenched grass sparkling in the early morning sun, no foggy days at the boat docks, no sunsets over the mountains, and even no candlelit dinners for two. Now think a bit more globally: no plants, no trees, no animals, and no people. As everyone knows, the life we are familiar with just can't exist without light. And neither can art. Well, at least not art created on canvas, paper, or clay.

Light on Paper

You could argue that a blind person or someone in a darkened room could develop an appreciation for a piece of sculpture by touching it. Painting, however, is an entirely visual art. It requires light appreciation by a viewer and it requires the contrast of light and dark on a flat surface to transform that surface into a piece of art.

Art, of course, has many definitions. We as watercolor artists create an image of what we see and feel and put it down on specially prepared paper. For those of us committed to realism in contrast to abstract or expressionistic images, "putting it down on paper" is a very real problem, often the *first* problem in the mind of the beginning artist. We see in three dimensions (height, width, and depth) and we paint in two dimensions (the height and width of the painting surface).

"So," you ask, "how do you make the eye of the viewer see three dimensions on a flat surface? What creates form in watercolor painting?"

I'll give you a clue. It's exactly the same phenomenon that allows us to understand and appreciate photographs, television, and movies. Now in the twenty-first century, we're so accustomed to processing two-dimensional visual information that we don't even think about what enables us to understand it.

Do you have the answer? Do you remember the topic of this lesson?

That's right: *light!* And also light's opposite, *dark*. Light and shadow create the illusion of depth on a flat surface. In other words, gradations of light and dark can create the illusion of three-dimensional space and form.

Of course, creating a piece of *art* goes way, way beyond getting all the lights and shadows right, but knowing and using the many aspects of light available to the watercolor artist will help you to create paintings you can be proud of. Your use of light and shadow will also affect the emotional impact of your work.

Corners and Curves

Look at the *Pemaquid Point Lighthouse, Maine* painting that opens this chapter. Why do the buildings have corners? Why is the lighthouse round? What makes you feel that the rocks will be a challenge to climb? The answer, of course, is light and shadow.

In painting, shadow is the essence of all form. An artist needs light areas to show darkness and dark areas to show lightness. We call the dark areas shadow. We see shadow in different degrees because light hits the surface of an object in different ways, or not at all. Your most important first step to creating artful watercolor is to recognize light sources and the shadows they create.

The primary light source (the sun in landscape painting) comes from a particular direction at a particular angle. For example, the light at high noon will hit a horizontal surface such as a meadow or the roof of a car at an approximately 90-degree angle. That means that the light rays come straight down from above. Thus, vertical surfaces, such as the wall of a house, do not get light from the sun at high noon. They are in shadow, called *object shadow*.

On the other hand, the light from a sunrise or a sunset may hit a vertical surface at about a 90-degree angle. That strong light creates the beautifully illuminated building walls you see at the beginning or end of a day. That same sunrise or sunset light hits horizontal surfaces such as the meadow or a road at an angle and, as a result, long shadows are cast (these are referred to as "raking shadows").

That's not hard to understand, right? Now here comes the academic version: *The orientation of a plane in relation to the light source and the angle at which the light hits that plane determine the amount of light that reaches each surface.* In other words, the amount of light that reaches each plane defines the object's form in your painting.

The *planes*, or surfaces, hit directly by the primary light source should be brighter than all

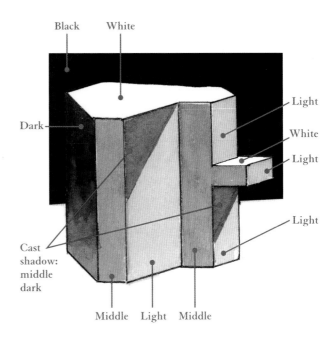

Values: white, light, middle, middle dark, dark, black

the other planes in your painting (if you are outdoors, that will be the planes that meet the rays of the sun at a 90-degree angle). The planes opposite the light source should be the darkest in your painting since they are not receiving light from the primary, and strongest, source. If there is only one remaining plane in your painting,

it will usually be neither particularly light nor particularly dark. (This is called a middle value. I will discuss that more in Part III.) If there are numerous other planes in your painting, their relative lightness or darkness will depend upon their position in relation to the light source. It is this change in *value* that helps to create the illusion of angles and/or roundness for a building, a tree, a piece of fruit, or any other three-dimensional object or surface.

ARTFUL MEANINGS

When talking about painting (at least for this book about watercolors), value has nothing to do with worth or money. *Value* refers to the relative lightness or darkness of an object or a surface.

Now look for a moment again at *Pemaquid Point Lighthouse, Maine* (page 30). In that painting, the sun is coming from the viewer's left, midway up in the sky. You can tell the location of the sun by the angle of the two dormer shadows on the roof of the white house.

Here's a test for you: Can you identify the lightest planes in this painting? What makes the buildings appear to have corners? Look around those corners, away from the light. The surfaces you see are middle values. As the values of the buildings change, so do the shadow values. Notice that the shadow value for the red house on the left is much darker than the shadow value for the white house. The potentially darkest areas of the buildings are opposite the light source, but they are not visible from the perspective given in this painting.

PRACTICE! PRACTICE! PRACTICE!

- Step 1: Practice turning corners. Copy the outlines of the buildings in *Pemaquid Point Lighthouse, Maine* (you can trace them if you prefer). Now place your light source, the sun, high on the right side of the scene. Which surfaces are lit, which are dark?
- Step 2: Paint a practice exercise of these buildings using only one color. To create the forms you must show surfaces lighter or darker in response to the light. (You can make your chosen color lighter by adding water. You can also use a combination of French ultramarine blue and burnt umber which creates a warm gray to darken your chosen color.)
- Step 3: Try painting the same scene again. This time, make it a sunset, with the sun directly behind the lighthouse. Remember: In this version, the darkest planes will be facing you.
- Step 4: Creating form with light and shade is an important exercise that you can use again and again with different subject matter. Copying the major outlines of an existing painting or even a photograph and then repainting it with the light source in different locations will help you to recognize light source and its effects. Do it whenever you have some spare time, until the recognition and evaluation of light becomes an automatic part of your painting routine.

The Light Source

To create an artful landscape that looks realistic, every single object in your painting (from a cloud to a building to a rock) should be painted so that it is responding to the *same* light source. Let's

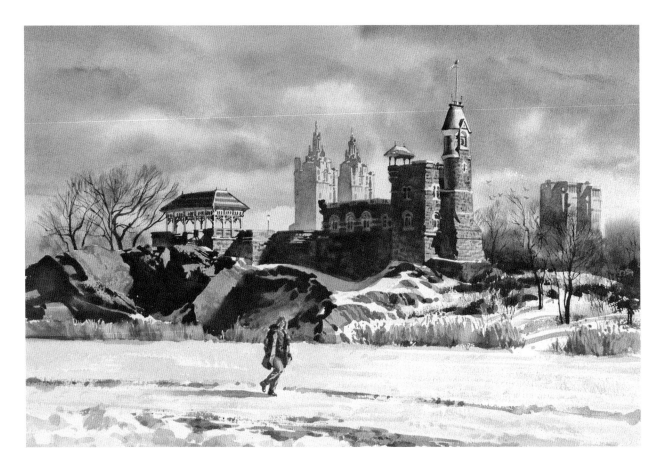

Central Park in Winter

stop to look at another painting, *Central Park in Winter*. Try to see it in terms of planes responding to light source.

The light source in this cityscape is from the sun on the viewer's right. The angle shows that it is probably late afternoon. The right wall of every building is well lit; the visible walls at right angles to that plane are in shadow. Each building and each object also has a cast shadow.

Look at the clock tower in the middle. It has an object shadow that defines its change in shape from round near the top to rectangular near the bottom. The girl walking through the snow in the foreground has a very visible cast shadow. Every

building in this painting has an object shadow. Every building is also oriented to the light in the same direction and therefore shows the same surface in shadow.

Now look at the cast shadows. All the cast shadows of *all* the buildings and *all* the trees and of the girl fall away toward the viewer's left at

HERE'S A TIP

Cast shadows will appear darker on a clear, bright day than they will on a foggy or hazy day. The edges of the shadows (as well as the objects) will be sharper, as well.

the *same* angle in relation to the light source. This consistency helps to create the realistic vision. It also creates an abstract pattern—the angles and the darkness of the cast shadows play against the verticals of the object shadows to contribute to the drama of the painting. In musical terms, these are rhythmic repetitions that hold the painting together.

Morning Light, Port Clyde, Maine – The cast shadows in this painting are very obvious. Notice how they're all at the same angle, in relation to the light source, which in this case is the sun.

LESSON 2
PLANES, ANGLES, AND LIGHT

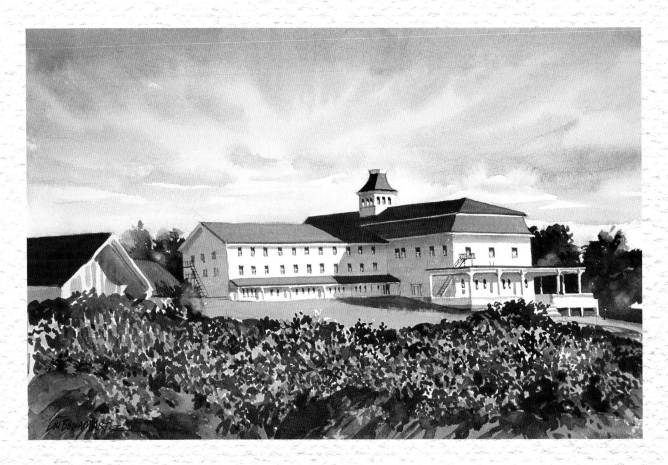

Block Island Hotel

. . . the artist is not there to be at one with the world, he is there to transform it.

—ANAÏS NIN (1903–77), French-American writer

I n Lesson 1, we were working with the relationship between light source and planes. Keeping that relationship in mind, I now want you to become aware of each plane's relationship to the ground plane. Look at my painting of a historic grand hotel on Block Island, Rhode Island, a boating landmark at the mouth of Long Island Sound. Pick out the vertical planes, diagonal planes, and horizontal planes. How is each plane related to the ground plane?

"Oh, come on!" you groan. "Are there really so many relationships in one little painting?"

The understanding of relationships is a magic potion that can change a camera shot into a painting. Your personal observation, interpretation, and reaction to spatial and value relationships can and will influence the composition of every painting you do. We'll be talking about those artful relationships throughout this entire book. Right now, however, let's stop a bit to consider the ground plane.

The Ground Plane

The *ground plane* is the surface upon which the objects in the painting stand. The concept of this plane is almost as important to successful watercolor art as the concept of a primary light source. Still-life paintings create an easy learning situation on this topic because, in most cases, the ground plane is a table. The table surface is flat and everything stands upon it. The objects in the painting therefore relate to the same light source upon the same flat surface.

In landscape painting, things get a bit more complicated. There may be, and in fact there often are, several ground planes in one view. The earth may slope; it may be broken by water; it may be jagged and uneven because of natural processes or man-made constructions. Therefore, before you start painting, you should take a mental inventory of the ground planes in the scene you wish to paint. Figuring out the ground planes is very important to maintaining a linear perspective.

For example, look back in Lesson 1 at *Pemaquid Point Lighthouse, Maine* (page 30). You do not see the ground plane in the foreground. You only know that the rocks rise up from it at angles. The ground plane of the middle ground (where the buildings stand and the contrasts of light and dark are greatest) is flat. The light and shadow relationships of objects on that land are consistent and predictable.

If you are painting outdoors in, say, Florida or Iowa, your ground plane will usually be more or less flat. However, if you are painting in New England or Oregon, for example, you may be looking at a scene with many different ground planes. In *Block Island Hotel*, you'll notice that the buildings stand upon a hill. The ground plane therefore slants. The angle of the incline and the position of the sun determine the angle of the cast shadow. As in *Central Park in Winter*, page 34 in Lesson 1, the shadows are an important element in the composition.

But even more important to the aesthetics of *Block Island Hotel* is the ground plane of the flowers in the foreground. They do not grow on the same well-manicured, sloped lawn where the hotel stands. A thin line of dark green shrubbery separates their ground plane from the slope. The land beneath the flowers is rough and uneven, but generally closer to a horizontal plane than the land behind it. How can you tell? Look at the shadows.

In *Setting Sail*, the ground plane is the slightly uneven sand beneath the figures and the toy boat. However, there is another flat ground plane in the pool of water in the foreground. If the boat were on that plane, you would have to consider how it would relate to the water and cast its shadow based on that.

Can you find a third ground plane? Yes, it is the ocean in the background. If you think of the waves as building upon their watery ground plane, it will help you achieve realistic effects.

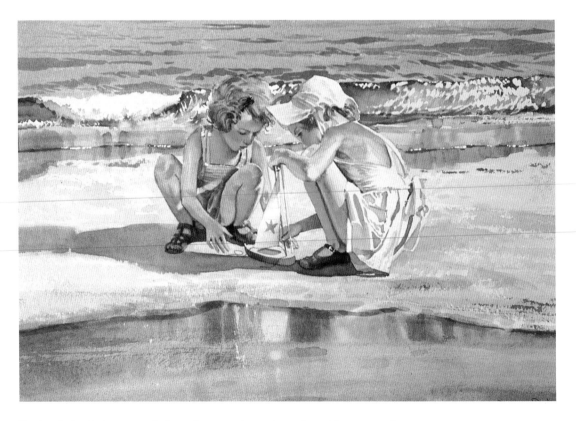

Setting Sail – Is the ground plane the same throughout the subject matter?

Landscape painting can be perceived and discussed relative to five different areas on the painting surface.

- The *foreground* is the area closest to the viewer.
- The *middle ground* or *middle distance* is usually the middle third of the painting and often the location of the focal point.
- The *horizon*, *far distance*, or *background* is the farthest surface area the viewer can see. In some paintings, like *Block Island Hotel* (page 36), the viewer does not see a distant horizon.
- The *sky* can comprise most or even all of a painting. Or not. The artist chooses how much sky appears in each painting. Sometimes there is barely a line of sky or perhaps the sky does not appear in the painting at all, as in *Setting Sail*. But it is always imagined and it is always influential. For example, the number of clouds, the wind, the time of day, and the season all influence the character of the sky. That character is reflected in the painting as a whole.
- The *focal point* is what the painting is about—the center of attention, as it were. It is often where the colors are strongest and the darkest darks meet the lightest lights.

Shadow adapts itself to the contours of the surface upon which it falls. On a flat surface, it assumes a shape similar to the object casting the shadow. On an uneven surface, the shadow will be distorted and it will follow the contour of the ground plane.

Light from the Ground

Okay, you understand ground plane, you understand horizontal, vertical, and diagonal planes, and you understand primary light source. You're ready to take on your next challenge.

Once you establish your light source and your ground plane, every other plane in your painting will have two relationships:

1. Every plane will be at some angle to the light source.
2. Every plane will be at some angle to the ground plane.

"That doesn't seem too hard to understand," you say. "An oak tree may be perpendicular to the ground, a palm tree may be bent. Why is that so important?" Because the relationships of objects, light source, and ground plane determine shadow; because shadow is the essence of form; and because *the ground plane can both receive and reflect light*. The use of reflected light in a painting is often the factor that differentiates an awesome painting from an acceptable one.

We'll spend Lesson 4 on reflected light, but I'd like to introduce you to the concept here because it is so important in the balance of color and value in a painting. Look at the small building on the left side of *Block Island Hotel* (page 36). With the sun coming from high in the sky (on the viewer's right) the diagonal plane of the roof of this building casts a diagonal shadow on the vertical wall. But look under the eave. What's that warm area of light between the roofline and the cast shadow?

According to the concepts of light source, because the sun's rays do not hit that particular surface, it should be without light—that is, it should be *in shadow*. Yet the warm light we see there is aesthetically pleasing, exciting. This dramatic

color contrast is the result of the perception of light reflected from the ground plane and from the side of the building. Now look at the *underside* of the horizontal roof of the main building's front porch (on the right side of the painting). That surface is also completely blocked from the sun's rays by the porch roof. Theoretically, it should get no light. Can you see the line of reflected light? Can you find other examples of reflected light on the buildings?

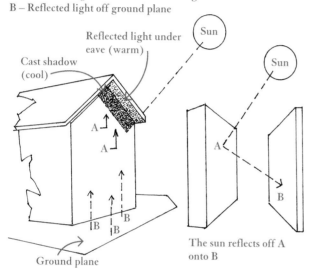

A – Reflected light off surface of building
B – Reflected light off ground plane

Reflected light under eave (warm)

Cast shadow (cool)

Sun

Sun

A

A

A

B

B

B

B

B

Ground plane

The sun reflects off A onto B

The ground plane can both receive and reflect light.

Light in the Round

If all the planes in life were flat and regular, the watercolor artist would find it quite easy to create realistic images. But we live among cubes, cones, cylinders, and spheres that in myriad combinations create many other shapes. In fact, our entire perceived world is made up of parts and combinations of basic forms. And to further complicate matters, the planes that comprise these basic forms are set at diverse angles both to the surfaces upon which they stand and to each other.

You may be thinking of building blocks, party hats, silos, and oranges. That's a start, but now expand your thinking a bit and imagine tree trunks, human heads, barrels, vases, ice cream cones, cabbages, carrots . . . you get the idea!

Okay, back to the concept level. If the relative lightness or darkness that we see in an object is dependent upon the angle at which its planes receive light and upon its relationship to the ground plane, what do you do when there are no edges? How about when there are no apparent strict verticals, horizontals, or diagonals? How do you realistically paint curved objects and their shadows?

Believe it or not, you think about planes. This is a time when your head (not your heart or your gut feelings or your visual impressions) should be in control. Think of objects without edges as though they were composed of many small planes, each catching a slightly different amount of light.

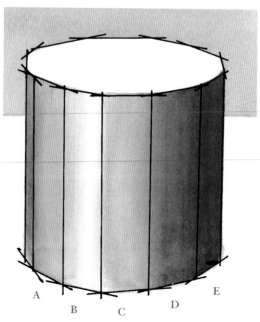

A

B

C

D

E

The planes of a cylinder change in value as the surface moves away from the light source.

Let's look at the drawing of the cylinder on the previous page. The light is hitting plane B directly, making it the lightest plane (the highest value). Planes A and C are both the same value, slightly darker than plane B, because each moves away from plane B at the same angle. Plane D is darker than plane C; plane E will be darker than plane D (unless there is reflected light from the ground or the sky).

Now look at the kaleidoscope of forms in the image below. The cylinders, cones, and spheres not only have planes around their circumferences, they also have planes at top and bottom where they are cut. When painting realistically, you should consider what part of a basic form you see, as well as its angle of presentation. When you understand this concept you will understand how *everything* the artist sees can be deconstructed into the shapes and pieces of the cube, cone, cylinder, sphere, and their various combinations.

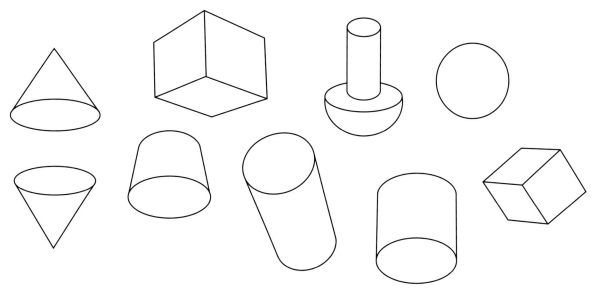

Everything an artist sees can be deconstructed into the shapes, pieces, and combinations of the cube, cone, cylinder, and sphere.

PRACTICE! PRACTICE! PRACTICE!

Go to your nearest copy machine and make several copies of the above image of the basic forms and their planes. On your copies, take a pen or dark pencil and indicate the probable planes on each object. After the planes are marked, choose a different light source for each copy you have made and show the direction of that light source on the paper with an arrow. Then paint right over your ink or pencil lines, using one color in different values.

When you feel you are successfully capturing form by using the gradations of values, from light to dark, depending on your light source, stop working with these form outlines and draw and then paint your own tree, apple, or lighthouse. If you are aware of the planes and how each catches the light, your drawings will look more "real."

On the Other Hand

"Is everything made out of these shapes?" you ask.

Well, yes, theoretically. Is there anything in life that doesn't have exceptions?

Consider theater for a moment. The character Tevye in the musical *Fiddler on the Roof* tries hard to look at the reality of every situation. He weighs and considers the options: "on the one hand," and then "on the other hand." His dilemma dramatizes the plight of every creative artist: "How realistic do I have to be?"

You'll hear me say again and again in this book that art is full of exceptions. Occasionally these exceptions (sometimes "mistakes") look more exciting and interesting than a compulsively realistic painting. For example, perhaps you accidentally streaked a dark area across the bright green of a lawn. Suddenly the whole painting seems to have a better focus, the buildings seem to stand taller and stronger, and the viewer feels more invited into the scene. There's nothing in the "realistic" plan of the composition or the actual source scene that indicates the need for a dark streak, yet it works.

Art is full of exceptions and exaggerations. One day, go to the library, sit down with some art history books, and look for the elongations, exaggerations, and realistic impossibilities done

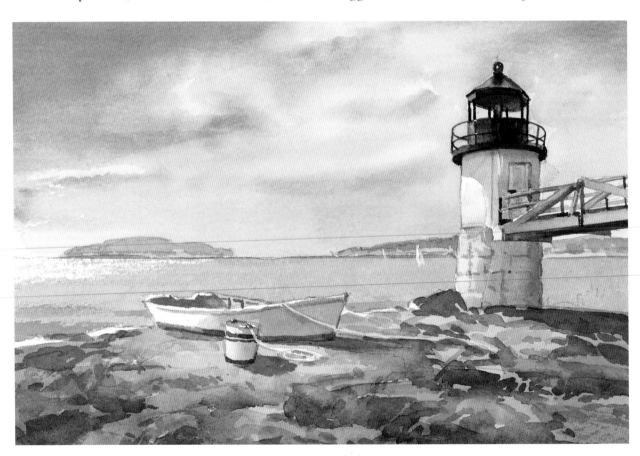

Lighthouse and Boat – How many examples of "artistic license" can you find in this watercolor sketch?

at the hands of the world's greatest painters. For example, the Spanish Renaissance painter El Greco had a tendency to elongate his figures for his personal expressive and aesthetic purposes. Artists such as Pablo Picasso, Henri Matisse, and Vincent Van Gogh also took liberties with their paintings. Although they had a particular subject they were looking at when they painted, they eschewed purely realistic imagery in favor of the exceptions and exaggerations that define their painting style.

Would you like an example from my work? Okay, look carefully at my painting of a lighthouse with a boat on page 42. What's "wrong" with it? Yes, the boat should have more cast shadow. But look at the white form in front of it. What is it? Yes, it's a bucket. It was not in that spot in actuality, but its placement in the painting, along with its color and form, are good for the composition and the play of light. But what about its size?

Light from Nowhere

The ability to see light in a shadow area or on the dark side of cylindrical shapes is the art of the eye. Again, some call it artistic license. Physicists, however, tell us that its source is reflected light from the sky and the ground plane. Scientifically, how much light there is and the origin of this light doesn't really matter; it is real regardless and it makes for good art. It is the reflected, almost magical light that makes a lighthouse come alive.

My painting *Eastern Point Lighthouse* is reproduced in its entirety on page 146. I chose to include a detail of that painting on this page because it contains a good example of the use of warm light on the side of the cylinder that is turning *away*

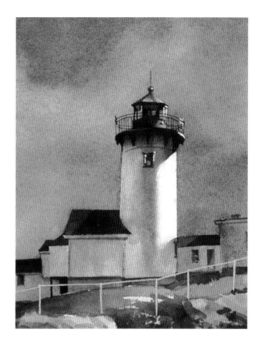

Detail from *Eastern Point Lighthouse* – Light makes this lighthouse come alive.

from the light source. That reflected light on the shadow side (the left side) separates the wall of the lighthouse from the sky and creates the illusion of roundness. I'll be talking more about reflected light in Lesson 4 and warm light in Part IV.

WORDS TO REMEMBER

- Understanding ground plane is essential to realistic watercolor.
- Every plane and every object in a painting has a relationship to its ground plane.
- The ground plane can both receive light and reflect light.
- The concept of planes is especially important when painting cylinders, spheres, and cones and all combinations of these basic shapes.
- Light and artistic license are an unbeatable pair!

SKYLIGHT

Port Clyde, Maine

> *God made the dome, and it separated the water above the dome from the water below it. God called the dome "the sky."*
>
> —GENESIS 1:7–8

I f everything not touched by the rays of the sun received no light at all, it would be easy to explain the secrets of light in the art of watercolor painting. But then realistic painting wouldn't be very interesting, would it? An art critic, or in fact any viewer, could point out the aspects of the painting that are very light and colorful and those that are very dark and colorless. And that would be about all there was to say on the topic of light.

Sunshine, however, is not the only source of the light by which we see the world. We live under a great dome of atmosphere. Within that dome, there are three sources of light available to the landscape artist: the sun, the sky, and reflected light. In the last two lessons, we've been working with a primary light source (usually the sun); now let's consider a secondary light source—light from the sky.

Fortunately for all life and for traditional realist painting, the sun's rays are reflected in each particle of air throughout the dome of the atmosphere. This molecular reflection is light from the sky, or skylight. It allows us to see surfaces opposite the light source and/or covered by cast shadows.

Not Touched by the Sun

Look carefully at the painting *Port Clyde, Maine* at the beginning of this chapter. As you can see by the cast shadows across the road, the sun is low, just above the horizon coming from the viewer's left. The side of the building with the stairway to the second floor (facing us) is getting only glancing rays of sunlight, yet it is well lit, a medium value. The color of the upper story can be easily recognized as a shade of yellow ochre and the lower half of the building is perceived as almost the same white as the front. Why? Because it is early on a bright day and the sky is full of light.

Now let's look at my painting *The Red Bridge*. In the painting, it is close to noon and the sun is directly above the roof of the bridge. The vertical wall of the bridge is therefore cut off from direct sunlight by the overhang of the roof. Why, then, can we see the color red on that vertical wall? In fact, why do we see a difference in the color directly under the roof and on the remainder of the wall? The darker area at the top is definitely in cast shadow from the roof overhang, yet we can still tell that it is red. And why is the remainder of the wall a brighter red when it is not getting direct sunlight?

The answer is the essence of this chapter. We see color on the wall of the bridge because it is being lit

The Red Bridge

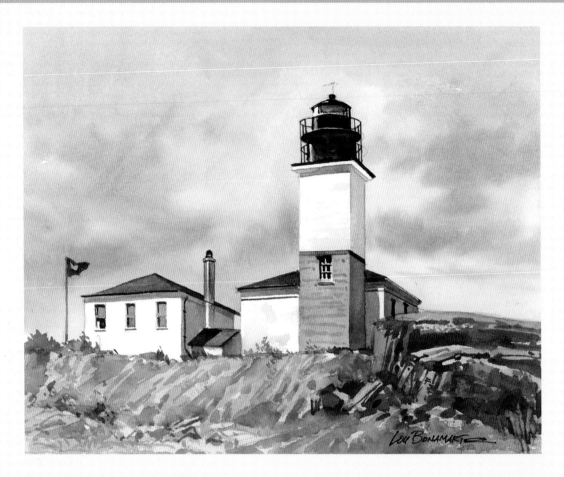

Beaver Tail Lighthouse, Rhode Island

Let's see how well you understand *skylight*. In this painting, the sun is at about 10 o'clock on the viewer's left side.

- **Step 1:** Think of the buildings in this painting as basic forms. Identify the cubes, cylinders, cones, and spheres. (Remember that a roof can be part of a cube tilted at an angle.)
- **Step 2:** Assign the number 1 to all the planes receiving light directly from the sun.
- **Step 3:** Assign the number 2 to all the surfaces getting light from the sky. (These are surfaces in object shadows.)
- **Step 4:** Assign the number 3 to the cast shadows. Why can we see color in the cast shadow on the small shed between the two buildings?
- **Step 5:** Now make a painting: Imagine a sunset taking place behind the lighthouse. Copying the forms in this painting, try to paint the cubes and other shapes when the light is behind the buildings. All the surfaces facing out of the painting will not be receiving any light directly from the sun—everything you can see will be courtesy of light from the sky rather than from the sun.

by light from the sky. The same is true of the stone-work that supports the bridge on the left side of the painting and under the right side of the bridge.

The Light We Breathe

All the molecules of matter suspended in the air influence light from the sky. If you translate that fact from your physics textbook into what we know about the perception of the human eye, it emerges that we identify the sky as shades of blue because of particle reflection. Take this idea a step further into the field of art and you will realize that the perceived colors of objects lit by skylight rather than by direct sunlight will be influenced by blue. This particle influence means that shadow sides of buildings and other objects not in direct sunlight appear cooler (more blue) and have less color intensity than planes touched directly by the light source.

In contrast, the direct light of the sun is intense, dramatic, warm, and bright. When it hits an object directly, the color perceived is usually warm and clear. We'll talk a lot more about cool color and warm color in Part IV. For now, though, just keep in mind that yellow is a warm color and blue is a cool color. Red is more warm than cool, but it can run a range of hues. Usually, warm colors are perceived as advancing into the foreground, while cool colors appear to recede into the background.

Objects in direct sunlight create strong contrasts with one another because sunlight intensifies the juxtaposition of colors, rather than muting them with blue tones. In most cases, an object or objects in direct sun are the focal point of the composition. At the same time, however, that focal point is given form and drama by the adjacent surfaces in shadow.

New York City Public Library – Areas in shadow appear cooler (more blue) than areas lit by direct sunlight.

A sketch of a cottage on stilts.

Using only French ultramarine blue and burnt umber, copy this drawing and make several paintings from it.

In one version, place the sun just coming up over the horizon on your left. The front of the cottage will be opposite the light source. How will light from the sky affect the front wall, the roof, and the stairs? How about the side of the building? Will it be darker or lighter than the front?

In another version, place the sun high in the sky (around 1 or 2 PM), just right of center. The roof is now getting direct sunlight. How do you make a dark roof bright? Remember that the top of each stair and the railings are also getting direct sun. How about the pilings holding up the house? How will these be lit by skylight? Where will the roof cast its shadows on the walls?

Make a sunset painting with the sun just above the horizon on the right side of the painting. Now the front of the house is getting the most direct light, but the roof isn't getting any. With the sun so low, will there be light under the house? Where will the cast shadows go? How long will they be? Where will the sky be darkest—at the top of the painting surface or at the horizon line?

Have fun!

Cast Shadows

If a cast shadow is created when an object blocks the light source from falling upon a surface (in other words, if there is no light), how can we see color in those shadows? Look again at *Port Clyde, Maine* (page 44) at the beginning of this lesson. The shadows across the road are long and dark. But within them, we see the yellow road line and patches of green grass. In *The Red Bridge* (page 45), the cast shadow under the eaves is still recognizable as red and the shadow of the bridge across the water holds reflections of light

Even though shadows are deprived of direct light, the light from the sky affects them all. Skylight and reflected light make up for the absence of sunlight and create color in the elements of the painting under object shadow and cast shadow. Instead of blackness, shadow areas are darker and cooler than their native color. Yet sometimes, within the darkness, there is a touch of warmer light as well. Often this is reflected light.

Cast shadows are usually even darker than object shadows, although the native color can usually still be identified. It is, however, always duller and more neutralized. Sometimes within a cast shadow, you can see reflected light, but, again, it is painted with very neutralized hues. (I will discuss more about reflected light in Lesson 4.)

ARTFUL MEANINGS

- The **dome of the sky** refers to the upper atmosphere or expanse of space that constitutes an apparent great vault or arch over the earth.
- *Sky blue* is defined in the dictionary as a pale to light blue color. It is the color of our atmosphere.

Depth and Distance

The blue element in skylight also helps create the viewer's perception that there is depth and distance depicted on the flat surface of a painting. Objects that are in the distance appear lighter, cooler, more neutral (less intense and more gray), and less detailed than the same or similar objects in the foreground. (They also appear smaller in size, but we'll discuss perspective in more detail when we get to Lessons 21 and 22.)

The Red Bridge (page 45) uses atmospheric color (the effects of light from the sky) to take the viewer under the bridge and into the distance. Faraway trees and water are lighter, bluer, smaller, and less detailed than the elements in the foreground. In *Port Clyde, Maine* (page 44), the trees at the horizon line on both sides of the painting are neutral in color despite the brightly lit day. They picked up their blue hue from the dome of the sky.

WORDS TO REMEMBER

- A landscape painter's three sources of light are: sun, sky, and reflected light.
- We can see surfaces in shadow because they get light from the sky.
- Objects in shadow appear cooler and less intense than objects in direct light.
- Cast shadows are usually darker than object shadows.
- The blue element in skylight helps to create our perception of distance.

LESSON 4
REFLECTED LIGHT

Lobstermen at Dawn

Amongst all studies of natural phenomena, light most delights its students.

—LEONARDO DA VINCI (1452–1519), Italian polymath

I n this world where telephones can instantly take and send images of a fisherman's catch from one coast to the other and digital cameras snap hundreds of photos of a three-year-old's birthday party, it's sometimes difficult to think of the photographer as an artist. But stop a second and remember the work of Ansel Adams. Without color, he celebrated the play of light on the landscapes of America.

Study an Adams photograph and you're likely to see every kind of light—the sparkle of direct sunlight, the modulated tones of light from the sky, and the subtle artistry of reflected light. Finding and using reflected light is a mark of both the photographer artist and the watercolor artist.

I introduced you to reflected light in Lesson 2 with the painting of the *Block Island Hotel* (see page 36). In that work, reflected light is especially apparent under the eaves and on the ceiling of the porch. The warm color used to capture that light is a bit of artistic license, but the presence of the reflected light is scientifically accurate.

Reflected Light, *Not* Reflection

Everyone is familiar with reflection. It's that annoying light that a camera flash catches on a pair of glasses so that the person in the photograph has two white squares instead of eyes. It's also the highlight on a metal teapot. And it's the mirror image of the shoreline on the flat surface of a lake. Reflected light is different—it's never as bright or as white. Its edges are soft. So soft, in fact, that some people never see it when looking at objects in the real world.

To compare the difference between reflection and reflected light, look at this painting of an apple. The reflection is the bright patch on the upper left. It is the bounce-back in response to

the light source. Now look on the right side of the painting. As the apple turns away from the light it grows gradually darker. That is, until the very last plane. The lighter, neutralized strip of color in that plane is the reflected light.

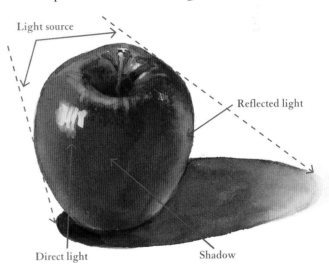

The highlight on the apple is a reflection of the light source; the light edge on the shadow-side is reflected light.

A Dash of History

Some critics and teachers say that reflected light is just an example of artistic license, and sometimes it is. But reflected light has been recognized and written about by artists and scientists since the sixteenth century. In fact, it was one of Leonardo da Vinci's favorite subjects. Sir Isaac Newton was also fascinated by the manifestations of light. And Albert Einstein once said, "All the fifty years of conscious brooding have brought me no closer to answering the question, 'What are light quanta?'" Reflected light is magical science that has withstood the test of time. The simplest definition is: *Light seen after having bounced off a surface.*

Backed up by science and history, with a little added artistic license, today's watercolor painters often use reflected light to separate two planes that are similar in value. Without the reflected light to divide and define them, the surfaces would merge together into a dark mass with unidentifiable planes.

The How and Why

The lobstermen painting on page 50 is packed with reflected light and some artistic license, too. Let's take a closer look at it.

In Lesson 1, you learned to identify your light source. Doing that is not much of a challenge in this painting. Find the sun coming up on the horizon. Then note the direction of the shadows inside the boat and on the dock. Once you do that you will notice that the viewer is seeing the side of the boat opposite the light source. The side opposite the light source in a painting should be the darkest, right? So what happened here?

The boat's port side is lit by light from the sky and by reflected light. The prow reflects the blue-gray of the water. Near mid-ship, the reflected light is warmer because it comes from the dock. Inside the boat, the lower side of the cabin is reflecting a blue color that contrasts nicely with the warm color below the painted blue-gray trim on the hull.

Now look at the pilings for the dock and at the container in front of the lobsterman in the yellow-ochre jacket. The container is lit by the sun on the left side and then becomes darker as it turns away from the sun. But on the right side of the container, the surface begins to turn lighter again. Where is this light coming from? One could argue for reflected light from the water, but the water in this portion of the painting is under the dock. What about light from the sky? It's pretty

HERE'S A TIP

Artistic license is a powerful tool for the painter. It is the ability to change what *is* into what *could be*. For example, the artist can leave out of his or her painting any number of things that exist in the reference material. (The great court artists of the Renaissance often left their subjects' warts and scars out of their portraits!) You, the artist, can also add an object or objects to your landscape or still life or move something from one location to another.

Artistic license can be a pass that lets you skirt around restrictive rules. It allows for changes not only in objects, but also in light source, color, value, and reflected light. Experiment with your artistic license. Try painting the light that could be or that almost is and see how it changes your work.

Not all practice requires holding a brush. Go to your local library and take out as many books as you can carry that contain quality color reproductions of works by world-class artists who paint in traditional realism. Any of the great Renaissance artists will do, or perhaps you prefer an American such as Winslow Homer or Andrew Wyeth. You can collect both oil and watercolor media. Look at each painting in the books carefully. Try to identify how the artist has used reflected light.

If you are part of a watercolor painting class, it might be fun to arrange for each student to find and color-copy a painting or two in which reflected light is used. Then bring them into class. You might be able to arrange with your instructor to spend a few minutes discussing and comparing different artists' use of reflected light.

Once you become aware of reflected light, you'll begin to see it everywhere and, with a little practice, you'll begin to use it in your paintings.

crowded behind the container for much light to get in. So what makes the warm light?

Yes, it's artistic license. The reflected light is just a bit lighter than what a camera would see. This use of light and color separates the forward container from the one behind it and also gives the container the illusion of roundness.

Now look at the piling nearest the foreground under the dock. The left side is warmed and illuminated by the sun. That line of light forms a beautiful frame for the focal point of the painting. But what about the right side of that same piling? Why does it show warm yellow light? Again you could argue for reflected light, and again I'd ask you, "From what?" The light is from artistic license and allows me to separate the front piling from the one beyond it. It also reinforces the strong vertical movement that stops the eye and takes it upward on the right side of the painting.

Do You Really Know the Difference?

The old trawler in *Gears, Ropes, and Pulleys* was docked near the ferry landing to Block Island. She's quite a character, and you might say that painting her portrait would be a bit of a challenge for the beginning watercolorist.

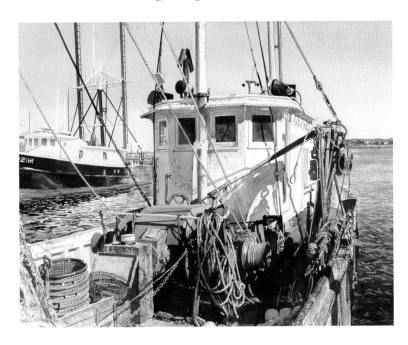

Gears, Ropes, and Pulleys

I'm not going to ask you to copy my painting, but I do want you to get a little practice in differentiating skylight from reflected light. You can do it just by looking carefully.

In this painting, the light source comes from the left side of the painting between ten and eleven o'clock. Accordingly, the left side of the cabin is illuminated, including the first two sections of the half-octagon at the cabin's front. The third section is in shadow, but that shadow is nowhere as dark as the cast shadow from the winch.

Why the high-value in a shadow plane? The surface is getting light from the sky. But do you see the bit of warm color right next to the mast?

That's reflected light.

Now look at the fourth panel. It is lighter than the adjacent third panel. Why? Since it's farther from the light source it should be darker, right? No. Indeed, it is farther from the light source, but it's closer to the water, which also reflects light.

Now look above the windows of panels two, three, and four. Do you see the orange and sienna there? It is the complement of blue (see Lesson 16 on complementary colors) and is intentionally located very close to the blue shadows. You could perhaps say the sienna over the windows is the reflection of rusty equipment. No matter what, it is a choice I made to create the excitement of competing color.

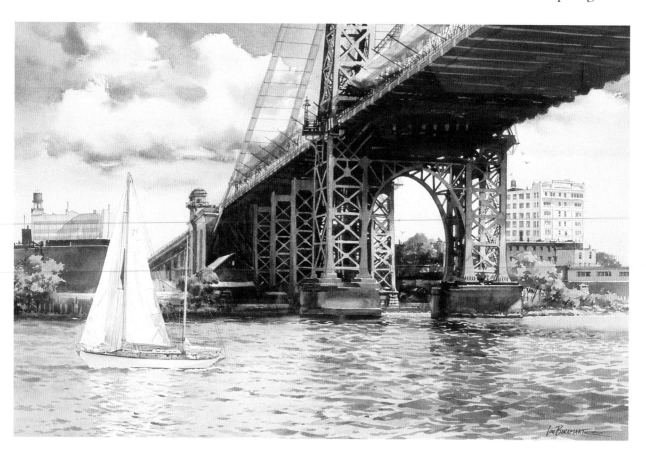

The Williamsburg Bridge

Seeing the Underside

Reflected light can be especially useful when you are painting from an uncommon perspective. It illuminates the underside of things. Look back at the skylight that lightens the shadow sides in *The Red Bridge* in Lesson 3 (page 45). Now compare the use of light to the underside of *The Williamsburg Bridge* on page 54. Reflected light from the water and light from the sky brighten the steel structure. Notice where the color turns warmer and then darker as it moves into shadow.

Squint your eyes and try to look at this painting of the Williamsburg Bridge as an abstract work. Look only for patterns of light and dark. As such, this is a daring composition with a dark diagonal from the upper left side to a point slightly beyond the center.

So what keeps the bridge from looking so dark and heavy as to become overbearing to the viewer? Why doesn't it divide the painting into two separate parts?

If you've been reading carefully, you already know that the use of reflected light on the underside of the bridge balances the painting. It also prevents the sailboat from stealing the show.

THE DAY'S LIGHT: TIME AND SEASON

Morning Light

> *Without tradition, art is a flock of sheep without a shepherd.*
> *Without innovation, it is a corpse.*
>
> —**WINSTON CHURCHILL** (1874–1965), Prime Minister
> of the United Kingdom and amateur painter

M ark Twain, who lived the latter part of his life in Hartford, Connecticut, is rumored to have said, "If you don't like the weather in New England, wait a minute." And it's so true. New England has four distinct seasons, every kind of precipitation, a variety of winds, and, from early morning to sunset, a constant play between sun and clouds. Where else could an artist find a better place to live?

Having said that, I don't expect a mass exodus to the Northeast any time soon (we're already over-crowded as it is), but I do want you to realize that changes in weather, season, atmosphere, and time of day affect your work no matter where in the world you are painting. Each change is an opportunity for a new perception, a new work of art.

"Now you've gone off the deep end, Mr. Bonamarte," you say. "Do you really expect me to do twenty paintings of the coffee shop around the corner?"

Not unless you want to. But I do hope you'll remember that every moment has unique properties. That perception was part of what made Claude Monet such a great artist. In Lessons 1 and 2, we discussed light source in landscape painting and how different angles of the sun's rays fall on different planes at different times of the day. In this lesson, let's look specifically at light throughout the day, along with some effects of the different seasons.

Morning Light

Morning Light (page 56) is a good example of the clear light characteristic of early morning. Shadows are long and vertical surfaces are lit with warm light. Despite the obvious coldness of the day, this painting is essentially warm in tone. As with many paintings of winter scenes, color is limited. What you see is shades of sienna and blue, yet what you

feel is awe at the perfect play of light and shadow. Your attention is both captured and delighted.

It is important to remember that the sun's light hits the earth at different angles in summer and in winter. Winter light is more oblique and softer; summer light is more direct and stronger.

PRACTICE! PRACTICE! PRACTICE!

Between 1892 and 1894, the renowned Impressionist Claude Monet painted the same façade of Rouen Cathedral in France again and again, capturing different moods and different light. He also made an extended series of paintings of haystacks and another series of poplar trees, all examining the various effects of external environmental factors on a certain subject. You can find images of these works on the Internet and in libraries. Study them to learn how changes in light can both affect and create a painting.

HERE'S A TIP

When the sun is hitting a white building or white snow directly, you can increase the drama and excitement of your painting by mixing a very diluted, very pale wash of new gamboge yellow and Winsor red and painting it over the sunlit surfaces. To the viewer the surfaces still appear white, but the effect is much more exciting.

Christmas Cove

Christmas Cove is another early morning painting. But, despite the name, the season is summer and the scene is a fishing village. If you look in the upper lefthand corner, you'll see the warm color where the sun is climbing in the sky. Gradually, the sky color changes as you look toward the right, moving into the more neutralized blues and grays that appear above the buildings.

The vertical walls of the buildings that face the early morning sun receive their light almost directly. They are brightly and clearly lit. On the other hand, since the sky is not yet fully lit, light from the sky is not at maximum effectiveness. Walls in the shadow areas are dark, with little reflected light.

Now, you might ask yourself, "Why is the deck in the bow of the bigger black lobster boat in bright light? Shouldn't more of it be in the cast shadow of the cabin?"

This brings up the topic of *ground plane* again. Remember: Every object has a relationship to the ground plane as well as a relationship to the angle of the sun. The bow of the lobster boat is riding higher in the water than the stern. Therefore, it is catching more of the same light that is illuminating the tops of the two floating docks and lighting the cabin of the boat directly behind it.

In the painting *Christmas Cove*, the small white boat tied to the dock (on the right side, two-thirds of the way up from the bottom—also known as the middle foreground) has an object shadow side on the cabin, but the same side of the hull is rather light. Having studied Lesson 4, you should be able to explain why.

If you immediately thought, "reflected light from the water," you are indeed learning to use the secrets of light!

Now apply the same thinking to the white boat in the lower left side of the foreground. Why is the side of the hull facing you only partly in shadow? Why is the side of the cabin facing you only in the very lightest shadow? Where does the warm light on the back of the cabin come from? Why is it not on the open cabin door? Shouldn't these surfaces be in total shadow?

The effects of reflected light is the answer to each of those questions. Where is it coming from? Where is it absent? For example, notice the patch of white floor next to the door. Look at the light hitting the top of the lobster pots. And, of course, there's the dock, a warm horizontal surface being licked by early morning rays.

Now try to copy the painting (or perhaps parts of it) as though the scene is being observed six hours later. You will be using the late noon sun as the light source. Consider how and where light would be reflected when you are working with a different angle of the sun at a different time of day.

High Noon

What happens when the sun reaches its highest point in the sky? The rays of light come straight down and strongly illuminate horizontal surfaces. The lightest planes in the painting *Noon Light, City Pier* run in a line near the bottom of the middle third of the painting, representing the roofs of the cars. The roofs of the higher buildings, the roof of the ship's cabin, and the tops of the pilings along the dock all have this same intense light.

"What about the highlight on the starboard side of the ship?" you ask. "That's not a horizontal plane, but it is still illuminated in the brightest light."

That strong patch of light on the bow is the result of reflected light from the surface of the water. It is aesthetically placed at that location to

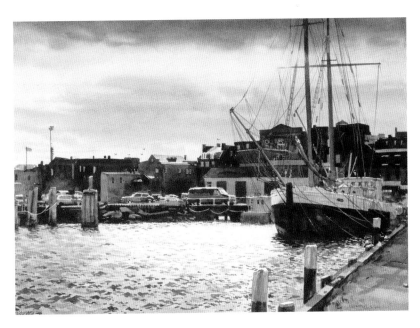

Noon Light, City Pier

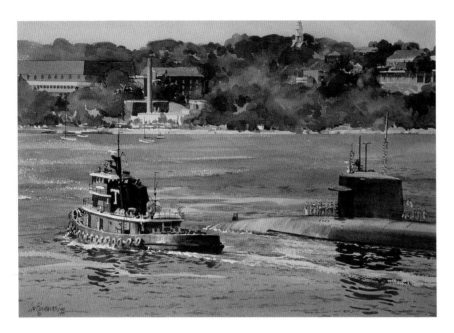

Heading Out

keep the eye of the viewer from running off the right side of the painting.

"How can the water give off so much reflected light?" you ask. The water is a large horizontal mass that is getting maximum light from the noonday sun and, as a result, its reflective power is immense. The sides of the pilings along the pier in the foreground, the sides of the ship's cabin, the two walls of the buildings near the center of the painting, and the sides of all of the vehicles are all receiving the same reflected light.

Because it is noon, the vertical sides of the buildings, cars, and the ship are not receiving light from the sun. They are technically in shadow, but nowhere are they without discernible color. All the vertical planes in this painting are lit by both light from the sky and by reflected light from the water.

The water in *Noon Light, City Pier* is a good example of the effects of mass in a painting. The larger the mass, the more light it can gather and reflect.

That's why the shadow colors are lighter on the vertical sides of the ship, the cars, and the buildings nearest the bridge.

Mid-to-Late Afternoon in Summer

In this painting of New London Harbor in Connecticut, *Heading Out*, the mid-afternoon sun on a summer day allows for strong and intense color. Because the sun is now past its peak and moving toward the horizon, however, the rooftops and even the tops of trees are not illuminated directly. Instead, the direct light hits the sides of the ships and the vertical walls of all the buildings that face the sun.

Because of the lower angles of light hitting the earth, there is less reflected light and less light from the sky than there would have been earlier in the day. The cumulative effect is a more dramatic contrast of lights and darks. Notice that the little bit of sky that can be seen in this painting is painted a seemingly faded color. It does not compete with the strong primaries (red and blue) that are the focal point of the painting, nor with the intense band of greens that is so characteristic of summer foliage.

HERE'S A TIP

When painting bodies of water, wave patterns get smaller as you move back into the distance.

Late Afternoon in Autumn

The goal of every landscape artist is to capture the perfect combination of the day's light, the scene, and the season, and thus communicate a mood or an emotion to the viewer. It would take thousands of words, or maybe a pretty good poet, to tell someone about the sense of quiet calm that ends a day at sea, as conveyed in this painting.

Because the late afternoon light is low, structures cast shadows onto the water. The dark, shadowed path of still water leads the viewer's eye to the center of the painting. The sky is neutral and the light is subtle, conveying a sense of stressless completion.

The chosen hues and the limited range of light and dark contrasts also add to the sense of satisfaction and peace in *Sunday Off*. The primary color in the painting is a cool gray-blue. The warm light and bright-but-neutralized oranges that create the focal point around the boat stimulate this normally receding hue.

How could a thing as mundane as a dock hold the focus of the viewer's eye? The use and positioning of the light controls this painting. The warm light on the dock against the cool dark

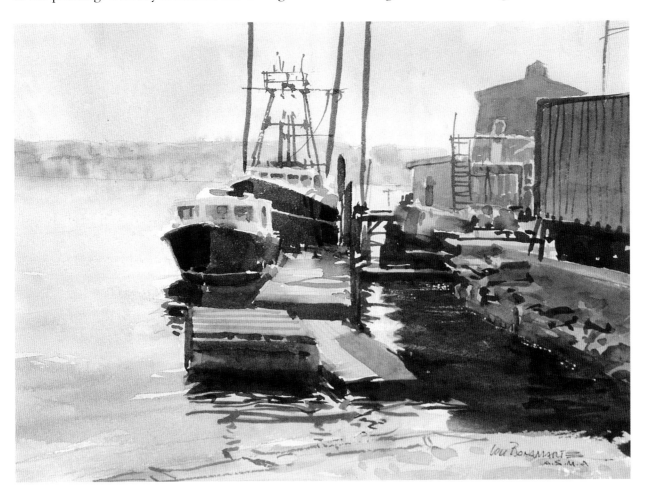

Sunday Off

of the hull creates a vibrant contrast that, paradoxically, remains peaceful. The sense of peace is conveyed by the use of complementary but subdued colors. The gray, neutral landmass in the distance reinforces the sense of late autumn and of one last pleasurable day before winter begins.

You'll learn more about the effects of warm, cool, complementary, and neutralized colors in Part IV. Color is inextricably mixed with light in watercolor painting, but we must separate the study of these two essential factors to avoid confusion.

Sunset

The sky is usually the focal point in a sunset painting, which most students love to do. Sunsets are a great opportunity to let colors flow, practice soft edges, use graded washes, and have fun! But there's a bit more to capturing these passing moments than just swinging brushes.

In *Cityscape at Sunset*, the sky comprises two-thirds of the painting. It is darkest and most blue at the top of the paper (nearest the viewer) and becomes lighter and warmer as it moves into the

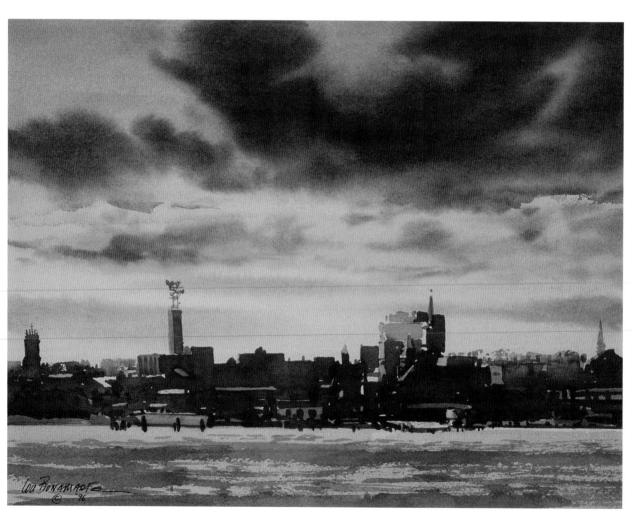

Cityscape at Sunset

distance, closer to the setting sun. All of the buildings are backlit, with the exception of various planes receiving reflected light from the sky.

When painting a sunset, it is important to remember that no matter how fluid the sky may be, buildings and other objects that are backlit must have hard edges in order to be entirely separated from the movement and color in the sky. Also, look carefully at the horizontal planes in the foreground. They may reflect color and light from the sunset. This is especially true of water, which will blend sky colors with its natural color. (The muddier the water, the more neutral the reflected colors.)

ARTFUL MEANINGS

A **backlit** composition occurs when the light source is behind the subject matter. The result is that the shadow side of everything faces the viewer. Sunsets are the most common example of backlighting.

WORDS TO REMEMBER

- Light changes with time of day and season. Each change creates opportunities for new paintings.
- In morning light, shadows are long.
- In morning light, vertical and horizontal surfaces are lit by warm light, but shadows are deep because there is less light from a sky that has not yet been fully lit.
- Light at high noon illuminates horizontal surfaces. Vertical surfaces are illuminated by skylight and reflected light.
- Late afternoon light is similar to morning light, except that it is usually softer and has more warm color in it.
- When painting a sunset, remember that all objects between the viewer and the light source are backlit.

LESSON 6
THE DAY'S LIGHT: WEATHER

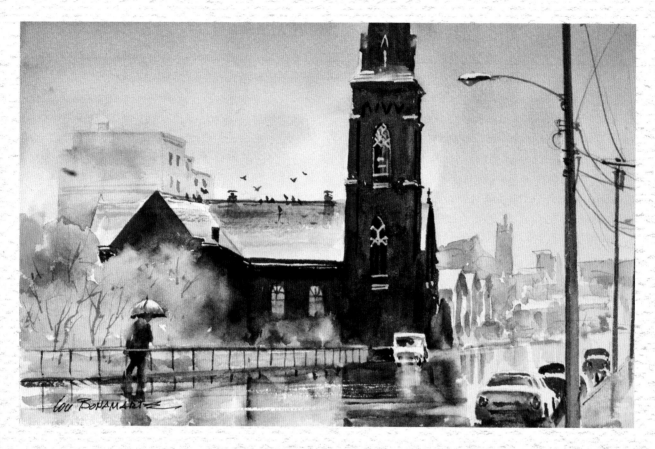

Atmosphere

With watercolor, you can pick up the atmosphere, the temperature, the sound of snow sifting through the trees or over the ice of a small pond, or against a windowpane. Watercolor perfectly expresses the free side of my nature.

—**ANDREW WYETH** (1917–2009), American artist

t's a new day. You feel comfortable with your developing skills as a landscape painter. You understand ground plane, surface planes, the position and effects of your light source, the dome light from the sky, and reflected light. You're ready to go *plein air*. You gather your stuff, only to realize it's raining cats and dogs.

Weather can be the bane of the landscape artist. It can also be his or her artful buddy. What's going on in the atmosphere can actually *create* subject matter. It's all in how we see what's happening around us.

Few artists, however, will set up an easel outdoors in the dead of winter in sub-zero temperatures. Instead, we take photographs, do sketches, and store memories. *Plein air* can be what you take back to your studio.

Rainy Days

Rain darkens the air as it falls. Each droplet takes up the light of the sun on one side and is in shadow on the other, thus taking away the radiance of the sun. (Of course, some of this darkening can also be blamed on the sun-blocking clouds that usually accompany rain.) Objects seen through the rain have blurred or indiscernible edges; colors are muted or unrecognizable.

Atmosphere (page 64) demonstrates the effects of a rainy setting on the subject you are painting. Notice that the horizontal surfaces (especially the road) are wet and therefore reflective and dramatic. Even in the foreground, however, hard edges tend to blur. The buildings in the middle distance lose their form. Colors become less distinct and more neutral. There is virtually no yellow in the painting and very little red. Without sunlight, primary colors lose their punch.

Fog

What fun it is to paint a foggy day! The artist can manipulate the mist and create effects that are almost tactile.

Look at *Sunrise on Kennebago* (page 66). As the sun comes up, the men in the boat are surrounded by fog lifting from the water. Everything is subtle

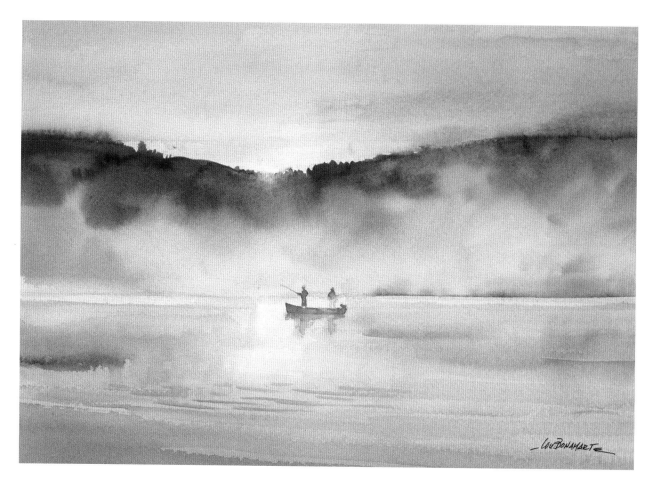

Sunrise on Kennebago

and misty, except the hard edge of the prow of the boat breaking through the fog and drifting into the reflection of the rising sun on the water. (Placing the lightest area of light against the dark boat and the fisherman on the left creates a dramatic contrast.) In the almost opaque air of early morning mists, I have created depth in the painting by lifting patches of fog in the foreground to show the waves lapping the shore and again on the right side of the painting to show the edge of the distant shore.

Because of the density of the atmosphere on a foggy day (the air is literally filled with suspended droplets of water), all objects lose their natural color and become grayer. Edges and details in fog become blurred (the more distant they are, the less discernible the edges), until finally the objects become nothing more than spots or silhouettes.

After the Storm

After a storm, the air is often cleared of atmospheric debris particles. It feels lighter, fresher, renewed. Edges become sharp and colors become clear again, even when all of the clouds have not yet departed.

In *After the Storm*, I tried to catch a bit of this feeling by choosing primary colors for the two houses in the foreground. Primary colors grouped together always create a certain intensity. In this case, they not only dominate the left-hand side of the painting, but their reds, yellows, and blues are also reflected in the wet street. The street colors are, of course, muted by the gray of the roadbed, but the echo of what's above moves the composition in a strong direction toward the warm horizon.

Cloudy Days

In *October Sky, Cape Ann* (page 68), the last light of the day barely falls on a pile of rocks in the

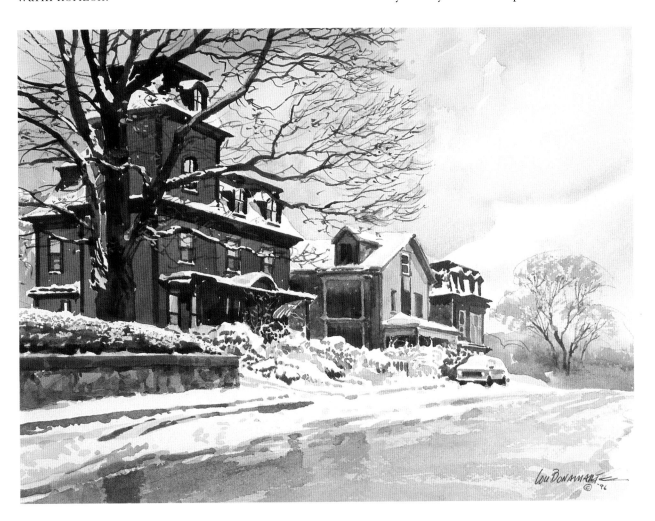

After the Storm

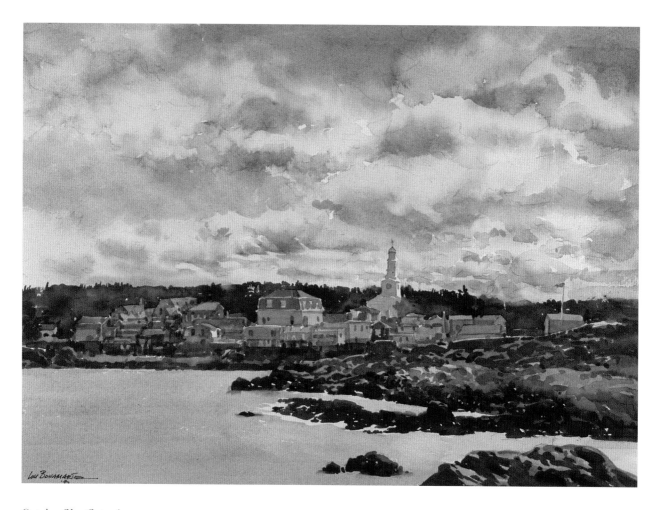

October Sky, Cape Ann

foreground, just catches a church steeple, and illuminates a lone flag hanging over the water, but that light fills more than half the picture plane with movement in the cloudy sky. The serenity of the water and the village is challenged by the threatening instability of the clouds.

This painting is more of a skyscape than a landscape. It is also a study in blue (with some burnt umber). Yet the excitement—the *art* of the painting—is not in the colors, but in the patterns of light and dark in the sky balanced against the quiet of the land and the sea. You can almost feel the movement in the atmosphere, as the clouds seem about to crash into each other.

HERE'S A TIP

Clouds are largest at the top of the painting surface (overhead for the viewer) and become gradually smaller as they recede into the distance and approach the horizon. Color intensity and shadow areas are also greatest overhead and gradually become neutralized as they approach the horizon.

Before we leave cloudy days, you might want to turn back to page 34 and look again at *Central Park in Winter*. In this painting, the sky is full of clouds. There are no hard edges or definitive colors; the shapes fade gradually into each other. This winter sky does not have the same sense of motion or impending storm as the late summer sky in *October Sky, Cape Ann*.

Take one more look back, this time to page 36, where you'll find the painting *Block Island Hotel*. You can see that clouds don't always block out sunlight. In this painting, they reflect the light into a glorious starburst over the hotel. The high values and warm colors in the clouds, and in the entire painting, seem to sing the glories of springtime.

Bleak Skies

It happens to everyone: you wake up, look out your window, and no sun! The entire sky is one color. There is no sparkle; everything looks grayish. This bleak sky occurs most often in winter, when the sun's rays are at a low angle and filtered by the density of the sky. In art as well as in life, this weather can create a somber mood.

Winter Along the Tracks is a painting in three planes. The foreground and the sky each comprise a third of the picture plane; the houses and train tracks dominate the middle third. The snow is depicted by unpainted white paper, the sky by a muted flat wash. The middle plane is painted primarily in subdued shades of red.

Winter Along the Tracks

The light source in this painting comes from behind the viewer and is indicated only by rooftops. Reflected light and cast shadows do not play a part in this composition.

Creating a painting with a gray sky limits the lightness or darkness of objects to the middle value range. (I will discuss *value* in more detail in Part III.) In this painting, the white snow in the foreground acts almost as a frame. It occupies the bottom third of the picture plane and then leads the eye into the scene. The result is that the focal point becomes the focal *area* (the entire middle plane) because there is no meeting of a lightest light and a darkest dark, which is the usual artistic device for creating a center of interest.

What a Gorgeous Day!

On a late summer day I painted a famous hotel on the coast of Maine, the Monhegan House.

The distant clouds are barely perceptible, the sea is calm, and a light wind fills the sails of the boats on the water. The focal point is the hotel, but the subject matter is the hotel within the village on a beautiful summer day. Large masses of light and color fill the sky, sea, and foreground grass. Across the middle third of the painting, however, small areas of light and dark alternate, yet they are, at the same time, connected. Perhaps the best analogy for this is the notes in a line of music: the sequence of the parts creates an artistic whole.

Monhegan, Maine is a view painted from a hilltop. Since the subject is in the middle distance, the union of light and color becomes more important than the structural details of the buildings. Reflected light is barely perceptible. The painting exudes a sense of peace and unity.

Monhegan, Maine

Paint this scene using various weather situations.

Try painting this scene in different kinds of weather. It includes sky, trees, buildings, and water. Try painting it in different seasons, too, or at different times of day. (Please take note that this is *not* in perspective.)

WORDS TO REMEMBER

- Weather helps to create subject matter.
- Objects seen through the rain have blurred or indiscernible edges and colors are muted or unrecognizable.
- In fog, objects lose their natural color and become gray, edges become blurred, and details disappear.
- After a storm, the air is often cleared of atmospheric debris particles. Edges become sharp and colors clear again, even when all of the clouds have not yet departed.
- Clouds come in many shapes, colors, and moods, and they always affect the light that falls on the earth.
- Painting with a gray sky limits the lightness or darkness of objects to the middle value range.
- Bright sunlight makes for strong contrasts.

INDOOR LIGHT

Tea for Two

*I cannot judge my work while I am doing it. I have to do as painters do,
stand back and view it from a distance, but not too great a distance.*

—**BLAISE PASCAL** (1623–62), French mathematician, scientist, and philosopher

While writing *Artful Watercolor*, Carolyn, my coauthor, was told by an acquaintance, "Nah, I don't pay much attention to watercolor. It's all daisies and pink petunias and stuff like that."

Ouch! I have a suspicion that man knows what he likes, but he doesn't like (or know) much about the art of watercolor.

I don't paint a lot of still life, primarily because I prefer to paint life as it is outdoors. But the principles of painting a quality still life are based upon the same concepts that are used to build a quality landscape: it's all about light.

I'd like you to compare *Block Island Ferry*, below, and *Tea for Two*, on page 72. Both use earth colors. There is a strong white form in each painting. And the composition of each moves in an oval around the center area. But it's hard to see them as cousins, much less as brother and sister, products of the same creative hand.

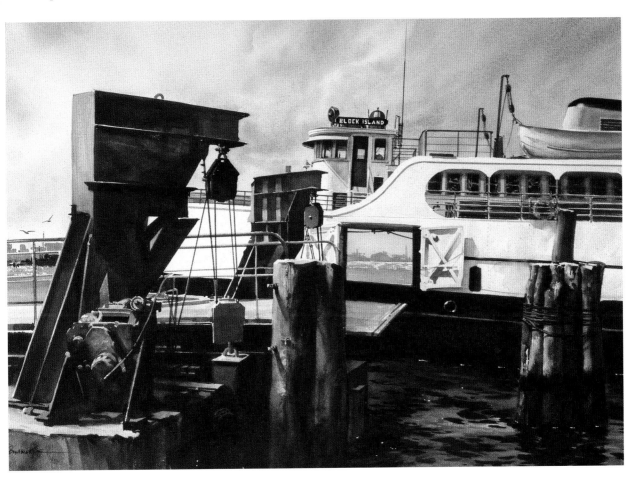

Block Island Ferry

In *Block Island Ferry*, you can almost feel the rocking of the boat and the salty taste in the wind. There's a lot going on. In contrast, the still life in *Tea for Two* invites you in. It is, in fact, still. You can't help but sense the feeling of security, the promise of calm comfort.

The use of light in the two paintings is very different and helps to create those opposite responses. In *Block Island Ferry*, light leads you toward the ferry in uneven steps, but without significant color changes, and it takes over the upper third of the picture plane. You can feel the huge and unrestricted arc of the sky. The light masses in the painting are large and powerful. Areas not receiving light are dark, limited and contained by hard edges.

In *Tea for Two*, the effective use of light is more focused and demonstrated across the middle third of the painting. It is also less vibrant. Cast shadows, which are minimal in *Block Island Ferry*, create the base for each object in *Tea for Two*. The position and extent of the shadows establish the tabletop as the ground plane. The shapes of those shadows help connect one object to another to form a unified composition. The background is abstract and dark, making the objects pop out at the viewer.

Candles, Windows, and Electricity

Light is the *sine qua non* of art. The artist must have it. When outdoors, that means natural light—the light of the sun and the sky. But indoors light is generated by fire or electricity and even when candles were used to light entire rooms artists still painted inside. Their subject matter was food and flowers; the stuff of sports, like hunted game or perhaps fishing gear; and, of course, people, from individual portraits to families, political and social groups to people at celebrations or other significant occasions. We still paint the same things, but now we have electricity, so lighting an indoor painting is much easier. Or is it?

Today, the artist who paints indoor compositions has total control over what he or she chooses to paint and over how the painting will be lighted. Photographic lighting equipment or other electrical light sources can be brought closer to or farther from the subject matter. These can be combined with artificial ceiling lighting that creates virtual daylight, or with natural light from a window. This seeming abundance of lighting resources, however, often creates an artistic problem: overlapping shadows.

HERE'S A TIP

In a still life painting, the ground plane is the most important plane. It is where things are arranged and where the cast shadows anchor the objects. Establish your still life ground plane first, then work in relation to it.

ARTFUL MEANINGS

Overlapping shadows occur when a still life or other subject is situated near a window and then lighted from the opposite side with artificial light. They also occur when more than one source of light is used. In each case, two sets of shadows are cast. They usually overlap in arcs. If you enjoy painting patterns, this can be fun. If you are striving for a realist image, however, it can be a daunting challenge.

The Artist as Creator

When you choose to paint a subject indoors, you are usually both the creator of the scene and the artist who interprets the scene into a painting. There are four things that you must be aware of:

1. The objects to be painted;
2. How the objects are gathered and arranged;
3. The point of view of the artist; and
4. The lighting.

Lighting is the most important of these. Remember: you are not just painting fruit or flowers; you are painting how the light falls upon fruit or flowers. Of course, for maximum effectiveness of that light, you must gather interesting objects, arrange them in a harmonious manner, and view the composition from an advantageous point.

Many artists feel that the best lighting for an indoor scene is natural light that comes from a north-facing window, which is constant throughout the day. Painting by north light, however, sometimes confuses beginning artists. They have learned that when outdoors, the object in sunlight is warm and the object in shadow is cool. Indoors, by a northern-lit window, the object in light is cool and the shadows are warm. This may seem like a paradox, but look closely at a still life lit by north light and you'll see that it's true.

If you don't have access to a northern-lit window, you may want to light your subject entirely with artificial (incandescent) light. But that brings up another problem. In artificially lit situations, both the subject matter and shadow are usually warm. A composition that's entirely warm can destroy the rhythmic pattern of warm/cool that keeps the eye moving through a painting.

So, to solve that problem, I call upon a little artistic license when I paint indoor scenes. For the sake of color and composition, I paint indoor subjects using the same lighting concepts that most artists would use outdoors in sunlight: I paint lit surfaces with warm colors and shadow surfaces with cool colors, even though it's not true to the actual tones of the still life. Not all artists agree with this method, however. I do this because most galleries use incandescent light and so, when I paint in cool, fluorescent light, my painting comes alive in the gallery's warm light!

PRACTICE! PRACTICE! PRACTICE!

When painting still lifes indoors, incandescent lights are preferred because of the shadows that they cast. When you light your subject with an incandescent light, you can control both the intensity and the position of your light source. To learn to interpret the effects of light on your subject matter, move the light source closer, farther away, higher, lower, and perhaps even behind the objects. Do some paintings that show the differences. It is much easier to try out the effects of light source changes indoors than it is to wait for the sun to change position or for the clouds to disperse.

Reflected Light Indoors

Reflected light works the same way indoors as it does outdoors. The ground plane reflects light upward. Objects in proximity influence each other. You may find, however, that it is a little more difficult to see and render indoor reflected light. Why? Because it is far less intense than the reflected light generated by the sun and sky.

However, the lack of intensity may actually be good for your creativity. Often, what you are actually seeing in your subject matter is not quite strong enough to make a noticeable statement on your picture plane. So feel free to enhance the reflected light (within limits).

Look again at *Tea for Two* on page 72. The most obvious reflected light is in the little blue container in the foreground. But you can also see reflected light in the bottom of the vase and in the shadow cast by the lemon on the teapot.

When painting your own still life studies, play at being "the creator" a bit. If you see an object in your composition that looks dull or flat or uninteresting, change the composition or try adding a highlight. For example, if you don't like having a big yellow, oval lemon in the center of your painting, cut it up. Just remember that "let there be light" goes a long way.

Work toward the best your studio can be.

Light in Your Studio

The light that illuminates your subject matter is not the only important light in your studio. It is also necessary to have adequate working light.

In the best of all possible worlds, you will have a studio that looks like the drawing on this page.

The light from the window will be warm; the light from the overhead fluorescent will be cool.

If at all possible, you should avoid using pole lamps and incandescent bulbs to light your workspace. They will cast shadows of their own on your working surface. The long tubes of fluorescent lighting create a more diffuse light source that does not throw sharp shadows. It is more like light from the sky rather than light from the sun. However, as I mentioned before, incandescent lighting can be preferable for painting still lifes precisely *because* of the shadows they cast. So, essentially, you should use incandescent light for the light source in a still life, but fluorescent light for the general workspace area.

If you are right-handed, try to set up with a window at your left side, as pictured in the image on page 76. If you are a left-handed artist, just reverse everything (although you're probably quite accustomed to doing that anyway).

Light

Shadow

You'll want the shadow of your hand to fall *away* from your working surface.

In the ideal studio, the light from the window will fall on your workspace. The fluorescent light from directly above will not cast shadows. The shadow cast by your hand as it meets the light from the window will move away from your work and from the tip of your brush, allowing you to see your painting clearly at all times.

The Joy of Indoor Painting

One of the joys of painting outdoors is being there amid all the sensory stimuli. But not all artists paint outdoors. Many do preparatory sketches and take a number of photos. Then they return to their studio with this reference material to compose and create their paintings.

A significant joy of painting indoors is comfort. You don't have to worry about changes in the weather; you can take a break for a cup of coffee if you like; and you can work into the night if you don't quite finish on time. But there's another joy of painting indoors: you can paint a still life. More than any other genre, the still life allows you to *create* your realist painting. You can find things that others might think ugly or ordinary and arrange them into something beautiful, or perhaps even something disturbing, but always something worthy of eliciting emotional response.

WORDS TO REMEMBER

- Indoor light is less intense and cooler than outdoor light.
- Lighting indoor subject matter has many possibilities, including window light and a variety of incandescent fixtures.
- Light your workspace with fluorescent fixtures to mimic clear, natural light.
- Beware of overlapping shadows.
- When painting still lifes, always establish the ground plane first. Then paint your objects upon it.
- Reflected light works the same way indoors and outdoors.
- Take the liberty to call upon a little artistic license when arranging your subject matter and choosing your lighting and colors.

LESSON 8
CHOOSING YOUR LIGHT

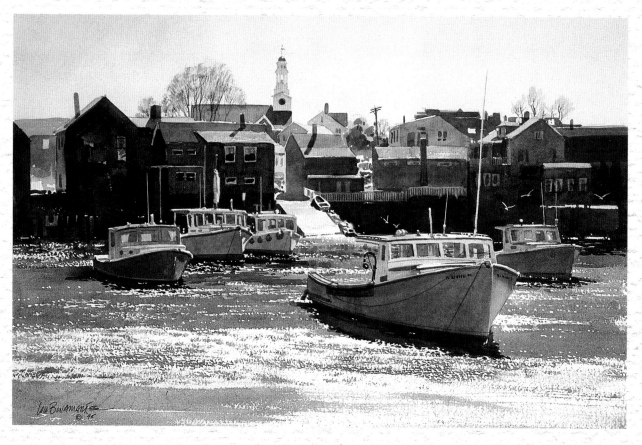

Cape Ann Harbor

Here are a few words, written almost four-hundred years ago, about the art of fishing. It's quite like the art of seeing light, don't you think? Just substitute "watercolor painting" for "angling" when you read it.

Sir, but that Angling is an art, and an art worth your learning: the question is rather, whether you be capable of learning it? for Angling is somewhat like poetry, men are to be born so: I mean with inclinations to it, though both may be heightened by discourse and practise; but he that hopes to be a good Angler, must not only bring an inquiring, searching, observing wit; but he must bring a large measure of hope and patience, and a love and propensity to the art itself; but having once got and practised it, then doubt not but Angling will prove to be so pleasant, that it will prove to be like virtue, a reward to itself.

—**IZAAK WALTON** (1593–1683), British writer

W hat's your most important tool as a watercolor painter? The quality of your paints? Your brushes? The type and quality of the paper? Your knowledge and talent? How about *light*?

Take a look at the paintings *Cape Ann Harbor*, page 78, and *Early Morning on the Dock*, page 80. The subject matter of the two paintings is very similar; in fact, they both depict Cape Ann, Massachusetts. But the visual effects could hardly be more different. What's the primary reason for the difference? *Light.*

One of the great joys of being an artist is the ability to make your own choices. You can choose your subject matter, you can choose your medium, you can choose your colors, and you can choose your light and how to use it. Let's take a closer look at these two paintings so that you can fully understand what I've done with the light.

Cape Ann Harbor

The viewer of this harbor scene is looking at water, boats, and buildings that are lit by a midday sun. Its rays are coming from the upper right side of the painting. The time is between two and three o'clock on a spring afternoon.

The focus of this painting is the boats on the water, not the New England fishing village. The buildings stretch across the upper middle quarter of the painting, yet they recede into the background. Because of the high overhead position of the sun, the colors of the buildings are both dark and neutral. Remember the walls are vertical planes and are not getting direct light. Think of them as an abstract pattern.

Their rooftops catch the bright light, reflecting the sun with neutral colors and creating a musical pattern of bright lights that moves horizontally across the painting. This light pattern is both emphasized and anchored by the dark vertical patterns of the buildings below it.

Like the melody that emerges in a symphony, the music of light, first noticed in the rooftops, moves into the foreground. The boat ramp and the tops of the anchored boats capture the light and bring it forward toward the viewer. Although that viewer is probably unaware of the artistry, the effect of these reflective roofs and decks is intensified by the relative darkness of the boat sides and building walls. This is the work of a realist painter (me), but the pattern of lights and darks, and of horizontal planes and vertical planes, could well qualify as an abstraction.

I chose to paint this scene in the midday sun because I wanted the light focused on the tops of the objects I was painting. In other words, I was seeking the repetition of bright light patterns anchored by object shadows (rather than cast shadows). The painting therefore has strong verticals against repetitive figures of light that move horizontally. The reflections of midday light on the water emphasize this effect.

In *Cape Ann Harbor*, it is important to notice that the prow of each boat catches the light on its right side. This use of light functions not only to define the form of the boats against their shadow side, but also to add another dimension to the play of light as it moves into the foreground of the painting. Each boat is given emphasis by its dark shadow on the water.

Looking from the foreground, the horizontal sweeps of the sparkling highlights in the water move up the painting to the brightly lit boat ramp (the lightest light against the darkest dark) and into the village. The vertical strip of a light yellow house sandwiched between the shadow sides of the two houses on either side of the boat ramp takes the viewer back to the play of light on the rooftops. Thus the use of light from a light source almost directly overhead unifies the composition by encouraging the movement of the eye through the painting.

The light source and its effects were integral to the creation of *Cape Ann Harbor* as a piece of art. And yet, very few would say that this is a painting of the movement of light. That's the art of it: using every tool available to put all the puzzle pieces together into a unified whole.

Early Morning on the Dock

While *Cape Ann Harbor* is composed of strong verticals, horizontals, and diagonals, all in bright light or dark shadow, *Early Morning on the Dock* is a painting of level horizontals, easy angles, and soft light. The viewer sees not high drama, but serenity.

The light is not long after sunrise. In fact, you can just catch a bit of mist rising off the hills in the right-hand corner. All the lit surfaces hold a hint of the rosy dawn and the surfaces in both object shadow and cast shadow seem about to rub their eyes and wake up. In other words, they are not very dark. This painting uses the middle of the value range, with a leaning toward high value (see Lessons 9–12 for more

HERE'S A TIP

Before you start a painting, always indicate the position of the light source with an arrow in the margin. Then identify the major planes in your painting. How does each relate to the angle of the light source? Once you make this exercise a habit, you'll have a safety mechanism for preventing painted shadows that go in the wrong direction.

in-depth discussions on value). Thinking conventionally, it conveys the sense of happiness that is usually associated with lightness and brightness. The ground plane of the village is indicated by a horizontal line of light located almost at mid-painting. This light is broken for aesthetic effect by two seawalls, one slightly behind the other.

The angles created by the play of light and shadow on the buildings on the left side of the painting are balanced by the angle of the illuminated dock on the right and the cabin and deck of the fishing boat.

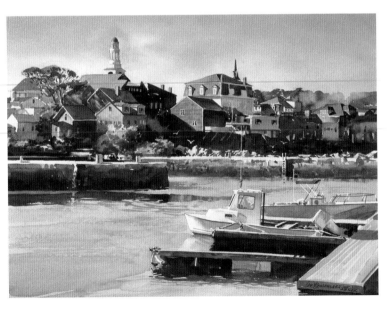

Early Morning on the Dock

Danville, Vermont Farm – A scene that's perfect for using photo references.

This painting in early morning light was done from photo references. Using photos allows the artist to capture light effects and details not likely to be seen when working under the time and weather limitations of on-site painting.

Photographs capture special moments for all of us. They also capture light, weather, action, and detail.

Take some time to look through your old pictures to see if any have captured a particular moment of light, the play of light and shadow, or the effects of weather. Create a painting using the chosen photo as your reference. And remember, you have artistic license. You don't have to reproduce the photo exactly.

So why don't we call *this* painting *Boats in the Harbor*? Because the focal point of the painting is the light in the village, not the boats. Although the cabin of the foreground fishing boat may be a nine on the value scale (meaning very light) and the side of the outboard motor-boat next to it a two in value (meaning very dark), they cannot compete for eye attention with the musical rhythm of light and shadow in the village.

This early morning on the dock is a moment of light, very much like a sunset. That particular play of light didn't last very long. Capturing it is what the artist does.

WORDS TO REMEMBER

- Establish your light source before you pick up a brush.
- Think about how your light source will affect the composition and visual effect of your painting.
- Delight in discovering the beauty of light and shadow everywhere around you.
- Enjoy the satisfaction of letting light work for you in your painting.
- Don't be a slave to making exact copies of anything. Put your creativity and knowledge of light to the best possible use.

PART III
VALUE

LESSON 9
THE VALUE SCALE

Red Tugboat in Winter

Chiaroscuro is "the art of advantageously distributing the lights and shades which ought to appear in a picture. . ."

—**ROGER DE PILES** (1635–1709), French painter and art critic

Previous page: *Two Men in a Canoe*

Many students who join my classes are already pretty good with the brush. They can do a flat wash or a graded wash; they can keep edges hard or soft; and they can even manage to make tree branches and electrical lines. Most of them, however, have not yet gotten the concept of *value*. Without an understanding of value, it's a long uphill struggle for a student who is trying to create quality, original art. Unless you understand the *value* of value in your painting, you're going to need a lot of luck, not to mention perseverance, in order to create works that you will find pleasing over the long term.

As I said way back in Lesson 1, in the world of art, *value* refers to the relative lightness or darkness of a surface. It is the underlying concept that enables an artist to effectively communicate his or her vision to another person. Changes in value create corners and shadows. Changes in value also help create the atmospheric perspective that leads the viewer into the painting.

In a nutshell: Art begins with light. Because we see light, we see value. Changes in value create the illusions of form and depth on the painting surface. That's it: value explained in three sentences.

Sounds pretty simple, doesn't it?

Don't be deceived—many students wrestle with the value concept. It takes a good deal of practice before seeing value relationships becomes second nature to the artist. I'm going to take four lessons to go over all the aspects of value that contribute to making a good painting. Stay with each lesson until you feel comfortable with the information being presented.

View from the Top

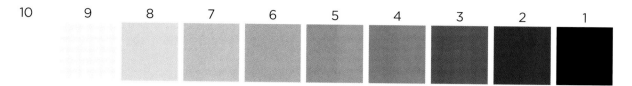

The value scale

The Squares in the Scale

Somewhere in your memories of grade school art class, you were probably introduced to the value scale (typically shown in gray). But if you don't quite remember the details, no problem. We'll start with a review.

"Why spend the time and effort on a review of this basic stuff when I'd rather be out painting? Or at least *learning* to paint!"

I often hear those words, or similar ones, mumbled at the back of my classes. I don't take offense and I really do understand your desire to "go out and paint." But not doing this "basic stuff" will only prolong your learning time. Unless you can "read" the value scale, the rest of Part III will seem as if it's written in another language. And you won't understand much about color either. So let's get to work on the essentials of value in watercolor painting.

At the top of the scale (number 10) is white—the purest, brightest white you can imagine. Let's call it "perfect white." Ideally, it's whiter than the paper this chart is printed on, but for the purposes of painting, it is your brightest white. At the bottom of the scale (number 0) is black—the darkest, deepest black you can imagine. Let's call it "perfect black." Again, it's darker than shown here. In between are nine shades of gray that progress gradually from *almost* perfect white to *almost* perfect black.

Today, computers can generate seemingly endless value scales, each square guaranteed to be just a bit lighter or darker than the one before it. However, you do not need to know, name, or differentiate every possible shade of gray in the basic value scale. In everything there must be some workable limits, and nine shades of gray is a good working number for the watercolor artist's value scale. The most important concept

in understanding the value scale is the relative relationship of a particular shade of gray to perfect white or perfect black. In other words, you must be able to assign the lightness or darkness of a surface to a spot on the value scale.

The task of using the value scale to help organize your artistic composition becomes more complex when you add color. Then you must put aside the intensity of a particular hue and try to assign it a place on the value scale according to relative lightness and darkness only. Later, we will look at applying the value scale system to colors in a wide range of hues.

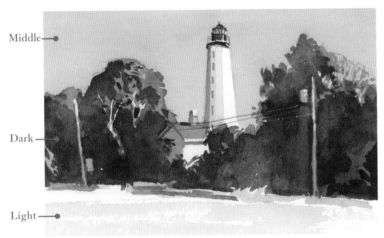

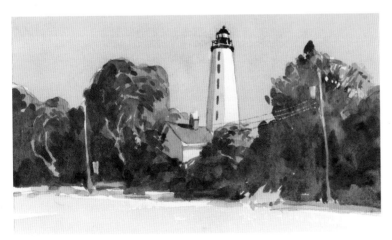

There are three major values in this painting. It's easier to see the different values in the black-and-white version: A) middle value, B) dark value, C) lightest value. Can you see how I used three different major values in the color version?

HERE'S A TIP

Always, **always,** *always,* think about the range and position of values in your composition *before* you start to paint. (More about this in the next lesson.)

Assigning Value

Now let's look at *Red Tugboat in Winter*, reproduced at the beginning of this lesson. This painting uses the full ten positions of the value scale. Some areas are at the very light 9 value: the snow in the foreground on the logs and wall; the snow in the middle ground on the boat and roof; and the highlights of the reflection on the water in the background. Other areas are at the other end of the scale (1 or 2). Look at the parts of the objects in shadow and at the reflections in the foreground water. These set the lower limit for darkness in this painting.

The entire sky is in the high-to-middle value range (8 to 6). The relatively small changes in value within this section of the painting create the clouds and the sense of distance. The boat and docking stations are in the middle range. The foreground water is in the low value range. The logs in the very foreground are very dark, but they are also snow covered, which means a juxtaposition of values that are at or near 9 with values that are at or near 1 (the lightest light against the darkest dark). The contrast creates the dramatic entrance to the painting.

What Key Is It In?

Don't worry! I haven't changed the title of this book to *How to Sing in a Choir*. With the term *key*, I'm talking about the overall feeling or perception of a painting. Much of that perception is created by the value and colors that predominate the painting surface. Paintings with predominately high values and light colors are often referred to as "high key" paintings. *Block Island Hotel* in Lesson 2 (page 36) is a high key painting. So is *The Red Bridge* in Lesson 3 (page 45).

Paintings where lower values and less bright colors predominate are often referred to as "low key" paintings. *Quiet Moorings*, below, is not a "dark" painting, but it is a painting with neutral colors and subtlety in its middle section and could therefore be called low key.

A good way to get a feel for the value range of your subject matter is to practice by painting in monochrome. As you complete each study, you will see not only value relationships, but also which values predominate. Then you will be able

Quiet Moorings

How many planes are there? How many values?

Here is a little take-home test I give to my students. This drawing is of a thingamabob of many planes. To do this exercise, copy the figure, choose a direction for the light source and then indicate it on your paper with an arrow. Using one color and black, paint the thingamabob so that the changes in value accurately indicate the form.

After you finish, do it again with a different light source direction and another color. And here's a hint: make crisp edges at corners, with one value hard against another; use gradual value changes at curves.

to alter value relationships for effect and essentially choose the "key" for your finished work.

For the ease and convenience of a quick study, you can use one color and black. Add more water to make the color lighter; add small amounts of black to make the color darker. Be aware, however, that black is not recommended for mixing by most artists because it detracts from the luminous quality of watercolor. But since I'm recommending that you do practice sketches to comprehend changing values, I don't think a little black will hurt. If you wish to stay with the method of darkening preferred by most artists, use a mixture of burnt umber and French ultramarine blue to darken your hue.

By removing the aspect of color from your work, you facilitate your ability to observe value. You can see this happen if you copy a color photograph on a black-and-white copier. When painting in monochrome, you simply can't create form without changing the value.

Now that you understand the concept of value in watercolor painting, you may be wondering where we go from here. Well, I'm going to teach you how to look at your subject matter a little differently. Let's say "more artistically." We're going to learn how to divide your surface into major value areas. Once you understand this working technique, you'll wonder how you ever painted without it.

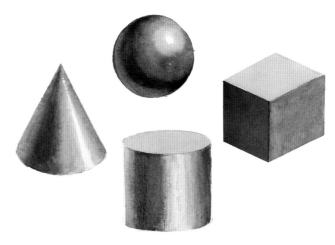

Forms take shape using value.

PRACTICE! PRACTICE! PRACTICE!

Go to an art museum or to your local library's art book collection, and look at the paintings of the masters. Study the ones you like best. Take a notebook, sketch the outlines of the works, and try to put numbers on the values.

For example, if you look at a Rembrandt or a Caravaggio, you will almost certainly see the full value range, with darkest darks against lightest lights. In many works by Renoir or Seurat, on the other hand, you will probably see work done entirely in the high value range. If you look at the later works of Goya, you will see that his art is dark with some dramatic contrasts.

The purpose of this exercise is to make you comfortable thinking in terms of value. Once you get it, it will become easy and your work will improve.

WORDS TO REMEMBER

- Understanding value is the key to creating the illusion of form.
- The value scale runs from "perfect white" (at 10) to "perfect black" (at 0). For working purposes, we label the shades of gray in between from 1 (darkest) to 9 (lightest).
- A painting may contain the full range of the value scale or it may be limited to only a portion of the range. The extent of the value range often determines the "mood" of the painting, for example, bright and exciting versus dark and threatening.
- The value range that predominates in a painting often determines its effect. Light values and bright colors create a high-key painting. Dark values and neutral colors a low-key painting.

MAJOR VALUE MASSES

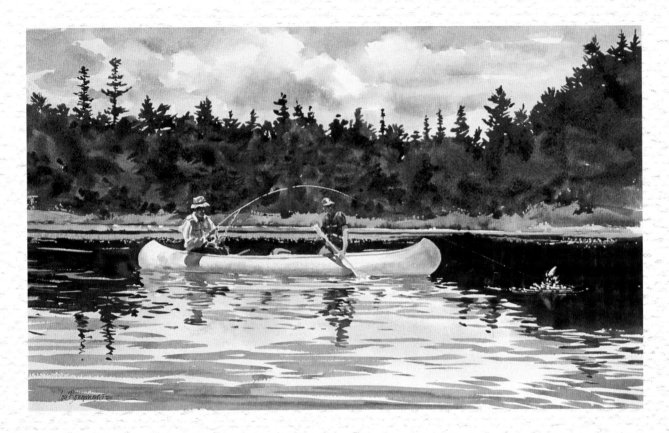

Two Men in a Canoe

Human life itself may be almost pure chaos, but the work of the artist is to take these handfuls of confusion and disparate things, things that seem to be irreconcilable, and put them together in a frame to give them some kind of shape and meaning.

—KATHERINE ANNE PORTER (1890–1980), American writer

At some point during my studies a teacher told me that "art is making order out of chaos." I didn't know it then, but this idea appears and reappears throughout Western heritage. It's been voiced by famous people as disparate as the German philosopher Friedrich Nietzsche ("One must still have chaos in oneself to be able to give birth to a dancing star."), the Polish-French painter Balthus, British writer Mary Shelley, German sociologist Theodor W. Adorno, and American composer Stephen Sondheim. To be so universal, it must be a pretty good idea and it has stuck with me all my years. "Order out of chaos" is a major part of my theory of watercolor composition, and I'd like to share it with you now. For a starting point, let's look at how *Merriam-Webster* defines chaos: "a state of things in which chance is supreme."

"Chance is supreme" is a key concept that must be remembered by anyone who wants to become a painter. The artist faces nature, is awed by nature, and wants to capture nature. He or she also looks upon all that humans have created. The element of *chance* in the world of the artist is created by time and perspective. At what moment does an artist see a particular scene? From what viewpoint? For example, Claude Monet did many series of paintings (cathedrals, haystacks, water lilies) that demonstrate how a painting can grow out of a chance moment or viewpoint.

The artist has a vision and a blank surface. On that empty workspace, he or she must collect the objects being seen and create an order that is aesthetically pleasing. In other words, the artist must change a chance moment or vision into an aesthetically unified whole, something to keep. Understanding the concept of the *value scale* in fine art is the most important tool in that creative process. No exceptions.

The funny thing is, though, I've been teaching for almost forty years and I've found that the value scale is the stumbling block of practically all of my students. This book is my effort to keep aspiring artists from stumbling. So as you work through the pages, please remember that "learning to use the secrets of light" is, first and foremost, learning to see and use *value relationships* effectively. Let's start.

Think the Big Three

As I've said, learning to see is essential for the beginning artist, but sometimes 20/20 vision gets in the way of creativity. When you conceive of and organize a painting, you should think in terms of major masses of value and their relationship to each other.

To do this, wipe out of your mind's eye *all* the details. I don't mean the bell on the cow in the pasture or the curtains in the windows of the farmhouse; I mean the *cow* and the *house*. And the fence, barn, garden, pickup truck, etc.

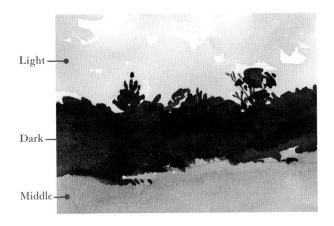

Light —

Dark —

Middle —

Think in terms of three major value masses: the foreground, the middle ground, and the sky (or background).

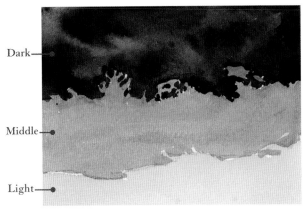

Dark —

Middle —

Light —

Just look what a change in the weather can do!

The ability to see value relationships is the first step in creating a painting. This visual perception is easy to demonstrate by using the simplest scene. For example, in the most basic landscape, there are three major value masses: the foreground, the middle ground, and the sky (or background). In the three-value demonstration above left, the foreground is a middle value, the middle ground is a dark value, and the background (sky) is a light value.

For most paintings, think "three" (light, middle, and dark), and then choose the cropping proportions and arrangement of the scene you are painting. "Choose" is the most important word in that sentence. The foreground is not always a middle value, the sky is not always a light value, and the middle ground is not always a dark value. For example, look at the value painting above right, which shows the three major value masses during a storm. The foreground is lightest, the middle ground is a middle value, and the sky is darkest.

PRACTICE! PRACTICE! PRACTICE!

Try your hand at painting three major value masses in different relationships. You can use the black-and-white value studies on this page or create some of your own. And remember, you can change not only the value of each part, but also the relative *size* of each part. The middle ground, for example, might be wide or narrow, or it might contain both wide *and* narrow areas.

HERE'S A TIP

Each major value mass should be in contrast to its neighboring value masses. The contrast can be as strong as a two on the value scale against a nine; or it can be as subtle as a three against a four or five.

Houses, People, and Things

When I teach value masses in class, there is always someone who objects: "What about the stuff we're painting? How do *things* fit into those masses?"

Major Values: A, B, C; Minor Values: 1, 2, 3, 4

In a painting there are major value masses, or planes, as well as value areas specific to objects within the larger masses.

In a painting there are major value masses (or planes) and there are value planes specific to objects within the larger masses. This is a concept that is easier to demonstrate visually than to explain. Look at the figures above.

In the figure on the left, the foreground (C) is the lightest value, the middle ground mountain (B) is the darkest value, and the background sky (A) is the middle value. The house, however, has its own set of value relationships. The front (1) is the highest, the side (3) is the middle value, and the roof (2) is the darkest.

"Okay," you say, "but what's that diagonal across the front lawn on the right?"

Good question. You're wondering why it is lighter than the value mass around it (C). The answer is because it is a path or road. That path is an object within the value mass. It has a value different from the major mass. If you wanted to get into details, you could paint rocks along its edge and each rock would have a light, middle, and dark area.

Now look at the figure on the right. This is the same composition, but painted with different value ranges that are of similar hues. Changes in value within an object create form. The roof (1) is, of course, catching the sunlight and is a 9 on the value scale, well outside the middle. The remainder of the building is in the middle range. The front (2) is a middle value, the side (3) is a dark value, but not the darkest value in the painting, so it's still in the middle value range. The bush next to the building also has three values: light, middle, and dark. The cast shadows of the bushes and roof (4) are even darker—probably a 2 on the value scale.

The major masses in this composition are also quite close in value. At first glance, the foreground (C) and the sky (A) look almost the same, but they are separated by the mountain in the middle ground (B) which is the lightest major value mass. It is generally a good idea to maintain a distinction between large value masses.

A *value mass* or *major value plane* is a large portion of a painting attributed to one value in the structure of the painting. It is essentially abstract and does not include objects, details, or the shadow effects of the light source.

Two Men, One Canoe, and Three Major Value Planes

Let's look at the painting that opens this lesson (page 91). The range on the value scale goes from midnight blue-black (1) to bright white (9). The painting's colors include several shades of blue and violet, several greens, yellow, and even a bit of red. The movement of the painting is definitely horizontal; notice that the tree line, the shoreline, the canoe, the reflections, and even the fishing rod all move the eye horizontally across the canvas. In most paintings, horizontal movement indicates stability.

Through the use of value changes, however, this painting is transformed from a placid moment on the lake to an exciting event. The trees and shoreline are middle value; the sky is light value. Both move quietly across the painting. The lake, the third value mass in the painting, is dark. (I know you're thinking that it looks pretty light to you. That light-value reflection of the sky is a pathway to the focal point, just like the walkway in the value demonstration painting above. I'll discuss this more in just a bit.)

Like the sky and the land, the water, too, moves quietly across the painting, except. . . Except that something is happening or about to happen. The canoe and the strong diagonals of the sky's reflection break up the placid, quiet darkness. The shapes and mass of these light values imposed upon the dark foreground mass actually create the focal point and the drama of the scene. The eye is led into the painting by the light value of the reflections and then focuses on the fishermen in their canoe—the lightest light against the darkest dark. And that's where the action is.

"Hold on!" you cry. "You said there were three major value masses in this painting. It looks like four to me."

Not quite. You are thinking about the details that you *see* rather than the large value mass *concept*. The lake is actually the dark value mass, even though there are a lot of light values within it. In terms of major values, the painting moves from the dark of the foreground (the lake) to the mid-value of the middle ground (the shoreline), to the light value of the background (the sky).

As previously mentioned, the white in the water is the reflection from the sky. The canoe and the men are objects in the painting. Remember, at the beginning of this lesson I asked you to wipe out *all* details when you consider major values. Even though the canoe and the men are the focal point of the painting, they are not part of the major value plane concept that is the painting's underlying structure. In just a bit, I'll explain to you how these objects and their light source fit into the three major value planes of a painting. But first another "except when."

Sometimes Four

In some landscape paintings, there are four major value areas: the foreground, the middle ground,

the distant horizon, and the sky. In the figures below, I've used a mountain for the fourth value, but it could be any mass. For example, a coastal scene might include shoreline, water, a distant group of islands at the horizon, and sky.

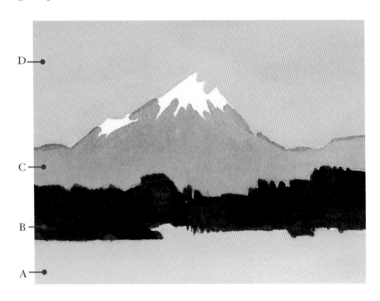

Sometimes there are four major value planes.

Four value masses with object values and shadows added.

The light (A), dark (B), middle (C), and middle light (D) sequence of the mountain illustration is an easy combination to work with, but watch out. Don't get lulled into a sense of security that leads you to find or impose these four values on everything you paint. The value ranges in a particular scene may be very close to one another. Or the pattern of values may be geometric rather than linear. What happens to major value areas then?

You can alternate values, as seen in the figures on this page. You can also let objects, shadows, and color enhance the value differences. Sometimes, when two major value masses are close to one another, the artist will place an object between them to emphasize the separation. This often happens in still life paintings. Shadows will also work as a separator in both still life and landscape paintings. When we get into color in Part IV we'll learn how two colors can be of the same value but have different intensities. An object or area of intense color can and will help the viewer sense the separation of two value masses. Again, it is easier to show you than to tell you.

The four value masses are quite distinct in the second mountain sketch, but separation of value planes and depth are added by the object values and the shadows. Color adds yet another dimension in the painting *Weathered Barns*. In that scene, it is midday with strong overhead light. There are three large value masses: the foreground, the middle ground, and the sky. All three masses are in the middle value range. So what makes the painting work?

Weathered Barns – Overhead light and three major planes, all close in value range. What makes the painting work?

In this painting, you can see the importance of objects, object values, and shadows. Their angles, colors, and textures create interest. In a little while, we're going to do a whole lesson on relative value within objects. Right now, however, hang on to the concept that most workable landscapes have three or four major value planes. When you decide to try painting subject matter other than landscapes, or even when you try abstractions, you will still have to deal with major value masses. Major value relationships are the structure upon which good art is built.

Step-by-Step Value Demonstration

You may be feeling a bit overwhelmed at this point, thinking: "Why do I need to know all this value stuff anyway? Why can't I just paint what I see?"

The answer is: because you are an artist, not a surveyor. Being aware of the major value planes in a prospective composition will assist you in the technical aspects of painting with watercolor. Like it or not, technical aspects are vital for an artist.

I've gathered together a sequence for you so that you can see the process from conception to a finished work, called *Church and Home*. The first illustration shows the three basic values divided upon the picture plane. The second illustration shows the church and the house drawn over the major value masses. They are similar to the canoe and water reflections in *Two Men in a Canoe*: light objects that will be painted against a dark value plane.

You could begin painting in the dark masses for a preparatory study and then draw in the objects, as in the second illustration. This will give you a feeling for the relationships of value masses and subject matter. Or you might paint the three value masses, working around the objects, as in the third illustration.

In a preparatory sketch, paint the value masses.

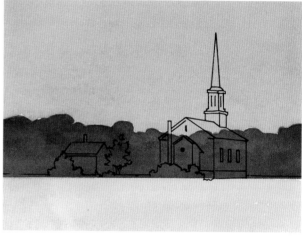

Then draw in the objects.

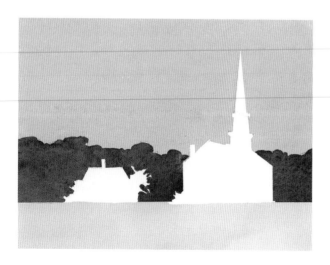

Light objects remain white against a dark value mass.

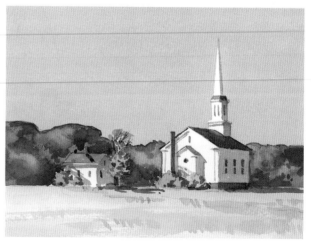

The scene in color. Now the light source has special effects in the painting.

Or you can do both. It's often constructive to pencil the location of the objects over the value masses to try out various positions. When you feel comfortable with placement, do another study leaving the objects unpainted. This gives you a better sense of balance because you are seeing the relationships of the major value planes without the visual distractions of objects and shadows.

The fourth illustration shows the painting in color. Now the light source has specific effects on the scene. Shadows are creating form. Color plays its role. If you work in this method, acknowledging the importance of value mass and then adding value changes within specific objects being painted, you will be painting realist watercolor.

Remember: *order out of chaos*. Your paintings need balance and order to be aesthetically appealing. The use of a major value structure will help you keep an essential simplicity in your work. With that foundation, your paintings will have impact.

Having made it through this lesson, you should have a whole new attitude toward starting a watercolor painting. Now you will first plan your major masses and *then* add the details that make an abstract division of space into a realist painting. Sometimes this new way of looking at the world—a world to be painted—will feel a little like pulling teeth. And sometimes (more and more often as you become accustomed to the method), you will have "ah-ha" insights. Your paintings will have more impact and appeal to their viewers, even though those viewers may not know why. And you paintings will become more satisfying to you.

WORDS TO REMEMBER

- An understanding of value relationships is the most important tool in the artist's creative process.
- The ability to see value masses is the first step in creating a painting.
- There are usually three major value masses in a landscape painting, but sometimes there are four.
- To organize a painting, think of the major value masses and their relationship to one another.
- Major value relationships are the structure upon which aesthetically appealing paintings are built.
- The use of a major value structure will help you keep an essential simplicity in your work.

LESSON 11
OBJECT VALUES

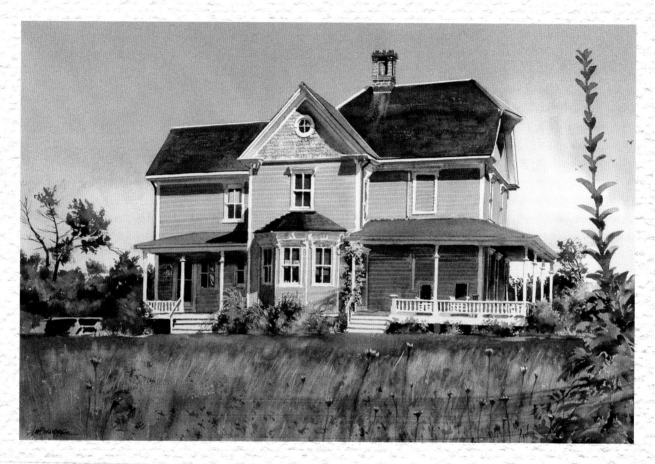

Yellow House

A painting is not a document of facts, but the artist's vision, stripped of the unessential, and arranged to express the motivating idea of the individual.

—**FRANKLIN JONES** (1921–2007), American artist

The last lesson was about major value masses; this lesson is about basic object values. Object values aren't minor—in fact, you can't paint realistically without understanding them. Looking now at my painting *Yellow House*, left, may help you grasp the difference between major value masses and object values (sometimes referred to as local value areas).

In the previous lesson, I asked you to take out *all* the details in order to see major value masses or planes; now I want you to put them back into your artistic perception and concentrate on the value differences that you see in particular objects or in limited local areas that appear within a major value mass. This is where the sun comes in! Light creates changes in our perception of value, and value changes in a painting create the illusion of three dimensions on a flat surface. In other words, the changes in the amount of light that you capture on each visible surface when you are painting—for example, the two sides and roof of a house—make the object appear real. You may have a relatively light value plane for the roof, a middle value plane

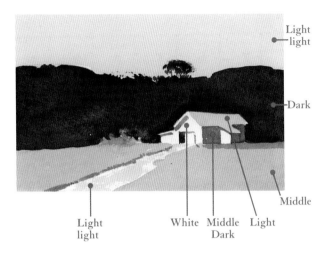

Value changes in a painting create the illusion of three dimensions on a flat surface. In this painting, the pathway is the same value as the sky, but it appears lighter since it is surrounded by a middle value.

ARTFUL MEANINGS

- *Object value* refers to the relative shades of light and dark that are created by the angle and amount of light falling upon the surfaces of an object. The changes of value that we perceive in an object create the illusion of a three dimensional form on a flat surface. For example, the play of light on different surfaces of a rock would be object value.

- The term *local value-areas* refers to the same perceptual creation of three dimensions when relative value changes are used to create form or atmosphere (sometimes intangible) in a space rather than on an object. A bubbling brook, a snowbank catching the last rays of sunset, or the reflection of light on the dark

water in *Two Men in a Canoe* from Lesson 10 (page 91) would all be considered local value-areas.

- The difference between major value masses and object values or local value-areas is the difference between the abstract structure upon which the painting is built (major value masses) and the creation of its three-dimensional illusions on the flat surface (object values or local value-areas). Major value masses are broad divisions of the working surface into an organizational pattern that is aesthetically satisfying. Within the major value masses, object values and local value-areas create the subject matter of the painting.

on the front of the house, and a dark value plane on the side of the house, all located within a major value mass that is middle dark. In this way, objects or local value-areas stand as separate entities within the value planes of the painting.

The Value of Sunlight

The sketch below is similar to the black-and-white sketches throughout Lesson 10. The light source (the sun) comes from behind the viewer's left shoulder and defines the three object values in the building. All surfaces directly facing the viewer are light; the roof, which faces the viewer at an angle, is a middle value; and the side of the building facing away from the sun (and the viewer) is dark.

Within this object (the barn) there are local value-areas, secondary objects that are created by using even smaller local value-areas. Each individual log has an underside that is darker than the top and middle of the log, thus creating the striped shadows across the barn. The cast shadows under the eaves and on the ground are even darker.

Your use of changes in value will create the illusion of objects, regardless of the major value mass in which they stand.

The log barn stands on the middle-value foreground mass, but it stands *against* the dark-value middle ground mass. The path across the foreground has an object value closer to the light value of the sky because it is indeed reflecting light from the sky. The grass in the foreground picks up some light from the sky as well, but the edge of the grass along the left side of the path has a shadow value darker than anything else in the foreground. This darkness is the result of artistic license, used to catch the eye. Because the grass is in the foreground (closer to the viewer than the middle ground or the background), the contrasts of light and shadow are stronger. We'll learn more about using value contrasts to help create the illusion of spatial depth in the sections on atmospheric perspective later in the book.

Here's an essential bit of knowledge, the key to using value changes to create the illusion of three dimensions: When you think about object value, you must always consider the basic forms (cube, sphere, cylinder, and cone). You studied them back in Lesson 2. All the objects you paint will be composed of these forms and parts thereof (with some adaptation, of course). Your understanding and use of the changes in value that you see as each basic form responds to the light source will create the illusion of three dimensions. The objects will be recognizable regardless of the major value mass in which they stand.

Value Relationships

Getting the relationships of major value masses and local value objects "right" (right for what you want to create) is a major factor in artistic composition (more about composition in Part V).

Danville, Vermont

Winter Farm

The focal point, or major object group, in a painting can be primarily dark, middle value, or light. It can be in contrast to adjacent major value masses or it can be in a similar value range. But its object values must be in the correct relationship to the light source that governs the entire painting. Considering your creative work as a whole, an essential part of the artfulness of your painting will depend upon how its objects relate to the major value masses and to the light source.

The Yellow House

Let's look at *Yellow House* at the beginning of this chapter (page 100). There are either three or four major value planes in this painting. Can you identify them?

Yes, that question is a bit tricky. What about the house—is it a major value plane? You could say, "Don't count the house; it's an object." Or you could say, "Yes, the house is an object, but it's also the largest value mass in the painting and has many objects and local value areas within it."

Both answers are right. This is a case where an object is so large that it becomes another

major value mass. Let's look at the painting a little closer.

The foreground of light-colored grasses and flowers is a middle-light value mass. The objects within it create the illusion of a soft fence of flora, light enough and detailed enough to invite you into the painting, but not large enough or light enough to keep the focus of your attention. It is followed by a middle-dark value mass: the lawn between the field and the house and the line of trees on each side of the house.

The house (considered a major value plane as well as an object) is the lightest value mass in the painting. It is central to the painting and it intently holds your eye. Within it, however, are myriad object values and local value-areas creating a play of light and dark that makes a stodgy old house dance with energy.

The sky is the middle value mass. (Notice that this whole painting, the entire value range of the major mass areas, are in the middle range of the value scale.) "But wait!" you say. "You just said the sky was a middle value mass, but the color behind the house is *white*. That's about as high as you can go on the value scale!"

Yes, but that white mass is clouds. Remember: *local value-area is created by light on an object or space*. These clouds are a well-lit object. That's fortunate (and planned), because the yellow of the house directly against the blue of the sky would be a bit hard on the eyes (two primary colors, one against another, are unpleasant to look at—I will discuss this more in Part IV.) Like the reflection in the water in *Two Men in a Canoe* in the previous lesson (page 91), the white in the sky is an example of a local value-area used to intensify the focal point

of the painting. (There will be an in-depth discussion about focal point in Lesson 23.)

The foundation and first floor of the house stand on the middle-dark value mass. Because the walls under the porch roof are in shadow, however, they are almost the same dark value as the major value mass on which they stand. That is their *local* value. If the house did not have a porch roof, it would all be in the same value as the bay window. The white of the porch railings contrasts nicely against the darker shrubbery and the walls in shadow.

The big green weed on the right side of the painting is an object with a local value in the middle-dark range. Why is it there? Because it nicely links the painting from top to bottom and establishes the station point of the artist and a sense of the distance from that point to the house.

ARTFUL MEANINGS

Station point is a term used to denote the place where the artist is standing in order to view the scene or objects to be painted. The station point is a crucial part of artistic composition because it determines how the artist wants to see (and organize) his or her material. But remember, there is always room for artistic license.

Besides being the highest value mass, the house is the focal point, the central object of the composition. It contains the lightest lights and the darkest darks (as well as the most intense colors, but we're building up to a discussion of color in Part IV). It stands *on* and *in* the dark value mass, but it is *not* a part of it. The dark value mass is primarily foliage with mostly soft edges. In contrast, the house is built of hard edges.

When painting corners, use hard edges and contrasting values. When painting curves, use soft edges and contiguous values.

Just as this painting has major-value masses, the house has its own local value system—light, middle, dark—just like painting a cube. By identifying the basic forms that we see in the construction of the house, it becomes easier to know what relative local value should be used on which plane in order to create the illusion of a three-dimensional object. For example: The main body of the house is a cube elongated to a rectangle. Think of the roof angles as cubes sliced through the middle and then tilted to form a triangle. Think of the bay window as a cylinder with six corners (and therefore six plane changes). Three of the six plane changes are visible.

PRACTICE! PRACTICE! PRACTICE!

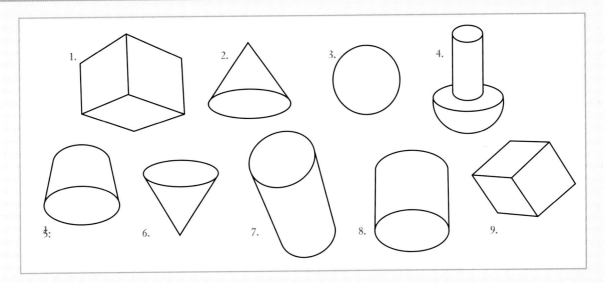

What can you draw using these figures and the value scale?

Object value or local value-area depends upon form and light. You first met the group of forms above in Lesson 2 when I asked you to assign values to the planes as illuminated by various light sources. Now you've had more practice with planes and forms, so let's test your creativity a bit. What can you draw using these figures (altered and/or modified, of course) and the ten-value system?

Here are some hints: Do you see an ice-cream cone in figures 2 and 3? Can you see an umbrella in figure 4? (Yes, it would need a narrower cylinder.) What about a mushroom? Now, that's an easy one! Do you see a bucket? Find the one form that can be changed into a peach, an apple, a grapefruit, or a cabbage. Draw each.

Have fun with this—look at the things in your life a little differently; make some interesting still-life arrangements. Again, remember that object value is dependent upon light and can be different from the major-value mass.

Weathered Barns

Not every painting has so vibrant and dominant a focal point as *Yellow House*. Sometimes the local area values or object values in a work of art are closely related to the major value planes in which they are located. Color, texture, and detail, as well as local area value changes, can then differentiate the focal point from the major value masses. Let's look at four of the stages in the creation of *Weathered Barns* to see how value masses and object values were developed into a painting.

Stage 1: I have done my preliminary sketches and know that the value relationships in this painting will be close. Therefore, I sketch the major mass areas and the local objects (the barns) and I paint neutral, light-value grays for the walls.

Stage 2: Now I indicate the darkest value mass (the middle-distance foliage) and the middle-value mass (the sky). I add the shadow of the forward barn because it is essentially the same value as the foliage and continues the horizontal movement across the painting.

Stage 3: Next, I paint the light-value green of the foreground. Using washes, I reinforce the value changes and shadows in the barn group. At this point, all three major value masses are indicated and the value changes in the objects are established.

Finished painting: Finishing *Weathered Barns* means adding detail. Notice that the ground plane in the foreground is now a slope. Shadow areas indicate the changes in terrain and vegetation. This kind of detail is just a matter of understanding the "shape" of the thing you are painting. You can almost "feel" the grass. Artists call that feeling *texture*. The added detail in the barns also captures the texture of aging wood. In the middle-distance dark value mass, notice that some of the trees take on a shape of their own. This sense of "realness" is accomplished by imagining the basic form of the tree and then indicating its response to the light source by changes in values.

The complication (or perhaps I should say the "creativity") in *Weathered Barns* lies in value relationships. The barns are almost entirely middle to

Stage 1

Stage 2

middle-dark values, and they stand in the middle-dark value mass of the painting. Why do we notice them at all?

The answer lies in local value changes: sunlight, shadow, detail. The lit triangle that escapes the roof shadow in the first barn is about an 8 in value, almost the same value as the grass. The roof of the barns is just a bit lighter than the sky. The walls are equal to the middle-distance values, but the details create a rhythm of dark and light and a texture of age.

You may be wondering, "Hmm . . . with a focal point so blended with the values in the middle of the painting, is anything happening?"

But that's exactly the point. *Weathered Barns* is a painting of serenity and harmony. The use of a relatively narrow range on the value scale for the major mass areas and a focal point that stands within the same value mass as its background contribute to that mood. There are no dramatic moments. The magic of the painting is in the alternating local area value changes in the barns and the foreground.

When compared to the finished painting, stage two of *Weathered Barns* has almost no movement. The finished painting is all about very subtle movement. The finely wrought appearances of and changes in light (one value to another, warm to cool, verticals to horizontals to diagonals) encircle the viewer with both the pleasure of serenity and the complexity of a moment captured in time.

As I've said before, *value* is a sometimes slippery, sometimes overwhelming topic. But it is the foundation upon which every painting is built. If you have a little trouble with the concept at first, don't give up. Understanding and using value concepts gets easier as you work with them; eventually they will become almost second nature. A good comparison might be a writer having to learn English grammar before he or she can write.

Before we leave this section on value, I have one more really important lesson: In talking about value masses and object values, remember that we're talking about *relationships*. Art, like life, is all about relationships.

Stage 3

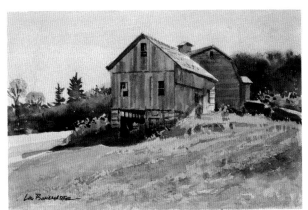

Weathered Barns – Final version

Copy this lighthouse and make it into a painting using the criteria given in the instructions below.

Here's a challenge that will call upon everything you have learned so far: Copy this lighthouse and make it into a painting.

- First, choose a light source and indicate it with an arrow. This will help you with shadows.
- Then, observe. There are three major value masses: the sky, the foreground, and the distant shrubbery at the horizon line.
- Try a dark, stormy sky with clearing light breaking at the horizon. Or try a clear sky in the high value range.

- You can make the foliage line dark or perhaps a neutralized gray, which would indicate distance.
- The foreground can be middle value, but remember that it might have cast shadows across it depending upon the position of your light source. Or you could try splitting the foreground into two value planes as in *The Yellow House*.
- Now, the big question: How many local value changes will you need to paint the lighthouse? If you are having trouble with this, look back at the forms illustration and exercise on page 41.

WORDS TO REMEMBER

- In painting, light and its resulting value changes define the basic forms that we see as buildings and objects.
- The local area values of objects and planes can be different from the major mass value of the area in which they stand. Or they can be similar.
- The basic forms can be altered and assembled in

many ways to create the illusion of any object.
- Local area value affects not only planes, but also details within those planes.
- Value relationships are created by the ability of the human eye to differentiate perceptions, from pure light to complete darkness.

Twin Tugboats

One is never tired of painting, because you have to set down, not what you knew already, but what you have just discovered. There is a continual creation out of nothing going on.

—WILLIAM HAZLITT (1778–1830), British essayist and critic

magine for a moment a large extended-family gathering. Among the group of cousins, one teenage girl is always talked about as the most beautiful. But when the family persuades her to enter a regional beauty contest, she does not win. What happened?

Every human society has a value scale for beauty, but in a group, beauty is evaluated by comparison. The same can be said of athletic ability. The "big man on campus" college quarterback may not look so big among the New York Giants.

If you can understand those two situations, you can understand relative value in watercolor painting. *Relative value* may sound a little too subjective as a topic to study in a book for new students. But believe me, it's not. The secret to grasping the concept of relative value lies in breaking the topic into its component parts. In this lesson, we'll review relative value within the basic forms and then we'll talk about adjacent values and the relative values of objects and major masses.

Pay attention and don't give up. If you want each of your paintings to be an artistic whole rather than a grouping of well-painted objects, you must first learn the concept of relative value.

Forms and Modified Forms

Since Lesson 1, we've been talking about planes and the basic forms: cube, cylinder, cone, and sphere. We've established that creating the illusion of these forms in a painting requires at least three basic values: light, medium, and dark. We've also acknowledged that these forms are combined and modified into the objects that we see. Being able to identify basic forms that make up an object will help you understand the value relationships within that object; just remember the planes of each form and the direction of the light source.

HERE'S A TIP

To paint objects in the distance, choose three values close together on the value scale. Remember: objects in the distance are usually lighter (higher in value) than objects in the foreground.

To paint objects in the foreground, choose more separated values for light, middle, and dark.

The Range of Value

Let's look at the opening painting of the twin tugboats (page 109). The object values in the foreground (the values on the two boats) are very distinct and separate from each other. The juxtaposition of sharp edges and high intensity colors creates a sense of the dramatic, a feeling of power. The reflection of the sun on the hulls is about as bright as a painting can have (a 9 on the value scale). The underside of the hulls and the dock are almost perfect black (1). The red of the cabin is right there in the middle of the value scale (5). All of these contrasts exist in a wedge through the middle of the painting.

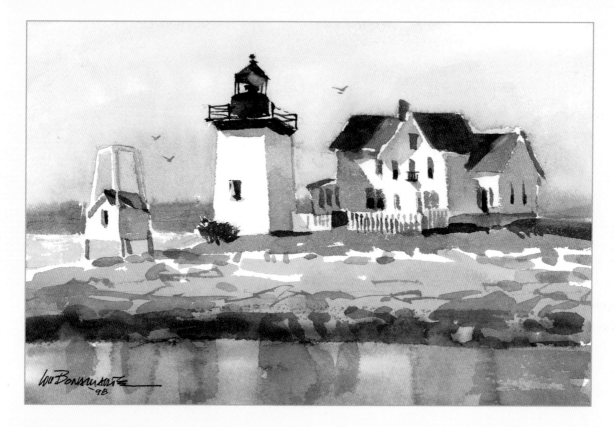

Hendricks Head Lighthouse

Look at this lighthouse sketch (it's not finished art) and identify the forms and the value changes that create them. You'll notice that this little sketch uses the value scale from 9 (almost perfect white) to 1 (almost perfect black).

Copy the sketch three times and do three different paintings using a color of your choice. Use water to lighten the pigment and a mixture of French ultramarine blue and burnt umber for darkening as needed. In one study, use only values from 9 down to 5. That's your high-key painting. In the next, use only values from 5 down to 1. That's your low-key painting. Finally, make a painting using values from 7 to 3. This is a middle-value painting.

Each of your paintings should convey the image of a lighthouse group under different circumstances. One study might be what you'd perceive on a foggy day, another at twilight, yet another on a bright day in summer. There could even be a sunset.

Consider which of the three value ranges might be appropriate for depicting the particular mood and atmosphere in each scene. For example, which set of values would make the lighthouse appear more distant and less distinct? Which range of values might convey the threat of an impending storm? Which range of values would you use to capture the serenity of a summer morning? In doing all of these exercises, you are using the concept of relative value.

Now look at the painting *The Captain's House*. In the house, the range of value between the lightest area (the building surfaces facing the viewer) and the middle area (the front of the house, with the porch), is rather close on the value scale. Now look at the brown fishing shack to the right. The relative values are stronger (farther apart on the value scale) there because of the angle of the sun.

Value Against Value

Now look at the value of the blue house against the trees. The line of trees comprises the middle ground of the painting and is the darkest value mass. (The sky is the lightest and the foreground—the water—is the middle value.) Although the range of values in the blue house hovers in the middle of the value scale, it appears to be rather light. Why? Because the light blue of the house is surrounded by the dark of the trees. The house also appears to advance out of rather than recede into the painting, even though it is a cool color. These are the effects of relative value.

Now look at the brown fishing shack. The values of the two visible sides of the building are

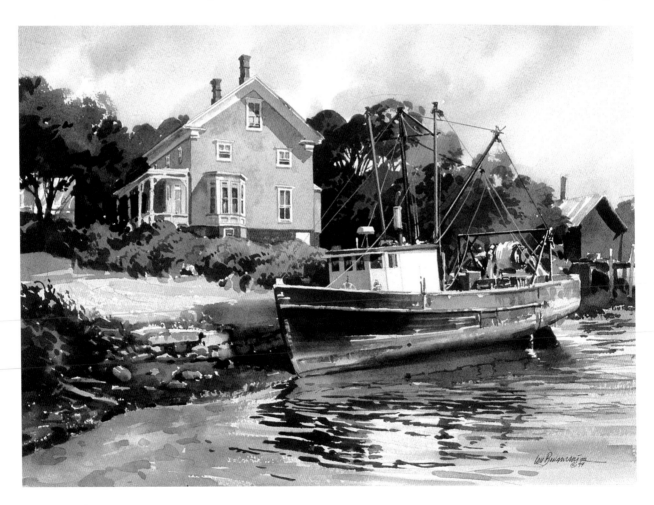

The Captain's House

close to those of the trees. The value of the roof is close to that of the sky. This building therefore blends with the major masses of the painting and is obviously not the focal point of the work.

Just as side-by-side value changes can highlight an object or move it forward or backward into the scene, values that surround an object on all sides can change our perception of both its value and color. I'm going to spend a lot of time on color in Part IV, but right now I'd like you to notice how one color can look quite different in two separate paintings. The reds of the covered bridge and the tugboat in the paintings below are very similar in value (although the bridge has somewhat more texture and shading.) But when we look at the two paintings, we see them as different. The overall key in *Red Tugboat in Winter* is lower than the high key of *The Red Bridge*.

In *Red Tugboat in Winter*, the value of the lit red side of the tugboat is higher than the values of the lit brown sides in the shipyard workstations. It is much higher than the shadow sides of the workstations and the water and docks. We

ARTFUL MEANINGS

In the art world, *advancing* and *receding* do not describe military troop movements or an aging hairline. Areas that advance seem to come forward in the painting; in other words, they seem closer to the viewer. Areas that recede appear to move back into the painting; they seem farther from the viewer. All of this, you realize, is on a flat surface.

Dark areas surrounded by light values make objects appear to advance, as do light areas surrounded by dark values. Using advancing and receding values, a light-value house against dark-value trees appears to come forward out of the flat surface. In this way, relative value contributes to the artistic magic of changing a flat surface into a three-dimensional image.

see it as a middle value, on the lighter end of the scale—let's say a 6. In *The Red Bridge*, the lit side of the covered bridge is much more intense than its roof or the foliage beneath it in the distance. We see it as a darker middle value (perhaps a 4) in

The Red Bridge

Red Tugboat in Winter

a painting where virtually everything else is light. Yet without their surroundings, the values of the reds in each painting are virtually the same. This is relative value at work.

This all goes back to the pretty girl and the football player that started this lesson. Remember, when painting and viewing art, our perception of value and color is influenced by surrounding value and color. A particular value may have a precise position on the eleven-degree value scale, but because our perception of every mass and form in a painting is influenced by the objects and shapes around it, viewers may see that value differently from its technical place on the scale.

Value and Major Masses

In Lesson 10, we discussed the major masses in a painting—foreground, middle foreground, and background—and the need to regard those masses as major value areas. In Lesson 11, we talked about object value, which may or may not contrast with major value planes. Now I want you to blend the two concepts together and recognize the relationships of major value masses and local value objects in a painting.

Let's start with *Twin Tugboats*, shown at the beginning of this lesson. The water in the foreground is the middle value; the distant horizon is middle light; the sky is light. The darkest and lightest values appear in the objects and local value-areas that are the focal point of the painting: the ships and their reflections. The drama in this painting is so strong because the full range of the value scale is concentrated in a specific group of objects in the middle foreground.

In *The Red Bridge*, the major masses are the foreground (middle dark), the distant foliage (light), and the sky (middle). Superimposed on this major mass value scheme, the bridge siding and shadow area stands out at a middle to middle-dark value juxtaposed against the roof's very high value. Two adjacent but distinctly different values therefore cross from one side of the painting to the other. The most intense colors and greatest contrasts cross in the upper third of the painting, just above the middle. There's no missing the focal point in this composition.

The Red Tugboat in Winter has a dark foreground (the water), a light distant horizon, and a middle-light sky. Superimposed on the darkest plane (the foreground) is the subject matter of the painting. The object values of the logs run from 10 to 1 on the value scale (from white to black), as do the values on the boat. Again, the relative values of the objects are very different, but in near proximity in the painting.

Rules? What Rules?

Perhaps you're feeling rather comfortable right now. You think that you're beginning to get this Major Value, Object Value, and Relative Value thing. Then you look again at the painting *The Captain's House* (page 112).

"Wow!" you say. "The painting *looks* great, but does it really follow the value guidelines we've been discussing?" Look at that wide dirt pathway leading from the yard to the boat. That very light area seems to be a bridge between the foreground and middle ground of the painting. The trouble is that it's a lot lighter than the middle value of the water, even allowing for reflections. The wide pathway of light creates an intense relative-value

contrast, but that pathway is certainly not what this painting is about (it is not the focal point). Do you call this "artistic license" or just breaking the rules?

No, the painting doesn't break any rules (or perhaps we should say "guidelines"). The foreground (the water) is middle-light. The rocks, bushes, and gravel are local-value objects upon the foreground. The background (the trees) is dark, and the sky is light. Worked into these value planes are the high-value pathway and blue house and the middle-value trawler with a high-value cabin.

A major mass diagram of this painting would divide it almost by thirds along value lines. The two major local value object areas (the house and the boat) are placed almost at the center of the painting, and are barely touching, so that their edges form a right angle. (This angle can be seen more in the dark value than in the outline of the objects.) Relative value changes dance within these two objects and the reflections in the water. Overall, the painting is middle-to-high key; the relative value changes create a movement that starts at the station point, moves into the painting along the dark value reflections in the water, up the prow of the boat, along the high-value pathway and to the house, which has high- and middle-value walls surrounded by the dark-value foliage.

HERE'S A TIP

If you're having trouble identifying values in a painting, turn it upside down and squint at it. When making value judgments, we are often distracted by recognizable objects, so it helps to turn them into abstract shapes. Squinting blurs the details, and turning it upside down helps eliminate object recognition.

Future Value

In Part II, we talked about light. Without it, we see nothing. In Part III, we've been talking about value, which is dependent upon light. Value allows us to depict three dimensions on a two-dimensional surface. In Part V, we will discuss *composition*. Some artists say composition is the element that makes a gathering of objects or planes into art. If that's true, what is the most important component of a composition? Balance? Color? Eye path? The list of compositional elements could go on and on, but I'm sure you've already guessed what I think is the right answer: the relationship of the values. Now that you understand relative value, let's move on to another vital element of composition: color.

WORDS TO REMEMBER

- If you want each of your paintings to hold together as an artistic whole, you must learn the concept of relative value.
- The range of value within a composition can cover the entire value scale or only a small portion of it.
- The range of local value within an object can cover the entire value scale or only a small portion of it.
- Value relationships can trick the eye into seeing advancing or receding space.
- The value relationships of major masses and local objects create composition.

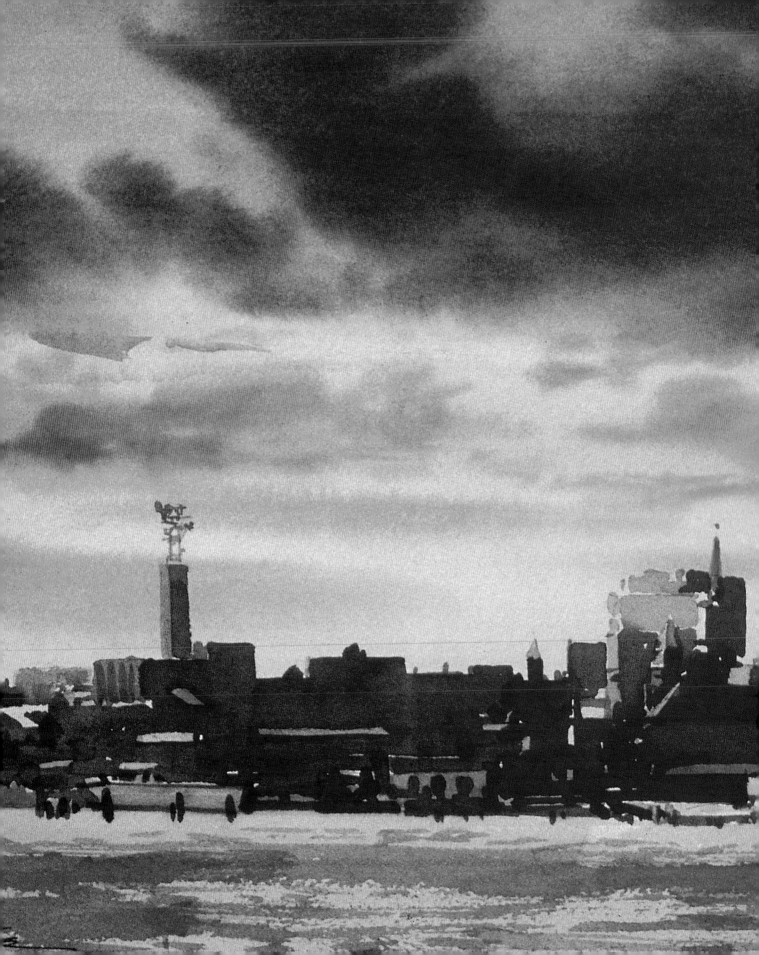

PART IV

COLOR

COLOR WHEELS

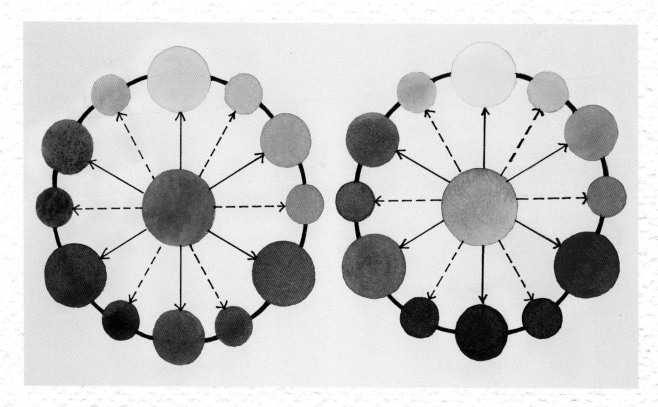

Two color wheels.

> *You can take it for granted that people know more or less what a street, a shop, a beach, a sky, an oak tree look like. Tell them what makes this one different.*
>
> —**NEIL GAIMAN** (1960–), British author and graphic novelist

Previous page: *Cityscape at Sunset*

R ecently a student raised her hand at the beginning of a class. "How come you're putting up two color wheels?" she asked. Some of you might be thinking the same thing right now after seeing the image that opens this lesson. If you have a good memory, you might remember learning about the color wheel in junior high school art class. You were probably taught that there is one color wheel and it has six spots, not twelve, that there are three primary colors and three secondary colors, and that the mud color in the middle is called a tertiary color. That certainly doesn't sound like the color wheels to the left.

I can explain and maybe even adjust some ideas. By the end of this lesson, you'll have made progress similar to advancing from a stone wheel to a spoke wheel. But first, to understand this lesson at all, you've got to understand the words in the *Artful Meanings* sidebar below.

ARTFUL MEANINGS

- *Hue* is the name for a gradation of a color.
- *Primary colors* are red, yellow, and blue. These colors are called primaries because they cannot be made by mixing together other colors. However, all other colors can be made by various mixings of these three primary colors.
- *Secondary colors* are orange, green, and purple. Each hue can be made by mixing two primaries in approximately equal amounts. Orange is made from red and yellow; green is made from yellow and blue; and purple is made from blue and red.
- *Tertiary colors* are made by mixing a secondary color with additional pigment from an adjacent primary color. For example, green is a secondary color. Mix it with more yellow and you have spring green or yellow-green. Mix green with more blue and you have aqua or blue-green.
- *Chroma* (sometimes called *intensity* or *saturation*) refers to the strength or weakness of the color.

The more pure and unneutralized a color is, the higher the saturation or chroma. Variations result in changes in the intensity that the viewer perceives. You can see a hue of blue, for example, that is so bright it is almost hard to look at or a hue of blue so neutralized you can hardly separate it from gray.

- A *complement*, sometimes called an *opposite*, is the color opposite a primary on the wheel. It is always a secondary color, never another primary. The complement of yellow is purple; the complement of red is green; and the complement of blue is orange. Mixing a complement into a primary neutralizes it. Placing a complement next to a primary in a painting calls attention to the area.
- *Pigment* refers to the material, either natural or manmade, unified with a binding substance to make paint.

As a beginning student, start with a six-point or six-wedge color wheel. Paint in the three primaries, leaving a space between each. Now mix the secondaries and paint them in the proper open spaces. Remember: you are working on understanding the relationships between the colors, not seeking perfection.

When you have painted several color wheels and feel that you have separated primaries and secondaries in your mind, try painting a twelve-point color wheel like the ones that start this chapter. To do this, paint in your primaries and secondaries, leaving a space between each point. Then take a secondary and add some pigment from the primary before it (moving clockwise). Paint that color into the space between the two. Then move to the next open space and take the same secondary and add a bit of the primary that comes after it (still clockwise). Compare the two tertiaries you have made. Then continue around the wheel, take the next secondary and add more of the primary before it, and so forth.

You can have a lot of fun and gain very good practice by noting or even naming the new colors. You will also learn the subtle differences between the colors you come up with. Adding a bit more or less of a neighboring color can be remarkable.

Why We See Color

You may have studied light and the prism in a high school physics class. Sunlight that passes through a prism (such as a drop of rain) breaks up into the colors of the spectrum (this is why we see rainbows). The colors we see (and give names to) are the portion of the sun's light that is being reflected back into the eye by an object.

The manufactured pigments we buy and the colors we mix on the palette simply reproduce those reflections of light from the sun to our eyes. When we see red, for example, we are seeing the reflection of the longest rays of the sun's light. The reflected rays we name as colors change in length subtly, shortening through secondaries and primaries until purple is reached (the shortest rays). The result is red, orange, yellow, green, blue, indigo, and violet. White is all reflected light; black reflects no light.

When we transpose this theory of light to the palette, we can start to talk about chroma, or intensity. Both primary and secondary colors can have high chroma. When a secondary color (such as orange) is mixed with an additional amount of a neighboring primary (in the case of orange, you would mix with either red or yellow) a new hue is created, but the chroma is not dulled.

Color loses intensity only when a non-neighboring primary or a complement is mixed in. For example if you made red-orange and then added a little blue, you would neutralize the red-orange and reduce the intensity. When a primary (red, for example) is mixed with its complement (in this case green) the effect is immediately a neutralized color.

In other words, any hue mixed with its complement will produce grays and browns. (That's the "mud in the middle" I was talking about earlier.) Some artists do call these neutral combinations of primaries and their complements "tertiaries." But I prefer the structure of the twelve-point wheel, in which tertiaries can be high chroma mixtures of a secondary and an adjacent primary.

LOU BONAMARTE COLOR WHEEL

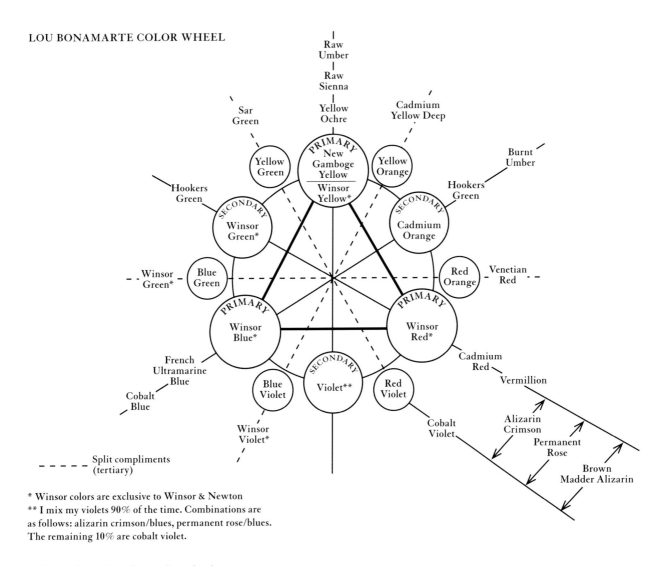

* Winsor colors are exclusive to Winsor & Newton
** I mix my violets 90% of the time. Combinations are
as follows: alizarin crimson/blues, permanent rose/blues.
The remaining 10% are cobalt violet.

A detailed version of my color wheel.

PRACTICE! PRACTICE! PRACTICE!

This is one of the most important practice exercises in this book. You can learn about neutral colors and darks colors by mixing them. Once you have created a color wheel, try mixing two primaries. Red and blue equals purple, right? What do you think will happen if you mix in some yellow? Most people will reply, "It will get lighter."

Nope! When you mix in the third primary, the color you make gets darker and more neutral (the more neutral, the less a recognizable hue). Now try mixing a primary, let's say blue again, and its complement, orange. You'll get a neutral brown. What will happen if you mix in just a little red?

Have fun with this exercise. The more proficient you become with mixing color and creating neutrals, the more professional your paintings will appear.

Why Two Wheels?

Many people were misled in junior high school art class when they learned that there is only one color wheel. Actually, you can paint dozens of color wheels, each one of them different from the others.

"Why?" you ask. Because you can't push a button for the "right" color. Color is always seen in relationship to something, either other colors or a background color. Light and color are key elements in creating an aesthetically pleasing painting. Choosing the "right" color at the "right" value for your particular painting, however, is always a challenge. The choice is a little like cooking: you can buy a package of frozen mixed vegetables or you can choose and chop the exact mix that you think should go with the meal you are preparing.

There are hundreds of pigments to choose from in the watercolor marketplace, each with its own name. But even pigments with the same name can differ from one manufacturer to another. If you want consistency in your work, you should begin to choose the palette of colors that you prefer to work with. (As a starting point, however, you can refer to my list of preferred colors on page 16.) Beginners may find it helpful to make color wheels that will demonstrate what the result of certain mixings will be before beginning a painting.

I use certain wheels (combinations of primaries) for certain subjects. Wheel A in the figure below works as follows: French ultramarine blue is a warm blue with a touch of red, new gamboge yellow also has a touch of red, and cadmium red light is red with a leaning toward yellow. Why is all this important? Because the primaries you choose determine the secondaries that you can create. Wheel A is a warm wheel.

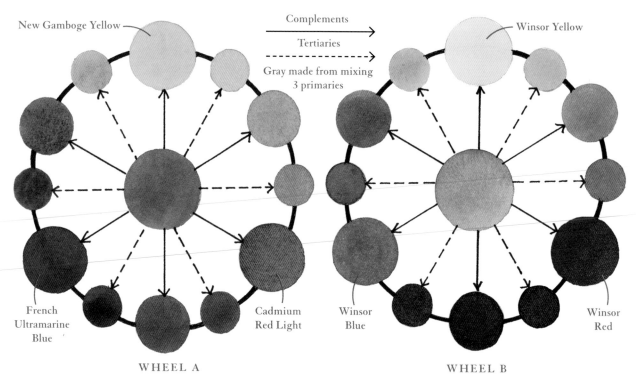

WHEEL A

WHEEL B

It can be helpful to create certain color wheels for certain subjects, depending on the combination of primary colors being used.

Wheel B, on the right, uses Winsor blue, Winsor yellow, and Winsor red as its primaries. Winsor blue has no red in its hue; neither does Winsor yellow. Winsor red, however, has some blue in it. What's the effect of this combination? Look at the greens in both wheels. Since neither Winsor blue nor Winsor yellow has any red in them, there is nothing to neutralize the green they produce. Wheel B therefore has a more intense green; it is brighter chromatically.

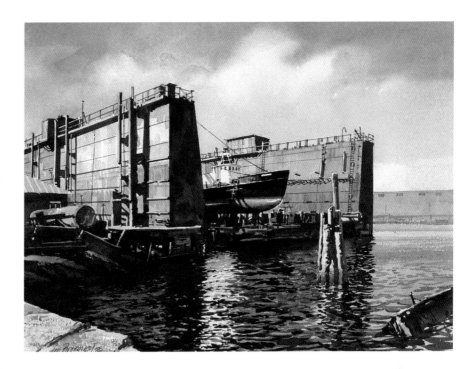

Face-Lift—Thames Shipyard

What if I said you could have only one of these wheels as your palette at any given time? Which would you pick?

The correct answer is: "It depends on what I want to paint." Wheel A might be good for a bright day with banks of clouds and the sun playing through them, or for a stormy day where neutralized colors play an important part. Wheel B might be especially good for a floral still life or any painting where pure, not neutralized, color is desired.

Face-Lift–Thames Shipyard

Face-Lift–Thames Shipyard uses colors similar to those in Wheel B. The dominant blue is intense, with no red. French ultramarine is introduced only in the shadow areas of the water. Look at the yellow in the highlights of the clouds—no red there. Look at the green roof on the left side of the painting. It's a clear combination of the blue and the yellow. On the other hand, the red on the farther away work station starts out as high chroma color, but it's quickly neutralized into a rusty orange.

Notice also the patterns created by the large dark masses in the painting. This darkness actually calls attention to the light. And you can't miss the focal point, the ship's white cabin, which is just above and to the left of the center.

Two Men in a Canoe

Two Men in a Canoe selects colors from Wheel A. French ultramarine blue helps create the impending storm in the sky and dominates the color of the water, which is of course a reflection of the sky. The green, produced by mixing French ultramarine blue with new gamboge yellow, creates the neutralized hues of the pine trees. A bit of cadmium red light appears in the men's faces and clothing and on the side of the canoe, just enough to get all three primaries into the painting.

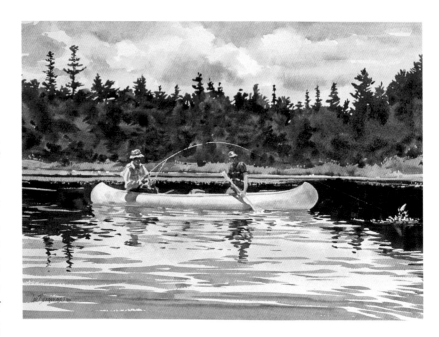

Two Men in a Canoe

WORDS TO REMEMBER

- Primary colors—red, yellow, and blue—cannot be created by mixing other colors.
- Secondary colors are created by mixing two primary colors.
- Tertiary colors are created by mixing a secondary color with an additional amount of an adjacent primary color.
- The color opposite each primary on the wheel is called its complement. The complement of red is green; of blue is orange; of yellow is purple. All complements are secondary colors.

- Tertiary colors are created by mixing a secondary color with an additional amount of an adjacent primary color.
- A primary color is neutralized by mixing it with its complement. A secondary color can be neutralized by mixing in a small amount of the primary color that was not used to create the secondary.
- The pigments you choose as your three primaries will determine the chroma of your secondaries.
- By choosing different pigments as your primaries, you can create many color wheels.

THE PERSONALITY OF WATERCOLORS

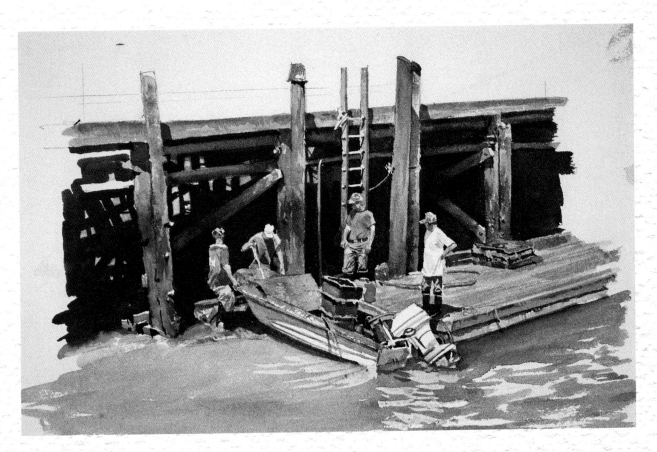

Hauling In—Stage 3

Every artist was first an amateur.

—**RALPH WALDO EMERSON** (1803–82), American essayist and philosopher

For the realist artist, knowledge and understanding of the foundation elements of painting (form, value, perspective, and composition) are necessary to create the structure upon which color works its magic. But color is the luminous, evocative element in watercolor painting that viewers respond to more consciously than anything else. For the artist, the use of color is also the most personal and complex aspect of watercolor painting. So keep the lessons of this section keenly in your mind as well as close to your heart as you study each of the foundational elements in this book.

To start our discussion on the role of color in art, let's look at the images on this page and the previous page. They are images of two different stages of a work in progress. Because the painting is not yet finished, you have the opportunity to see the development of color at work.

In *Hauling In—Stage 1*, I drew a composition lightly in pencil and then painted in the figures.

Next, I surrounded the figures with dark, neutral values. That strong contrast makes the men stand out. The standing figures are also in harmony with the strong verticals in this painting.

At this early stage of the work, however, there is tension in the scene. Do you see it? Look at the collision of the two strong diagonals, blue versus orange. This is a near clash of complements. And where is that tension placed in the composition? The focal area.

This men-at-work scene is underlined with the equivalent of a pointed arrow. The blue and orange intersect, pointing outward and that thrust toward the viewer is unsettling at best. Although the painting is incomplete, as it is now, the colors almost drive the composition off the paper.

Hauling In—Stage 1

What do you think has happened in *Hauling In—Stage 3* (page 125)? The tension of the two opposing diagonals is now stabilized and integrated into the unity of the whole. How? With the magic of color.

Just as the intense blue and orange diagonals have the power to jolt the eye, the neutrals in the painting have the power to calm it. Look at the neutralized green of the seawater; the red and green complements inside the boat; the hint of a green hose on the diluted and neutralized red of the dock. Now there is motion and activity, but not conflict. (I'll show you the finished painting later.)

Are you surprised that there is so much to say about the colors in a relatively small painting? Trust me, the topic of color is big enough to fill volumes. For now, let's get to know a bit more about its "personality" and power.

The Wealth of Color

A very fine student once pointed out that watercolors resemble the typical American teenager: advancing and receding; warm and cold; transparent and opaque; permanent and washable. She had it right, and that rich variety is exactly what makes the medium (and maybe teens too) so interesting and challenging.

But too much of any good thing can be overwhelming. Color is good, but the challenge for you, as a beginner, is to choose your individual palette (at most eight to ten colors) and then get to know the pigments you have chosen so well that they empower your creativity.

The limited palette I recommend is not really limiting. Compare it to friendship, for example. Having a dozen good friends spells security for most of us, especially if the friends are well chosen. Having those close friends, however,

ARTFUL MEANINGS

- The *Merriam-Webster* definition of transparent is "fine or sheer enough to be seen through." In watercolor parlance, *transparent* (or sometimes translucent) means that an underlying color, shape, or line can be seen through the pigment painted on top of it.

- According to *Merriam-Webster*, **opacity** is "the quality or state of a body that makes it impervious to the rays of light." In watercolor words, opacity is the ability to mask the color beneath it. Different pigments have different degrees of opacity. The most opaque are sometimes unpopular. For example, many watercolor artists do not use black or Chinese white because they feel these opaque pigments reduce the luminosity of the watercolor medium.

- *Merriam-Webster* defines **luminosity** as "the relative quantity of light" or the "relative brightness of something." In watercolor painting, luminosity is created by the whiteness of the surface upon which the work is done because that whiteness shows through the transparency of the pigment.

- *Staining color* refers to the degree that the pigment will permeate and remain on watercolor paper. A staining pigment cannot be easily washed out, even when the paper is scrubbed.

- *Granular color* refers to the amount of sediment in a pigment. In varying degrees of different hues, granularity reduces the ability of the paper to reflect light through the pigment.

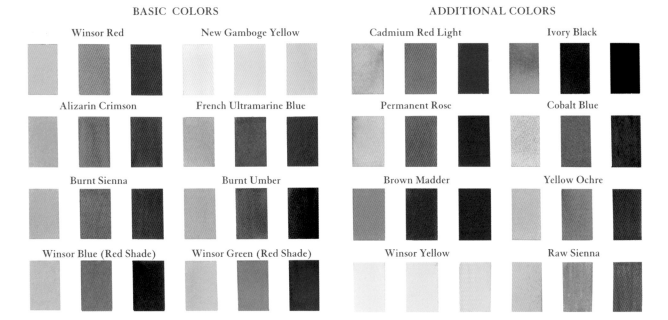

BASIC COLORS

Winsor Red New Gamboge Yellow

Alizarin Crimson French Ultramarine Blue

Burnt Sienna Burnt Umber

Winsor Blue (Red Shade) Winsor Green (Red Shade)

ADDITIONAL COLORS

Cadmium Red Light Ivory Black

Permanent Rose Cobalt Blue

Brown Madder Yellow Ochre

Winsor Yellow Raw Sienna

These color charts show my recommendations for starting colors.

doesn't prevent you from getting to know lots of other people. In fact, good friends can become the standard by which new acquaintances can be evaluated. That's true of color also.

So choose your "inner circle" of colors and then get acquainted with as many others as you like. The color charts on this page show my recommendations for starting colors.

HERE'S A TIP

Remember:

- If you use dirty water to dilute a pigment, you will dull (neutralize) the color. This can work in a positive way if you *want* the color dulled.
- If you use clean water to dilute a pigment, you will lighten the hue. This is called "making a tint."

PRACTICE! PRACTICE! PRACTICE!

This exercise will help you develop your insight into the hue characteristics of watercolors.

1. Paint a one-inch (or larger) square of French ultramarine blue.
2. Dry it with a hairdryer.
3. When it is completely dry, paint a half-inch wide outline around it with Winsor (pthalo) blue.
4. You may have thought French ultramarine blue was a warm blue. Does it still look warm?

5. Next, paint a one-inch square with Winsor blue and this time paint the half-inch border with French ultramarine blue. How do these hues interact? Which color is dominant now?
6. Continue this exercise with the following color combinations:
 - Winsor yellow and new gamboge yellow
 - Winsor red and cadmium red light
 - Burnt umber and burnt sienna

Be sure to paint two versions of each combination.

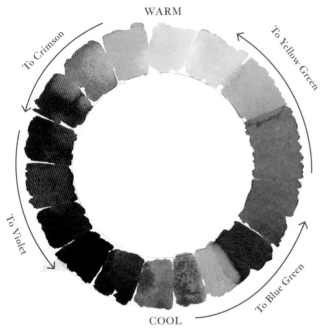

WARM

To Crimson

To Yellow Green

To Violet

To Blue Green

COOL

Within every area of color, you have a warm version and a cool version

Warm and Cool Colors

Within every area of color, you have a warm version and a cool version.

You'll hear me say "warm" and "cool" in reference to color many times in these lessons, so it would certainly be a good idea to get these concepts separated and understood before we go any further. Just as in studying a new language, you may be unsure and have to stop and think a bit as you use these words in regard to the colors you mix and their appearance in your paintings. But the more you paint, the easier judging the relative warmness and coolness of a color will become.

Let me go over the basics again. The colors on the red-yellow side of the wheel are generally called "warm" and the colors on the blue side of the wheel "cool." And within every color, you can have a cool version and a warm version. But don't let that make you nervous; we'll discuss *relative color*

in Lesson 16. For now, just be aware that red with some blue mixed in is a "cool red" (such as alizarin crimson) and red with some yellow mixed in is a "warm red" (such as cadmium red light). A cool red, however, is always warmer than a warm blue.

As you can see from doing the practice exercise on page 128, color can play tricks on your eyes. I'm going to give you a few more generalizations about the effects of warm and cool color, but I'd like you to keep in mind that art is full of exceptions to virtually every generalization.

- Warm hues tend to increase the apparent size of an object.
- Warm and dark hues make objects advance (come forward), while cool and light hues make objects recede into the distance. Buildings in the far distance are usually painted in cool, light hues, no matter what color they actually are. A common mistake of beginning painters is to put the houses they can barely see off in the distance into varieties of red and yellow.
- Using related hues next to each other softens outlines.
- Using contrasting cool and warm hues next to each other sharpens outlines.
- A close contact of warm and cool hues attracts the attention of the viewer.
- Warm hues are stimulating; cool hues are calming and placid.

HERE'S A TIP

Whether the hue is warm or cool, a dark value surrounded by light values tends to advance, or come forward, in the painting.

Twin Tugboats

The interaction of warm and cool color plays an important part in creating the impact of the *Twin Tugboats* painting above. The warm, high-chroma red of the cabins next to the dark, neutralized green of the hulls advances the boats toward the viewer. It's as if you could almost step aboard. The cool blue of the foreground water near those red-hot cabins screams for attention. Now look at the distant shore: light, neutralized purple with the houses barely indicated.

Staining and Nonstaining Colors

Some beginning artists are fearful of watercolor. "It's too hard," they say. "You can't cover up or erase your mistakes."

This is somewhat true and somewhat untrue. Because watercolor is a transparent medium, it is not possible to eliminate a color or an object by simply painting over it. In fact, you can't even make a color lighter by painting over it. Every new application of paint darkens the value— sometimes just a bit, sometimes a lot.

Let me explain this challenge with a comparison to oil painting. On canvas, you can easily paint a whole composition in shades of blue and, after it dries, you can paint right over it with other colors wherever you want. No one (except an art historian with lots of high-tech equipment) will ever know there was a blue underpainting as long as the new layer of paint

is thick enough and covers the entire surface. If you were to do such a paint-over in watercolor, the viewer would see all or most of the underlying colors and shapes. In the watercolor medium, painting over a color changes the original color, but does *not* wipe it out.

Use this simple line drawing for the painting exercise discussed here.

Copy this simple drawing, indicate a light source, then create two paintings.

In the first one, use the primaries in Color Wheel A in the last lesson (page 122) and mix the needed secondaries. Remember: one primary should be dominant.

In the second painting, use the primaries in Color Wheel B, mixing the secondaries. Again, use one dominant primary.

This exercise is not easy. First you must indicate a light source. Then you will have to assign value and color to each plane in the painting. You will have to decide which areas will have high chroma and which will be done in neutralized colors. But try to do it. You'll be surprised at what you'll learn.

But this transparency does not mean that watercolor painting is uncorrectable. Many errors can be "lifted out" with water and a little scrubbing. However, many colors are "staining" to a certain degree. Staining colors leave a residue on the paper that cannot easily be removed.

WORDS TO REMEMBER

- Viewers respond more consciously to color than to any other aspect of a painting.
- Each watercolor pigment has a personality, including temperature, transparency, tendency to stain, and tendency to advance or recede.
- Each artist must find the pigments that work best with his or her particular vision.
- The relative "temperature" of a color (warmer or cooler) is really a matter of its relationship to other nearby colors.
- Some pigments stain the paper more than others, but many watercolor mistakes can be corrected.

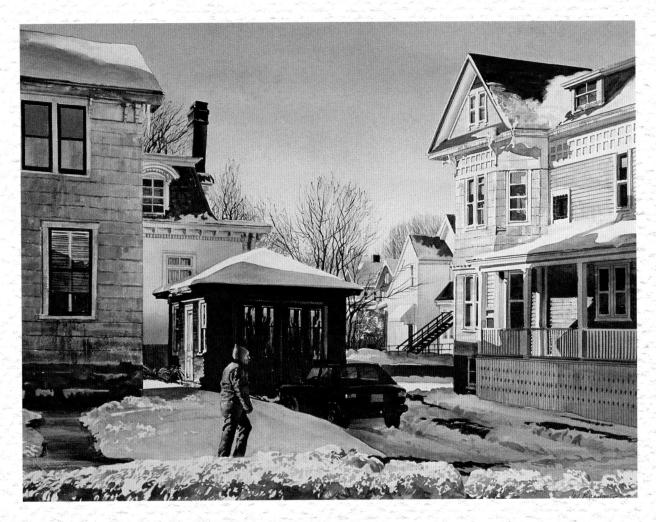

William & Granite, New London, CT

To live a creative life, we must lose our fear of being wrong.

—JOSEPH CHILTON PEARCE (1926–),
American author

Not every color comes from a tube or a block. Look at the houses in *William & Granite, New London, CT* on page 133. The wall of the house on the left (in shadow) is a play of subtle light, but can you name its color? The lit surfaces of the house on the right are yellow, but what shade of yellow? The winter sky above fades into the horizon, but what colors were used and how were the varying degrees of fading created?

You are the one who chooses and creates the colors you want in your paintings. Fortunately, watercolor is the perfect medium for mixing your own colors. You can mix on the palette or on the paper. Too much mixing, however, can ruin an otherwise fine painting.

In class I once said, "I think the genes for the good watercolorist and the good cook must be a lot alike. Not to pat myself on the back, but I personally love creating in the kitchen." Everyone in the class seemed to be thinking "really?" So I had to go on a bit and explain my premise.

I believe that certain personality traits are important to both good color mixing and good cooking. Each endeavor has its rules and, in each, rules can be adjusted. Of course, when one is adjusting, the risk of making a mistake goes up. But we learn and grow from those mistakes and we find out how to fix things, too. Did you know, for example, that you can fix a dish that's too sweet just by adding a touch of lemon juice? Fixing watercolor mistakes is not always that easy, but some mistakes can be washed out by rubbing with a stiff bristle brush or picked out using the tip of a single-edge razor blade.

If you sometimes come up with new techniques, new colors, unusual perceptions of your subject matter, or anything else "not in the book" and you try things out, you may indeed have some corrections to work on or you may end up discarding some otherwise pretty good paintings. But what creative person hasn't crumpled and discarded a good deal of his or her work?

Let's take the cooking-color mixing comparison a little bit further. Both have recipes of a sort. Two tablespoons of butter, two tablespoons of flour, and one cup of milk creates a basic white sauce; one part blue, one part red, and a touch of yellow gives you deep purple. If everyone followed these recipes exactly, art and cooking would be consistent, more like manufacturing than creating. Everything would be standardized, like frozen dinners or mass-market art prints.

Some people are guided by the rules but still excel in mixing, whether in the kitchen or the studio. Using the same basic knowledge, they are able to create outstanding dishes or particularly appropriate colors. What are the human characteristics that prompt an individual to go beyond the measured formula, to strive for an excellent working relationship between form and color, to try something new, to create something unique? I believe the artist (watercolor or kitchen) needs:

- Panache: the word *panache* comes from Middle French, when it described a big feather on a hat or helmet. In today's English, it means "dash or flamboyance in style or action" or simply "verve."
- A bit of derring-do: this term comes from Middle

English and means, literally, "daring to do."

- Courage that is born of a belief in oneself. Courage is not a word often heard in the art world (or the kitchen). But it takes courage to try something new or to give "maybe" a chance, to take a stab at something when you don't exactly know what the result will be. Watercolor and the art of cooking demand the courage to create.

The good cook is not afraid to taste and add a bit more seasoning. The good watercolorist is not afraid to take a second look and add a bit more red or blue or yellow. The mastery of mixing is a learned skill that must be combined with personal fearlessness. And if you make the wrong choice? The world does not end.

The "Right" Answer

Very often in class, I'll be demonstrating a technique for handling some aspect of a painting, let's say a sky, when someone will call out, "Excuse me, Mr. Bonamarte, but what colors did you mix to get that shade of blue?" He or she wants me to stop and name the colors and proportions that I mixed while the wash I am doing is literally running down the vertical paper on the easel. This type of question is usually asked by a person who wants to be told what to do in order to achieve success. The questioner wants to know *exactly* what colors I used so he or she can copy me and "get it right." Mixing color doesn't work that way.

Choosing and mixing color is the most personal aspect of art; it relies strongly upon individual preferences. This lesson cannot provide you with all the "right" answers to all your color-mixing problems. It is simply a good beginner's guide—you will have to learn what works for you by trial and error. Learning to be an artist is an ongoing educational process, and all education is really self-education.

HERE'S A TIP

Boldness—a fearless approach to putting brush to paper—is always a plus in watercolor painting.

The Munsell System

Albert Henry Munsell (1858–1918) was an American artist, author, teacher, and the inventor of both instruments and terminology for color measurement and discussion. His standards have been accepted worldwide. He is responsible for our concepts of hue, value, and chroma. Other derivatives of his work include the commonly used terms *tint*, *tone*, and *shade*.

ARTFUL MEANINGS

- A *tint* is a lighter version of the color you start with. In watercolor painting, a tint is produced by adding clean water to the color. (In oil or acrylic painting, a tint is produced by adding white.)
- *Tone* is a term used loosely in the art world. Most often it refers to the relative value of a color. Sometimes, however, it is used to discuss the intensity of the color. Tone is achieved by adding gray to the color you want to neutralize.
- A *shade* is produced by darkening the color you start with. Most watercolor artists recommend using the color's complement or near complement to create a shade. Black will also do the job, but the color will lose some of its luminosity since black blocks the reflection of light from the paper. However, keep in mind that black can make some beautiful low-key colors, such as maroon (which is red mixed with some black).

Munsell is considered the "father" of the artist's color system. There are a number of books on the market that discuss Munsell's systems, and you can still find his books in libraries. We artists owe him a nod or perhaps a hats-off of thanks, but be aware that just studying words and pictures is not enough to call yourself an artist. You must do the job. Each color you mix should work well in a specific place in a specific painting. That sounds easier than it actually is.

Take tints, for example. You're only mixing a color with water! That should be easy enough. Not exactly: You need to control the quantity of water and the movement of the brush. Look again at the sky in *William & Granite* (page 133). You need tint-control to make the sky lighten gradually.

Now consider shades. Everyone agrees that a shade is darker in value than the original color. But is it *warmer* or *cooler* than the original color? It can go either way depending upon what you need and

what you mix. That's why we say "a shade of red" for example. There can be many shades, each a bit darker than and different from the original color. Adding ivory black both darkens and neutralizes a color.

To make things interesting, watercolor has more ways to create hues, shades, tints, and tones than can be written out in any one-volume book. You can mix color on the palette, directly on the paper while the paint is still wet, or by painting over a color that has already dried on the paper, called glazing. The results are not always what you expect. Sometimes the surprise is awesome; sometimes it is disappointing, even to professional artists. But remember: mistakes and disappointments help you grow.

With practice and patience, you'll get the hang of which colors work in what ways, how to mix them, and how best to work with what you have.

Mixing On The Palette

By mixing your color on the palette before applying it to the paper, you will be more likely to have a consistent color throughout. Be sure to mix enough pigment for the entire area you wish to paint, as well as a little extra for possible use elsewhere. It is very difficult to duplicate a mixed color after you have run out of paint.

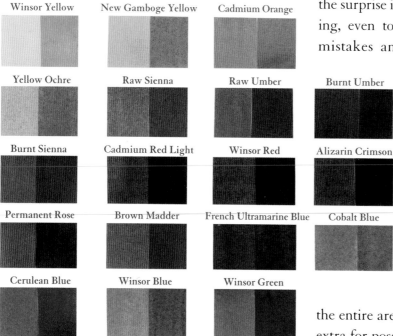

Before and after adding a "touch" of black to these colors on my palette.

You can use the center of your palette to mix your colors.

Be certain to use clean water to achieve tints. In fact, you'll want to wash and refill your clean water jar often. You'll also need a dirty water jar that is often emptied and refilled for thoroughly rinsing your brush before dipping into another color. Otherwise, you will bring traces of other colors into your mixture from the dirty brush and water.

So how often should you change the dirty water jar? I have a confession about that: I often use the dirty water to dull a pigment when I want a more neutralized look. This is a bit risky, but it usually works. So how grimy can you let the water get? It's up to you, but don't let it look like a muddy puddle on the roadside.

When mixing on the palette, bear in mind that wet pigments will mix together more thoroughly and accurately than pigment that has dried and been reliquefied. This is why I prefer tubes to solid watercolor blocks. However, having tubes doesn't always solve the problem since many artists allow the tube colors to dry out in their wells. Also, many artists add water to custom-colored paint that was mixed on the palette and has dried. The result may or may not be disappointing. The likelihood of getting exactly the same color by adding water to a dried mix is slim.

The Compound Wash, a.k.a. Glazing

Unique to watercolor is the method of mixing colors by thinly painting over a color that has already dried on the paper. This technique is only possible because of the transparency of the medium. It is called glazing or compound washing.

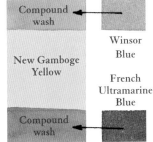

One hue (new gamboge yellow) showing two different techniques for mixing colors: compound wash and wet-on-wet.

Look at the top of the exercise sheet on the previous page. It demonstrates compound washes using new gamboge yellow as the first color that has been laid down. To the right of the rectangle of yellow are the colors used in the glazing.

Mixing Wet on the Paper

The technique of putting two colors into the same area consecutively is called *wet-on-wet*. To make it work, you must have a plan and execute it quickly. Usually, you work on damp paper. Apply the lighter color to the paper first. While it is still wet, paint into it with a second color. The two colors meld together to form another color or colors.

Using wet-on-wet, you will achieve subtle and varied changes within a color area. Brush pressure, the movement of the brush, the wetness of the paint, the wetness of the paper, and the ratio of pigment-to-water can all cause mixtures to vary rather than create a consistent color change over the entire area on which you are working.

ARTFUL MEANINGS

- *Compound wash* and *glazing* are terms used interchangeably in watercolor painting. To do a compound wash, the artist lays down a color and waits for it to dry. Then he or she covers that color with another color, producing a third color.
- *Wet-on-wet* is a watercolor technique that creates soft edges and melded colors. Using damp paper, the artist puts down one color into appropriate areas. Then he or she adds one or more other colors, again in areas that seem appropriate. The colors run together, the edges blend, and new colors are sometimes created. Sometimes water patterns and stains are created too, which the artist may or may not like.

Painting wet-on-wet is a delight to many artists. The runs of color, however, are often beyond the artist's control and uncontrolled patterns are anxiety-provoking for many students. My best advice is to keep working at wet-on-wet if the results appeal to you. You may think the technique is too uncontrollable, or you may be delighted with what the paint and water can magically do together.

Night Scene in Winter

The background of this painting was done using the wet-on-wet technique. Notice the soft edges and subtle movement of color. To do this, I wet the background section of the paper, being very careful to work around the area I would later paint as the roof. It was important that the roof area remain dry while I was painting the sky area, so that its crisp edges will come forward. (If you are uncertain of your ability to keep a straight line to your application of water to paper, you can use masking fluid. See page 26 in Part I.)

The house and foreground were painted on dry paper. Compound washes were used for the shadow areas. White paper was left untouched

PRACTICE! PRACTICE! PRACTICE!

Choose one or more of the exercise paintings you've already done and do another version. (Or you can copy the night-scene painting on the next page.) Use the wet-on-wet technique for the background and compound washes for shadow areas.

Don't be disappointed if you don't get perfect results. This is an exercise to teach technique; getting good at it takes time. On the other hand, you may just be surprised at how different from your original attempts this painting looks!

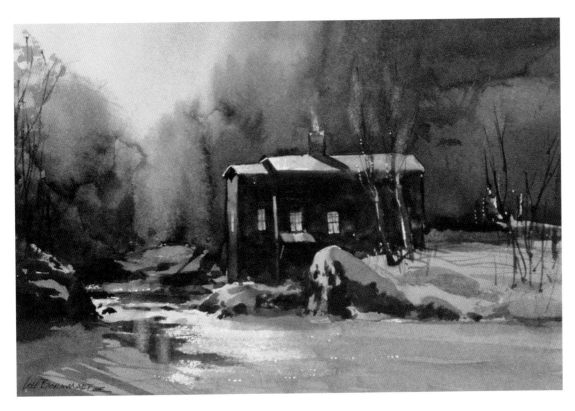

Night Scene in Winter

for some of the highlights; others were picked out with a razor edge. The windows were painted using new gamboge yellow with a compound wash of diluted burnt sienna for shading.

A Bit of Colorful Advice

If you are feeling overwhelmed by all the possibilities of color in watercolor painting, take a deep breath. Everyone is. After forty years of teaching, I'm *still* learning; I'm *still* surprised sometimes; and I *still* throw out versions of my work. (Other artists do, too. Before the computer put the "delete button" into frequent use, my coauthor says she threw three sheets of paper in the wastebasket for every one she sent to the publisher.)

Try to delight in what happens when you experiment, and try not to expect every project to be worthy

of the National Gallery. And, for goodness sakes, don't set *perfection* as your standard. Two centuries ago a very great artist, Eugene Délacroix (1798–1863), said, "Artists who seek perfection in everything are those who cannot attain it in anything."

RELATIVE COLOR

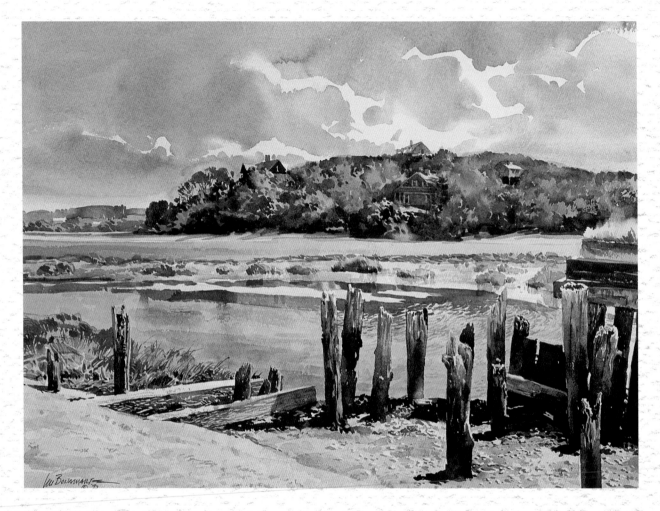

Cape Cod Inlet

Every artist dips his brush in his own soul, and paints his own nature into his pictures.

—HENRY WARD BEECHER (1813–87),
American clergyman and abolitionist

've already mentioned that color is the joy of the watercolor artist. It's a statement worth repeating. But the awe and wonder of color is also full of trickery and challenge. The same color will look different when it's adjacent to different colors. What appears to the eye to be a high value in a particular painting might actually be a high-chroma, medium-value color. A hue of medium or medium-dark value on the value scale could be a relatively high value in an actual painting.

We've talked about the awe and wonder aspects of color, now let's look into some of the trickery and challenge that's involved in creating an eye-pleasing painting. Here's a question for you: What is the dominant primary in the painting *Cape Cod Inlet*, left?

Influenced by the beautiful weather in the scene, many people quickly answer, "blue"! But it's not blue. If you eliminate the clouds and the reflections, there really isn't a large area painted in blue and the blues that *are* in the painting are rather neutralized. The dominant primary in *Cape Cod Inlet* is actually yellow.

"Hold on!" you say. "There's no yellow in the whole painting!"

You've forgotten about the color wheel and the value scale. There is yellow in this painting, in a variety of hues and values. The yellow in the middle-foreground has just a touch of blue in it, making it lean to the green side of the wheel. In the foreground is a high-value yellow ochre, which is a somewhat neutralized hue. Small areas in the trees and in the foreground gravitate toward the yellow-orange side of the wheel. The neutralized blues against these yellows help the artist create the play of light in the scene and thus capture the beauty of the day on paper.

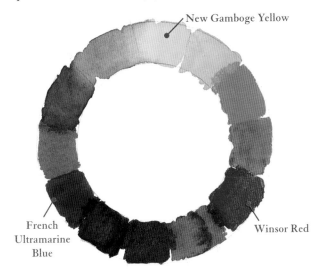

New Gamboge Yellow

French Ultramarine Blue

Winsor Red

On the left is a color wheel created using the three primary colors marked in the illustration. On the right are all the colors as they appear on my palette.

Yellow is the strongest color on the palette and it always catches people's attention. The three paintings I'm going to talk about next all have a strong use of yellow, but its dominance is tamed by the way it's positioned on the picture plane and by its relationships to nearby colors. Once you understand the relative effects of yellow in these three examples, you'll be able to apply your knowledge to other colors. As I said, yellow is the strongest hue, and therefore the most difficult to work with.

The Lemon

The lemon in the still life *Tea for Two*, bottom left, has areas about as high in intensity as yellow can get, which is pretty intense. In addition, it's a semi-circular shape and circle forms always draw attention. So why doesn't the yellow lemon grab the eye and hold it on the left of the painting?

The tricks (or perhaps I should say the "artful strategies") in this painting lie in value and color relationships. In most paintings, the lightest hue (here, the cut lemon's rind) would be the highest value. This is almost so in this painting, but there are many more factors to be considered. This lemon stands against a white teapot, which is the largest mass of any value in the painting except the background. This white, the highest value in the painting, is also repeated in the highlight of the cup.

Tea for Two

Against this white, the lemon steps down a bit, although it's still pretty intense.

Another reason the yellow of the lemon doesn't hijack the viewer's eye is because another yellow on the other side of the painting balances the composition. Look at the box on the right side of the painting. Although it looks tan at first glance, it's actually primarily yellow ochre, a member of the yellow family. You can also see yellow's relatives near the base of the cup, as well as just a hint of the hue in the warm reflected shadow at the bottom of the teapot. And, of course, yellow ochre is the dominant color of the handle of the teapot, which serves the important function of completing the circular eye path. (We'll talk more about eye path later in Lesson 24.)

Tea for Two is not a painting about tea or a yellow lemon. It is a painting about color and balance. The three primaries form a triangle close to the center of the painting: yellow lemon, blue cups (both warm and cool blues are used), and red flowers. Notice that all three complements are also included: light purple cellophane inside the cup, orange in the lettering on the vase, and green on the top of the vase and in the flower stems. The painting vibrates with the competition of colors. No single one wins (yellow puts up a good fight but plays fairly), and together they create an enticing composition.

The Sunset

As I said, yellow is a dominant color and, consequently, it is also a dangerous color. Too much of it can ruin the balance of a painting. So *Cityscape at Sunset* was a risky scene to paint. In a way, it *is* a painting about yellow, unlike *Tea for Two*.

So what makes *Cityscape at Sunset* work? The most intense yellow runs horizontally across the painting, just below the midline. Its effect is tempered by its close cousins, orange and red, but the overall drama is increased by the use of yellow's complement, purple, at the top and bottom of the painting. The sky almost trembles with the quick transition.

The yellows at the horizon line and the highlights on the buildings are made even brighter by the dark silhouettes of the buildings. The foreground is a neutralized and higher-value version of the sky area directly overhead of the viewer.

Cityscape at Sunset

The House

One would think a big yellow house as the only object in the center of a painting might be a bit boring. Not this yellow house. What makes it work?

First, it's pleasant to the eyes. The yellow is not a high chroma yellow, even though it is a relatively high value. The mix is new gamboge yellow with some yellow ochre. Burnt sienna and burnt umber are lightly dragged through the yellow to simulate boards. All these colors are close on the color wheel and therefore family members, sort of like cousins. The result is an eased intensity. (Imagine the house painted with the yellows in *Tea for Two*!)

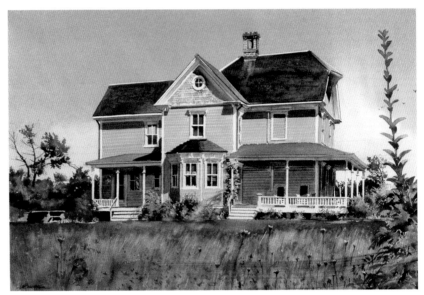

Yellow House

In this painting, the color of the porch roof is almost as important as the color of the house. The warm-but-subdued red of the roof is yet another relative of

ARTFUL MEANINGS

- ***Relative color*** has several meanings in the art world: there are *relative colors* and there is *relative color*.
- ***Relative colors***, or ***related colors***, are those having a relationship or mixing connection with each other. They are usually in the same area of the color wheel. They may be a different manufacturer's hue, they may be more or less neutralized, they may be of a different value, or they may be colors mixed from adjacent colors.
- ***Complementary colors*** also have a relationship. Sometimes they fight, sometimes they love. Blue and orange in equal amounts and standing adjacent to one another in the center of a

painting will fight, each demanding attention away from the other. On the other hand, a yellow shape with a purple shadow can appear serene, the shadow securing the yellow object on the picture plane. When discussing complementary colors, some teachers use the oxymoron ***friendly opponents*** to describe their relationships.

- ***Relative color*** is an area of pigment considered in relationship or proportion to something else. Relative color also refers to the *appearance* of a color in its surroundings. The exact same color can appear warmer or cooler, darker or lighter depending on the adjacent colors.
- An ***analogous color palette*** is a palette limited to colors on only one side of the color wheel.

the yellow. The entire central object of this painting is in harmony, the rich warm hues bounded by the neutral brown-black upper roof and the white trim. The background is another primary, blue. The foreground greens are relatives of both yellow and blue.

The Dominant Color

Most paintings have a dominant color. Even *Tea for Two*, which is a painting that intentionally uses all three primaries and their complements, has yellow as a dominant color.

Choosing and using a dominant color that works well aesthetically in a painting is a matter of balance. Part of the path to success is using a limited palette. Choose one color, choose some neighbors on the wheel, and then choose some complements. In this manner, color will help unify composition.

When all the major colors are used equally in a painting, the work usually becomes disjointed and can be stressful to the viewer. Having said that, I must add that there are exceptions created by the skilled and well-practiced hand. However, for beginners, using too many colors often breaks apart an otherwise fine painting.

We've talked about the dominant yellows in *Yellow House*, *Cityscape at Sunset*, and *Tea for Two*. Now let's look at two marine paintings with different color relationships. You don't need me to tell you that the

dominant primary color in *Winter, Camden, Maine* is blue. The painting is in a high key, but its chroma is muted as the blues move into violet. Against the violets, the complementary yellow inside the boats is dramatic, even though it's neutralized.

The viewer hardly realizes the electricity created by the yellow hue. The insides of the boats are warm and inviting at the bottom of the picture plane. But the boats point into the painting, where cool colors take over. How often complements are used and how much space they take up in a painting is a matter of personal taste. Sometimes the smallest amount of the complement is most effective. Sometimes two complementary colors are used in a painting extensively and have to vie for position and power. It all depends upon the effect the artist wants to convey.

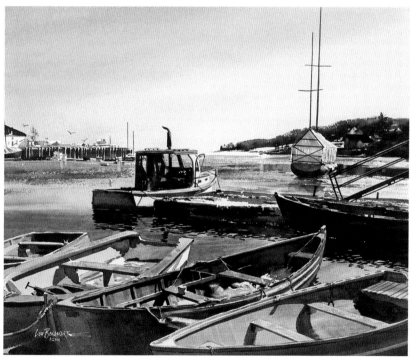

Winter, Camden, Maine

Eastern Point Lighthouse is done in a lower key than *Winter, Camden, Maine*. Neutralized grays are dominant in the sky, the granite walkway, the shadows, and the sea. The focal point is still emphasized with color, however. Look at the red roofs, neutralized in harmony with the rest of the painting, but still definitely a warm red. The orange-browns of the rocks are also neutralized but still warm. The browns and the reds are separated by red's complement, green. The tension of red and green across the central area of the painting creates as much drama as the angry sky and sea.

Another complement pair in this painting is less obvious but just as powerful. Do you see the yellow ocher (a complement to the gray-purple of the painting) in the reflected-light side of the lighthouse? How about under the eaves, in the grass, and in the spray of the crashing wave? Now look at the sky. It isn't completely gray, is it?

A quick glance says there's no yellow in this painting, but we can now see that's not true. Without the relative colors of yellow, gray, and purple, this painting would be dull and dark, without movement.

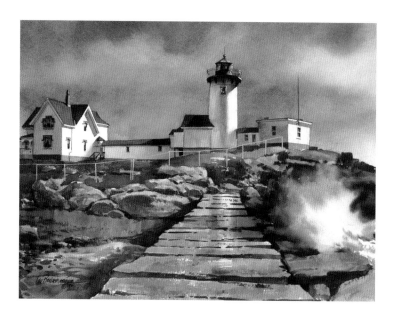

Eastern Point Lighthouse

The Power of Your Palette

The colors you choose for your palette will dictate the moods and effectiveness of your paintings. Be careful to choose colors that will express what you are trying to convey through your art.

MONOCHROME

Many art instructors like to start their students with a monochromatic palette. Some students object, wanting to dive right into luminous colors. They know that a monochromatic palette will produce low-intensity paintings, with everything muted by black or a mixed dark for the shadows.

So why do teachers want to start without an array of color? Because painting in monochrome builds a stronger foundation, allowing students to get to know the potential and problems of one or two colors before moving on. It's also a great way to study value relationships, which are the very backbone of art. And it helps keep you from learning bad color-mixing habits since you'll learn to mix and use tints and tones before you can make muddy multi-color combinations.

You can choose any color for your monochromatic painting exercises. Most students find yellows the most difficult to handle and French ultramarine blue and burnt sienna the easiest. When you do your practice paintings, be sure to use the white paper for the highlights.

While learning to paint in monochrome, don't worry about the appropriateness of the color to the object. (If you are painting in red, for example, your grass will be red. Just dull it down with a mixture of French ultramarine blue and burnt umber.)

ANALOGOUS COLOR PALETTE

If you wish to try using an analogous palette in several paintings or as a painting style, always choose a dominant color. This advice is especially important when you are doing floral paintings. (And it is the same advice given by professional florists to students in flower arrangement classes.) A dominant color gives focus and strength to your painting.

PRACTICE! PRACTICE! PRACTICE!

Use this simple line drawing for the painting exercise discussed here.

Copy this scene and paint it using only one color and either black or a mixture of burnt umber and French ultramarine blue. Do it again with another color. Then again. Be sure to use the techniques for mixing that you learned in the last lesson. How do your three paintings compare for mood and impact?

Now paint it again using an analogous palette (three or four colors next to each other on the wheel). You can still use black or the umber-blue mixture to darken the hues. Paint it one last time with one dominant color but all the colors of the wheel available.

Once you have chosen your dominant color, allow yourself to use the related colors on the color wheel in various positions on the picture plane. As always, you can use black or the umber-blue combination to darken the hue.

For more versatility, choose a complement of the dominant color and give it a space on your palette with the analogous colors. Use it only where it will be most effective in creating focus and tension. You'll be surprised at the interesting effects you can get.

THE THREE-PRIMARY PALETTE

The three-primary palette has a lot more than just three colors: it is the full palette of the artist. As I said earlier, having the three primaries available means there will be six pigments on the palette because you should have a warm and cool version of each primary. You can mix all the secondaries and tertiaries with the three-primary palette. Most artists, however, include store-bought colors for the secondaries green, purple, and orange, and also for many tertiaries. The full palette also includes neutralized and mixed colors such as yellow ocher and burnt sienna. In the next chapter, I'll talk about my palette and how I use it to produce paintings as different as *Tea for Two* and *Lighthouse in a Storm*.

Everything is Related

When you're ready to create a full-color range painting completely on your own, decide on a dominant color and then choose other colors within its family for use in appropriate places. Next choose some complements to add emphasis and drama to bring the work together in an eye-pleasing way.

You will need to think about the key (high or low), the value structure, the subject matter, the focal point, the relationship of planes and masses, the highlights, and the eye path. (To do that you're going to have to read this whole book, of course.)

Whenever you paint and in whatever color spectrum you choose, always remember that you are trying to get a unified whole on your picture plane. Besides color, think about the rhythmic repetition of warm and cool areas, the effects of light and shadow, and the need for perspective. The secret, or artistic strategy, for success is to remember that *everything* is related. Understanding relationships is an essential element of becoming an artist.

WORDS TO REMEMBER

- Color is full of tricks on the eye and challenging choices.
- The dominant color in the painting will have a relationship to each of the other colors.
- Complementary colors used close together create stress and drama.
- Analogous colors used near each other quiet the impact of a single color.
- You can choose your color scheme from many possible palettes: monochrome, limited, analogous, and three-primaries full palette.

THE BONAMARTE PALETTE

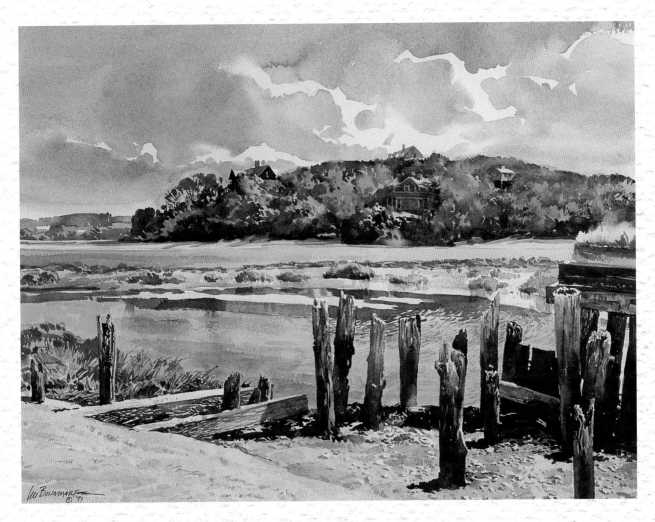

Cape Ann Harbor

Let each man exercise the art he knows.

—**ARISTOPHANES** (c. 446–386 BCE), Greek playwright

While painting *Cape Ann Harbor* (page 149), I used all the colors on my palette. Are you thinking that it doesn't really look that way? Well, the dominant color is blue, and both warm and cool blues are used, changing into violets in several places. Both red and green move across the center third of the picture plane. And below the reds, there are yellows and umbers. I can't help but think of Santiago in the movie adaptation of Hemingway's *The Old Man and the Sea*: "Think what you can do with what you have."

My Way

In the next two lessons, I want to share with you the discoveries and decisions I have made about color. The use of color is as distinctive to the watercolor artist as fingerprints are to individuals. Color is at the peak of the artistic pyramid, which means that it depends upon everything else for optimum effect.

Light enables us to see. Value allows us to transpose what we see onto the two-dimensional plane. Perspective helps us portray an image that appears to coincide with reality. Composition allows us to build value relationships into an aesthetically pleasing arrangement. Color creates the magic that allows us to capture a unique perception and share it. Every artist must choose the colors that work for him or her.

ARTFUL MEANINGS

The **Pike Palette** was developed by John Pike, an American who worked in many visual-arts media, in the 1960s and is still being used extensively today. It has twenty wells arranged around three sides of a rectangle (for a visual example, see page 23 in the Tools and Supplies section). Its design is the product of many years of experience and experiment.

Forty years ago, I was a young artist building an identity. I enrolled in a watercolor class taught by John Pike in Woodstock, New York, and I came away with admiration for his work and a belief that the colors in his working palette were the "right" colors. For a long time I taught classes using the Pike Palette and Pike's selection of pigments. The colors he used were French ultramarine blue, Winsor blue, Winsor green, Winsor red, burnt umber, burnt sienna, alizarin crimson, new gamboge yellow, and ivory black.

Over a period of time as my own work developed, I began to feel a little uncomfortable with Pike's palette arrangement. I found that it was somewhat high key for my intentions as a watercolor artist. Gradually, I added other colors to suit my needs and to allow me a more versatile approach.

My choices were not random. Like a good coach putting a team together, I made my selections based upon pigment strength, personality, and appropriateness for the job to be done. The job of each color (its "position on the team") requires both strength and versatility. Here are the choices that I've made for my basic palette. Other pigments may be added as needed for specific purposes.

YELLOW FAMILY

Winsor yellow has no red in it. It is like lemon yellow: intense, transparent, and staining.

New gamboge yellow contains red. It is warm, transparent, and permanent.

Yellow ochre, an earthy yellow, is warm and opaque, and very permanent.

Raw sienna is another warm, earthy color, but stronger than yellow ocher. It is very permanent and somewhat granular.

RED FAMILY

Winsor red has a slight blue cast. A cool hue, it is permanent, transparent, and staining.

Cadmium red light contains yellow. It is warm, permanent, somewhat opaque, and staining.

Venetian red is an earth red, actually red-orange in hue; it is extremely permanent, opaque, and staining.

Cadmium orange is a somewhat opaque tertiary.

Alizarin crimson is a red with blue tones. It is transparent and staining.

Permanent rose is a bluish crimson, transparent and staining.

Brown madder alizarin is an earthy, low-key crimson that is transparent and staining.

BLUE FAMILY

French ultramarine blue has a touch of red in it. It is transparent and somewhat granular.

Cobalt blue is a pure blue, transparent and somewhat granular.

Winsor blue, similar to **pthalo blue**, is transparent, staining, and comes in two shades (red shade and green shade, depending upon which side of the color wheel the hue is located).

Cerulean blue is opaque, granular, and much like Winsor blue, with a red shade in hue.

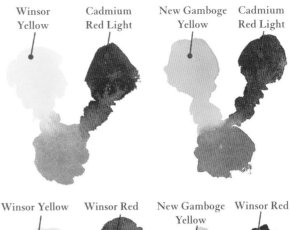

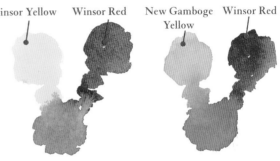

If you want just the right orange, you must carefully pick your red and your yellow.

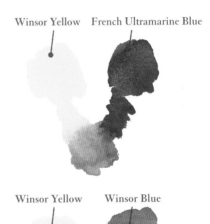

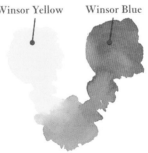

When mixing green, you've got to know what blues can do.

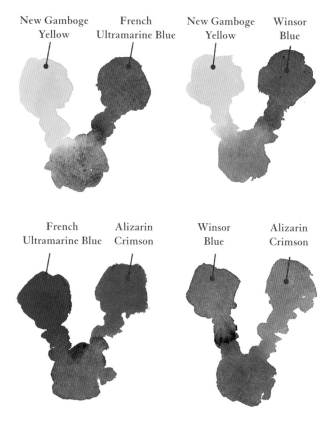

New Gamboge Yellow — French Ultramarine Blue

New Gamboge Yellow — Winsor Blue

French Ultramarine Blue — Alizarin Crimson

Winsor Blue — Alizarin Crimson

New gamboge, with its hints of red, creates a more neutral green. Winsor blue (green shade) creates a more neutral violet.

Winsor green is transparent and staining; it has a blue shade and a yellow shade.

EARTH COLORS FAMILY

Burnt sienna is transparent and warm, with red undertones.

Burnt umber is also transparent and warm, but darker brown than burnt sienna, and a bit cooler than raw sienna.

Raw sienna is a low-chroma primary color that is translucent and granular.

Raw umber is a cooler, darker, and grayer version of raw sienna.

Ivory black is cool, opaque, and granular.

These swatches show all my colors shaded with a touch of ivory black.

HERE'S A TIP

Red has a tendency to appear rather gray when diluted with water. To capture the effect of sunlight in lighter values of red, add a little yellow.

French ultramarine blue and burnt umber make a cool gray. If you want a warmer gray, add just a touch more of burnt umber.

A Place For Everything

The wells on a watercolor palette are designed to keep pigments both separate and available to the artist at the same time. Keeping colors from mixing with each other, however, can be almost as difficult as keeping sand out of the beach-resort swimming pool. Just the touch of a brush with French ultramarine blue on it can change the color of an entire well of cadmium red light, for

example. But the effect of a random touch is less disastrous when colors in adjacent wells are also adjacent on the color wheel.

Look at the painted sample of my palette below. It is divided like the color wheel. Across the top are the yellows. Down the right side are the reds, with one space reserved for black. And down the left side are the blues, with a space for green at the top and a space for violet at the bottom.

Why does this work for me? For the very same reason it works for most of my students: It is an ordered progression of related hues. In addition to allowing the artist to see families of color together, it helps keep the colors from being contaminated in their wells. A drop of Winsor yellow into the new gamboge next door will not do noticeable harm. Nor will a drop of alizarin into the cadmium red light, and so on.

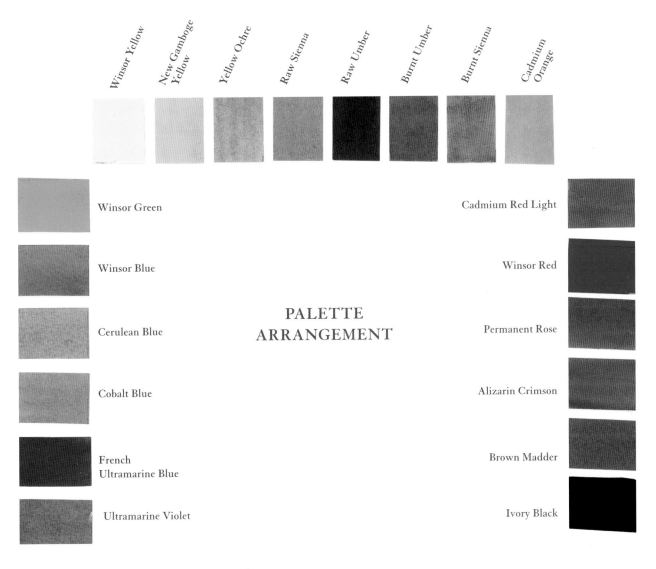

Winsor Yellow · New Gamboge Yellow · Yellow Ochre · Raw Sienna · Raw Umber · Burnt Umber · Burnt Sienna · Cadmium Orange

Winsor Green

Winsor Blue

Cerulean Blue

Cobalt Blue

French Ultramarine Blue

Ultramarine Violet

PALETTE ARRANGEMENT

Cadmium Red Light

Winsor Red

Permanent Rose

Alizarin Crimson

Brown Madder

Ivory Black

This is my palette arranged for maximum efficiency.

Some students write the names of the colors in indelible ink on the outside edge of their palettes. This is not as good an idea as it seems. Remember, you may want to change the entire palette for a particular painting. It is generally better to paint a palette plan for yourself like the ones in this lesson. Keep it with you for reference when painting until the colors become so familiar that you recognize them instantly.

High Chroma and Low Chroma

My palette is a little like an orchestra. Although every instrument in an orchestra can play the same note, each plays it with different character. Likewise, every color in my palette can have high value and low value, but each has its own hue, chroma (intensity), and personality. We've already mentioned warm and cool color families and warm and cool versions of a single color. But we haven't discussed the chroma of my palette yet.

Just as I have warm and cool hues, I have a palette that contains high chroma and low chroma hues. As you recall from Lesson 13, chroma is the saturation or purity of a color resulting in intensity. Few artists paint using a high chroma throughout a work. Usually high chroma is reserved for the focal area. Other parts of the work are painted with colors that have been neutralized to some degree.

By having a palette that includes both high and low chroma colors, I save myself a lot of unnecessary mixing and ensure that I get the color I want. For example, let's say I'm painting a low-key yellow object. Instead of reaching for new gamboge yellow and neutralizing it, I reach for a low-chroma yellow, such as yellow ocher or raw sienna. From there I have a better chance of reducing the chroma easily.

If I'm painting a red object in both shadow and light, like a barn for example, I mix for maximum intensity on the light side. I choose a high-chroma red like cadmium red light and add just a bit of high-chroma yellow (new gamboge) to intensify the illusion of light. On the shadow side, I stay with cadmium red light, but dull and darken it with brown madder alizarin, burnt umber, and a touch of French ultramarine blue.

Blue can easily lose its chroma because it is already a cool color with a relatively low chroma. When I am painting blue in light and shadow, I use Winsor blue, pthalo blue, or cobalt blue for the light side. For the shadow side, I use French ultramarine blue, a touch of burnt umber, and brown madder alizarin.

Don't Let It Get To You!

Mixing colors can be overwhelming for the beginning painter. Many instructors actually tell their students which colors to mix for each part of a painting. This may result in a better effect in that particular painting, but it won't help you much when you want to start the next painting, especially if your instructor is not there to advise you.

The best way to learn the use of color is to use it. Have you ever gotten a hand-knit scarf or sweater from a beginning knitter? The stitches are inevitably uneven and it always looks bumpy. A year later, the same knitter is producing beautiful, smooth work. It's like that in painting too. Your early work will be a little bumpy. Keep going.

WORDS TO REMEMBER

- The use of color is as distinctive to the artist as his or her signature.
- Every artist must eventually choose the palette of colors that best express his or her artistic goals.
- The arrangement of pigments on a water-color palette is a personal choice. Some form of organization of the colors, however, aids in identification, mixing, and prevention of contamination.
- I suggest a palette that has warm and cool versions of each hue, and high chroma and low chroma versions of the primary colors.

HERE'S A TIP

Be sure you keep some scrap watercolor paper nearby when you are mixing colors. (The backsides of practice exercises or paintings that you consider disposable will do fine.) Whether you are mixing on the palette or "mixing" directly on the work-surface by painting one color over another (a compound wash), try your mixing first on the scrap paper.

Remember, however, "scrap" paper *never* means the backsides of computer-printer paper! It's important to practice on the same paper you will do your painting on. Paper has personality, too, and you must get to know it. Later you can experiment on a variety of available papers.

MY SUN-COLOR THEORY

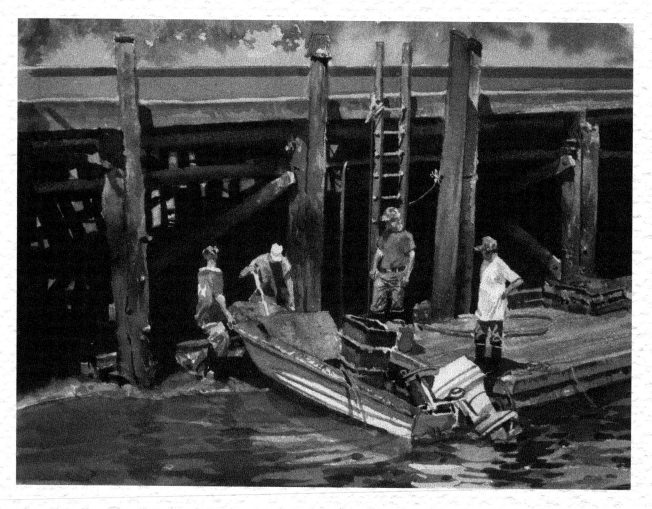

Hauling In

Anyone who keeps the ability to see beauty never grows old.

—**FRANZ KAFKA** (1883–1924), Austro-Hungarian writer

n the painting *Hauling In,* it's the end of a day and the guys are hauling in the boat. This painting is now quite different from the two earlier versions you saw in Lesson 14. It is a unified whole that captures and pleases the eye. If it were music, it would be a fugue in two voices. The two "voices" (blue and its complement, orange) play with each other, sing to each other, dance back and forth across the picture plane.

Hauling In is a good example of the sun-color theory that pervades most of my work. Using this theory, I depart most often from the photographic point of view, which records objects upon a surface, and I use the painterly point of view which uses an interaction of color, value, light, form, planes, line, and composition to create an aesthetic whole that is inseparable, stimulating, and satisfying.

And now I'll tell you how I do it and how you can use it too.

Sun-Color Theory and Light Source

In Part II you learned about light source, and here we are back to the first painting in that section. What more can we learn? We've discussed the three major sources of light for the outdoor artist: the sun, sky, and reflected light from another source. These three sources affect hue, temperature, value, and perception.

"Okay," you say, "but what's your sun-color theory?"

The color we attribute to the sun is yellow. Light falling on a surface directly from the sun will affect that surface in a warm and positive way. Value and chroma are usually high when facing the sun. The size of the object may appear larger, and the object may appear to advance in the painting.

The second source of light is the sky. The color we attribute to the sky is blue. Blue is a cool color, used extensively in shadow areas. When objects face away from the sun, they are in shadow but receive light from the sky. Shadow sides therefore are usually cool and influenced by blue.

So already we have two major contributors to our paintings, a warm yellow and a cool blue. These colors do not just sit quietly together. They take turns. You are now working with rhythmic repetitions of warm and cool and light and dark within the painting. *Rhythm* and *repetition* are key.

Look at the line of buildings in *Pemaquid Point Lighthouse, Maine* (page 158). From left to right you have dark neutral green, warm red, cool dark red, neutral dark tree against white, blue shadow side, white, red roof, white lighthouse, blue shadow side, blue sky, white light house tower,

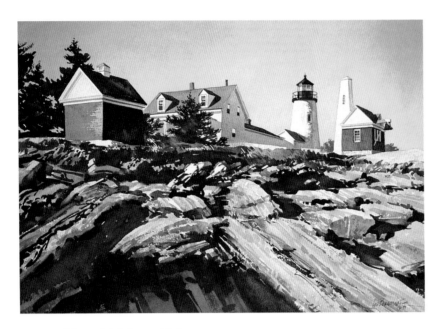

Pemaquid Point Lighthouse, Maine

bright red shed, cool red shadow side, blue sky. Across the entire painting, warm hues alternate with cool hues. The rhythm created by this is subliminal; the viewer is rarely aware of it, but is always responsive to it.

HERE'S A TIP

In general, when planning your painting, don't situate your objects with a cool color facing direct sunlight.

Sun-Color Theory and Reflected Light

The third source of light, reflected light, adds a third voice to the music of sun color theory. I said earlier that reflected light is a tool of the artist that adds character and movement to objects. But it is also a real phenomenon that was written about in the fourteenth century by Leonardo da Vinci.

He wrote: "You should pay the greatest attention to the things surrounding the bodies you wish to portray . . . in that the surface of every opaque body partakes of the color of its object, but the impression is greater or less in proportion as this object is nearer or more remote, and of greater or less power." In other words, light and color reflect from one object to another. Think of the cool teapot in *Tea for Two*, with the yellow of the lemon reflecting upon it within the cool cast shadow. In *Pemaquid Point Lighthouse, Maine*, look at the warm reflected light above the picket fence on the shadow side of the building. That warm color helps carry the eye across the painting to the next buildings.

In many cases, the appearance of reflected light within shadow creates a quieter, less dominant rhythm of light and dark, warm and cool color. Let's look at some examples: *Lone Tree, Late Autumn* (page 159) and a detail from *Block Island Hotel*, seen earlier on page 36.

Reflected light brings life to the darkest side of this old tree. It also lights the underside of the main branch growing to the right. And—surprise!—look at the shadow of the tree. Yes, you can find reflected light even in shadow.

Notice the cast shadow under the eave of the barn in *Block Island Hotel*. It is cool and deep. But the underside of the eave itself is reflecting the warm light of the sun on the barn. Now look at the shadow side of the roof. It is alizarin with some

brown madder and blue, creating a red that is both cool and dark. Now look at the other sunlit roof. It is a high-chroma, high-value red. The flowers in front of the building are somewhat neutralized.

In this little detail from the large painting, we have a focal point where the colors alternate dark and cool (roof), white (barn siding), dark and cool (cast shadow), warm and light (eave), white (roof line), and high-chroma red (roof). This rhythmic use of color makes a painting come alive. Your viewer will have a better feeling for the light source if you use this theory of alternating warm and cool color.

Detail from *Block Island Hotel*

Sun-Color Theory and Forms

It is the alternation of warm and cool color that gives form to many objects in a painting, especially cylindrical objects. The reflected light on the dark side visually turns the surface into a cylinder even though the picture plane is flat.

Without reflected light, the central object in *Lone Tree, Late Autumn*, the tree, would appear to be a flat surface. The tree is almost monochromatic, but the lit side—illuminated by warm reflected light—is intensely textured. The dark side needs to share some of that semblance of texture, too, or the trunk will appear divided into two pieces. This

Lone Tree, Late Autumn

HERE'S A TIP

Even in shadow areas there should be an alternating of warm and cool colors. Of course, everything is relative. All shadow hues are cool, but some are cooler and darker than others. For an example, look at the shadow side of the barn roof in *Block Island Hotel* or at the area under the docks in *Hauling Out*.

Choose a simple subject: a barn, fishing buoy, lighthouse, tree, etc. Now paint it without any sun-color theory. Paint the colors as you see them. Then paint it again, this time being aware of where warm light or cool light is illuminating the surface. Find where the reflected light is likely to be, even if you can't see it; then paint it in. Keep you lights warm and your shadows cool, but with some alternation of color.

is accomplished by the use of warm red-brown in the shadow area.

In the detail of the barn in *Block Island Hotel* on page 159, the reflected light under the eaves lifts the surface and gives it form by bringing it forward. Without that light, the two colors (under the eaves and in the shadow) would lie flat against one another.

We've said again and again that light and value create form, and the main building in *Monhegan Island, Maine* is composed of a light value, a middle value, and a dark value. But look at the middle value, in the shadow side of the house. It starts out dark and cool at the corner, but moves toward the outside corner with a warmer color and slightly lighter value against the medium dark-but-cool neutral of the background behind it. On a side note, notice that the eye path into this painting is in the alternating yellow and green of the foliage, yet another sun-color theory rhythmic technique.

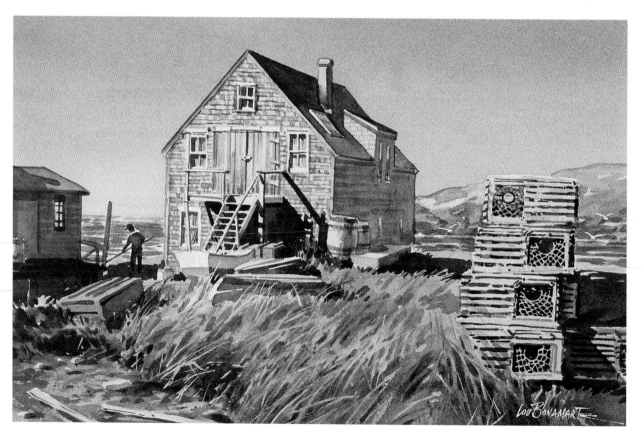

Monhegan Island, Maine

Sun-Color Theory and Composition

Hauling In, from the beginning of this lesson, puts sun-color theory to work to capture a moment. The painting's dominant primary color is blue, complemented by a lot of neutralized orange. The brightest (highest chroma) colors in the painting are the whites of the boat, its blue rails, and the men's clothing. These objects and figures are made to stand out against dark, neutral background colors. But within that dark background, look for the warm red tones that come into play.

More important, the latticework of boards at the back of the pier creates an abstract pattern of light balancing the intense activity and light around the boat. Notice also the red-orange cap on the pole in the center of the painting. This bit of strong warm color is the peak of a triangle formed by the working men and their boat.

Now let's look at the foreground. The dominant color is blue, with some white and a lot of neutralized, complementary orange. When I commented on the second stage of this painting in Lesson 14, all three primaries were represented and a good deal of a neutralized green had been used. What has happened since the earlier versions?

The painting has become more earthy, less pristine and proper. Dulling the colors of the boxes in the boat took the spotlight away from them. The painting depicts a group of working men and it is the dynamics of the group that causes the color to circulate around the focal point.

The orange in the water is reflective of the sand beneath its surface and continues the diagonal movement of the dock and its neutralized orange edge, thus pointing to and buoying the blue in the painting. There is also reflected light on every pole of the pier.

Hauling In is a painting of contemporary people in action. The movement of the painting captures the feeling of working together, just as its colors work together, just as the play of light and dark works together.

Sun-color theory is the process of taking our gift of light and transforming it into art. It is the culmination of all you have studied in this book. But it is also the beginning. Now you have the tools to develop as an artist, to communicate your vision and perception to others. In other words, to create beauty.

WORDS TO REMEMBER

- Sun-color theory guides most of my work.
- The three sources of light (sun, sky, and reflection) must work together to create a unified painting.
- Light defines the form of an object. Reflected light can give an object roundness.
- The alternation of light and dark, warm and cool in a painting creates a musical rhythm of movement.
- A dominant color can often be supported by neutrals, especially neutralized versions of the complement.
- A balance of color adds to the joy of life and the quality of a painting.

PART V

COMPOSITION

LESSON 19
THE QUESTION OF COMPOSITION

Lone Fisherman in Early Spring

Art is a lie that makes us realize the truth.

—**PABLO PICASSO** (1881–1973), Spanish painter and sculptor

Previous page: *Downtown New London*

W hat is composition? That's a tough question. The word is used in every field of the arts—music, visual arts, writing, dancing—and it includes a myriad of different elements. To search for an answer to "what is composition?" perhaps we should ask, "what is a composer?"

Most often we use that word to refer to a person who writes music. The music composer's work is written down in the universal language of specific symbols on a five-line staff. Musical symbols represent intangibles: pitch, duration, tempo, rhythm, volume, harmony, dissonance, timbre. Add a performer who can read the symbols, and the composer has created a unified piece of art that moves through time.

Like the musical composer, the visual artist works to create an aesthetically unified piece of work. And, also like the musician, he or she uses tools that are subjective and intangible: color, value, mass, form, balance, light, and organization. For the abstract visual artist, these elements may or may not have a relationship to the world of our perceptions. For the realist visual artist, the art of composition also includes using an array of tangible and recognizable objects as reference material to create an illusion suspended in time, as opposed to moving through time.

In a nutshell: If you want to paint paintings worthy of being called *art*, you've got to do more than paint collections of objects. All the elements of a quality painting must fit together like a well-cut jigsaw puzzle. If one part is missing, the unity is gone.

In the following lessons in Part V, Composition, I'll discuss the elements that contribute to creating compositions that express your visions and your ideas. But let's start with a little history of what the word means in both theory and practice.

The Big Idea

As I said earlier, the term "composition" is used in all the arts. It originates from the Latin composition. If you look even further back, the concept of *composition* derives from the Greek word for synthesis, meaning the "composition or combination of parts or elements so as to form a whole." From classical times to the Middle Ages to the Renaissance and into modern times, *composition* has referred to the ordered plan or structure of a work of art.

In the late 1940s, work by German art historian and philosopher Max Raphaël (1889–1952) demonstrated that the concept of composition dated back to prehistoric times. After studying the cave art of southern France and northern Spain, his published work theorized that the more than twenty animals on the ceiling of the Altamira cave in Spain are actually a single, ordered composition based around a central axis.

More recently, other excellent examples demonstrating his theories of the prehistoric sense of composition have been studied in Lascaux and Chauvet in France. Scholars now generally agree that great artists lived within early Homo sapiens communities, and most of them had a plan *before* they put pigment on the walls of a cave.

Composition has been an essential element of art since before people learned to write, and it still is in the twenty-first century. Even in the most abstract paintings there is composition. Sometimes it is an intentional repetition or organization of color, line, mass, or other elements that create a sense of rhythm that unifies. Sometimes composition is easy to spot; you can discern and discuss "what's holding this painting together." Sometimes it's more of a *je ne sais quoi* (French for "I don't know what"). But believe me, if it's art, composition is there.

ARTFUL MEANINGS

- *Abstract art* is non-representational art. That is, art that does not attempt to create the realistic illusion of recognizable objects.
- The term *abstract expressionism* came into common usage around 1950. It describes spontaneous, personally expressive art with an emphasis on movement and it is often large-scale, such as the work of Jackson Pollock or Willem de Kooning.

Choosing What to Paint

Before you can start to create a composition, you must have an idea, a vision, something that you want to paint. It isn't enough to take a good photograph and then copy it using brushes and watercolors. Instead, you should use the photograph as a reference to help you in depicting objects and areas while using your artistic license to help you *compose* with elements such as value, mass, and color. If you are an artist, you will not want to copy exactly what you see; you will want to create art.

Assuming that you begin with landscapes, you will almost certainly want to leave things out of the scene you are looking at, perhaps move some objects, change some values, alter some colors, and change some relative proportions (for example, the amount of sky or foreground). You may want to choose a light source that will create longer or shorter shadows. You can choose relative values to establish a high key or a low key, or to emphasize drama, conflict, or serenity, or just to catch a feeling in the air.

Before you begin a painting, you should ask yourself: "What am I trying to say? To capture or convey?" Once you figure that out, the trick is to accomplish the goal you set for yourself. Sometimes, often in fact, there are no words that could have said what a painting conveys. Without words, the goal of the visual artist is to paint an emotion, a mood, a perception, or an insight.

As long as you are a practicing artist, however, there *will* be one word that will motivate you, stimulate you, and sometimes drive you crazy. That word is "how." As artists, we are forever learning, forever trying new techniques, new colors, and new relationships in order to create a composition that is an aesthetically unified expression.

Format

Before you begin working with major masses, planes, and values to create a study, you must make a decision regarding the format. How will you set up your paper? For example, will the painting be wider than it is tall (horizontal, or landscape) or taller than it is wide (vertical, or portrait)? Or will the scene fit most effectively into a square space?

A painting made in a format inappropriate to the subject matter may seem too squeezed or tight, or it may seem too empty. But everything depends

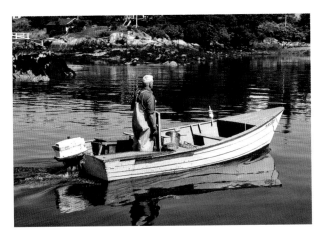 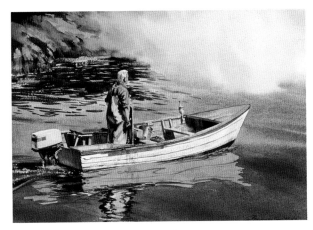

I created this painting, *Fog Bound*, using the photograph on the left as reference material.

PRACTICE! PRACTICE! PRACTICE!

Sit down one evening with a box of old photographs. Choose a few that you think might make good paintings and ask yourself *why* they would make good paintings. Then take a sketch pad and some pencils or drawing charcoal and do several studies of each photo. Try different value schemes and varying focal points. Experiment with the same scene at different times of day or in different weather. Consider what would be the best shape for your painting: a horizontal or vertical rectangle, or even a square. Ask yourself why that particular format works. Then choose your favorite composition out of all your sketches and try to do a painting using a limited value range.

upon how the artist *sees* the subject matter. To give you an example, let's look again at my painting of Christmas Cove.

The format of *Christmas Cove* is horizontal, like the majority of landscape paintings, which is why another term for this shape is "landscape." This style is more likely to give the artist the ability to capture the illusion of space, the breadth of the scene in view. The title tells what the painting is about: an image of a seaside village capturing the interrelatedness of the houses, forest, sea, and ships. The painting is comfortable and serene, and does not confine the viewer.

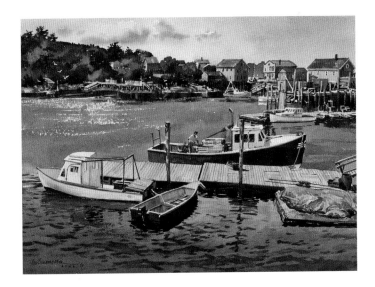

Christmas Cove

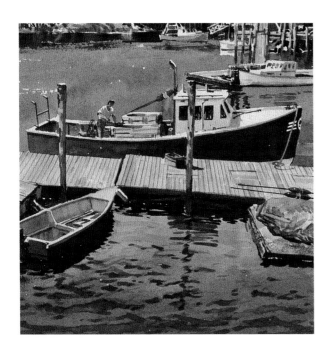

Christmas Cove cropped to a square format.

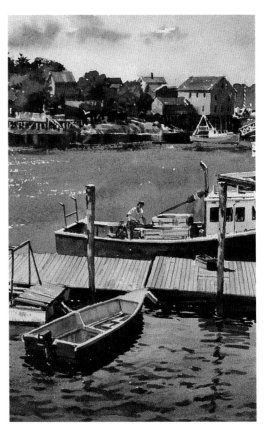

Christmas Cove cropped to a vertical format.

What would happen, however, if we were to change the format? Well, all the objects in the painting simply wouldn't fit in a vertical frame and a square painting would be awfully tight, neither comfortable nor serene. So let's take out some detail areas and try them in a vertical or square format.

As a composition, this isn't too bad, but it is an entirely different painting. It is a painting of a fishing boat, not a cove. There is no sense of the setting, not even a hint of sky, in fact. However, it does have a foreground (the water), a middle foreground (the dock) and a background (the lighter water behind the boat), as well as a definite focal point (the boat). A square format can work very well with a single-object subject or with still-life paintings such as flowers or fruit. My painting of the old trawler, *Gears, Ropes, and Pulleys* (page 53), is a good example of this.

This vertical detail from *Christmas Cove* does not work as well as the square format as a stand-alone painting. One feels as though there are layers from bottom to top, separated like steps rather than connected as planes. This is a situation where the vertical format is contrary to the feeling of the setting.

The vertical format often works well in portrait studies of people or animals (another term for this shape is "portrait"). Think of the works of the French artist Théophile-Alexandre Steinlen (1859–1923). The vertical/portrait format also works especially well for still-life paintings with upright objects, such as a vase of flowers (think about Vincent Van Gogh's *Sunflowers*) or even a

single flower (such as *Iris*, below). In landscape painting, the vertical format can be very effective if the subject matter is naturally a tall view. For example, you might choose a vertical format for an old oak tree (take a look at *Lone Tree, Late Autumn* on page 159), or a tall building (think of Claude Monet's Cathedral paintings), or perhaps a valley with a waterfall or running brook (such as Asher Durand's *Kindred Spirits*).

Lone Fisherman in Early Spring

One of my students has named *Lone Fisherman in Early Spring* (at the beginning of this lesson, page 164), her all-time favorite of my paintings. I'm not

Flower studies work well in a vertical format.

HERE'S A TIP

Always carry at least two viewfinders (paper frames) when you are painting outdoors, one rectangular and one square. Look through one at a time to choose your subject matter and your picture format.

exactly sure I agree with her, but let me tell you what she said:

"You can *feel* the beauty of nature and the quiet intensity of the fisherman in this painting. The cold almost causes your breath to escape in little puffs. I could live with this beautiful moment hanging on a wall of my home forever."

That's pretty strong stuff. It's unlikely that a photograph of the same scene would elicit that kind of reaction. So what evokes these emotions? Light, composition, color, spatial relationships, and technique. And don't forget the relationship of values, the focal point, balance, repetition, eye path, and just a bit of detail.

Let's look at the painting as an artistic composition. The foreground (the stream) takes up two-thirds of the painting. The background is the dark pine forest on the left side of the painting, with just a bit of sky. The middle foreground is the far side of the stream with its snow-covered rocks and trees.

A high value wedge of mist or fog enters the painting on the left side. One could argue that this cool light moving across to the middle of the painting steals a bit of the focal attention from the fisherman. And it's true that competition (the fisherman against the light) does exist in this

painting, but there is no conflict between them. These two aspects of the painting are a compositional unit.

Notice that the light-colored fog or mist at the left is an abstract, soft-edged area and that there is little or no detail in the objects it illuminates. On the other hand, the fisherman is detailed with sharp edges. Either one without the other completely changes the impact of the painting. Without the fisherman, the painting is a beautiful landscape without a focal point. With the fisherman, human scale is added and the work is anchored with a strong focal point. The fisherman without the competition of the light local value area is just a figure in the water with very little sense of atmosphere or drama. If you would like to get a sense for the figure without the effect of light value-area mist, take your hands or some pieces of scrap paper and cover all of this painting except the rectangle around the fisherman. He becomes then a lone figure in action, but not part of a composition that is asymmetrically balanced.

For most viewers the directional flow (eye path) of the painting begins at the lower right with the cool, high-value moving water contrasting the warm-colored fisherman. The eye moves quickly, however, to the bright, cool light on the left side.

You can't help but go there; the movement of the water and, more importantly, the value relationships take you. You start a diagonal drive with the high-value water in which the man stands, move to contrasting dark-value water, and then to the balancing high-value mist or fog. From there you come back to the fisherman because your eye follows the light-colored rocks on the far side of the stream and the patches of higher-value rapids in the stream.

This composition is connected by its pattern of value changes. The value changes create movement that is continuous and satisfying. As we learned at the beginning of the lesson, composition is the "combination of parts or elements so as to form a whole."

WORDS TO REMEMBER

- All the elements of a work of art must fit together into a unified whole.
- Choose not only what you want to paint, but also what you want to leave out.
- Find the right format for your idea.
- You must learn the elements of artistic composition just as you learned grammar. When the rules and guidelines become second nature to you, you will use them without even thinking about them.

SPATIAL RELATIONSHIPS

Waves Crashing

There is nothing worse than a brilliant image of a fuzzy concept.

—**ANSEL ADAMS** (1902–84), American photographer

*S*ometimes the hardest part of being an artist is facing the white paper. Decisions, decisions: *What will be big? What will be small? What will be light? What will be dark?* In other words, how is the space on a picture plane going to be allocated?

We've already studied the three major planes of landscape painting: foreground, middle ground, and far distance, or sky (remember that sometimes there are four planes). We've discussed mass and form and the effects of value changes and light. Now we're down to the question of how these elements combine or separate or work together in the unique organization that will be your painting.

"So where do I start?" you ask. "Aren't there any rules?"

There are plenty of guidelines, but I don't think you can call them rules. When it comes to organizing space into a composition, I don't think there is a single tenet on the books that hasn't been broken to produce a masterpiece.

Composition is a delicate creation. One misplaced or wrongly sized object or value area can be the dissonant chord that mars the music. Success is often dependent upon intuition. Even a single stroke of color can pull everything together or stick out like the proverbial sore thumb.

Think Odd

Let's go over some of these guidelines. For starters, rarely do you want to divide the paper into symmetrical or equal areas, or have an even number of similar objects or sections. In other words, avoid organizing your paper into equal halves or quarters. Why? These divisions are too stiff. The viewer's eyes won't keep moving

around the composition if everything is equal. The painting divides into parts instead of fluidly progressing from one section to another.

Three is often a magic number in art, but it usually needs a magic word to go with it. That word is *unequal*. It's a bit of a paradox that three unequal pieces will contribute to the unity of a whole, but once you get the idea, creating an "unequal" but balanced composition will become second nature.

Considering spatial relationships, let's look at *Waves Crashing*, the painting that opens this chapter. The horizon line is in the top quarter of the painting. The sky is the middle value. Below the horizon is a three-sided mass that represents the open, calm sea. That value is dark, and the line

that divides it from the crashing waves is a strong diagonal that starts just above the middle of the painting and moves almost to the other side to meet the horizon line. So far, nothing is equal. The parts play against one another and at the same time are in harmony with each other.

Now look at the crashing waves and white foam of the middle foreground. The major wave, starting at the left side, is green, then turns white, then returns to a jagged line of green again, then back to white, and then back to a softer echo of the green. The white then becomes gray and falls forward toward the viewer. That's five different color planes and then a coda (concluding section) that bends forward, all within a single wave.

Now look at the object forms in the foreground: mainly two large rocks, almost exactly alike and pointing the same direction.

"Doesn't one of the 'rules' of composition say that you shouldn't place two similar objects next to each other?" you ask.

You're right, but, as I said, it's a guideline, not a rule. These almost-twin rocks point to a third large rock (top right) that balances the composition by competing with the strong diagonal line of the waves. This is a great example of the rule of threes at work, creating a strong composition.

Think Simple

Too many highly detailed and separated objects in a painting can make it look overcrowded and disjointed. Instead of details, think about large planes or masses and object values when you plan and begin a painting. Consider how these elements connect to each other or are separate from each other. Detail should be the last element you think about in your composition.

Let's look again at *Pemaquid Point Lighthouse, Maine* on the next page. The spatial relationships of the major value masses are not at all equal. The dark foreground (with some light objects—the rocks) fills more than half the painting. The sky fills less than a third. The buildings are the focal point (middle foreground) and the lightest in value, but they occupy the least amount of space on the picture plane.

How can the most important objects occupy the least amount of space and still work as a composition? In this painting, the strong diagonals of the foreground point directly toward the buildings. In other words, the rocks move your eye to the buildings. Those buildings are high above the artist's station point. We, the viewers, therefore look up to them and thus they increase in stature.

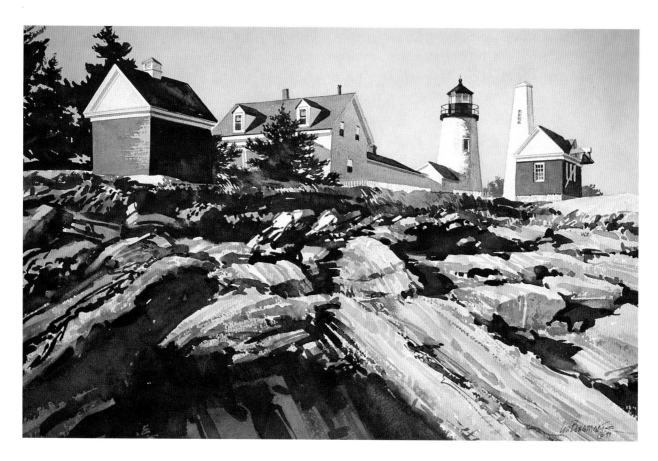

Pemaquid Point Lighthouse, Maine

This is a painting broken into three simple parts. There are no distractions such as storm clouds, debris on the rocks, or flags flying from the buildings. The illusion of rocks is created by value changes. The houses are simple cubes, the lighthouse a cone, the other tower a modified cylinder with edges. These shapes are arranged in a row across the painting. They would be boring, except the intensity of the reds and the jagged line of their rooftops create a moving and interesting pattern against the plain blue sky.

Pemaquid Point Lighthouse, Maine is a dramatic painting based on a very simple design. Its sense of awe is created by the artist's station point and view (the horizon line is above his line of vision). The spatial relationship among the buildings is harmonious and stable. The spatial relationships among the rocks are full of inequality, movement, and strong value changes. Details such as the picket fence, the trees, and the windows contribute to the realism of the scene but they are not the first concern of the artist planning for an aesthetically effective composition.

HERE'S A TIP

To establish compositional balance, somewhere in a landscape painting there must be a straight line.

Positive Space and Negative Space

Each shape or value in a painting creates another shape that is the negative space around it. They must all fit together, virtually unnoticeable by the viewer. It's a little like creating a patchwork quilt—no matter how complex the pattern, when finished all the pieces must fit together and look like a quilt.

For an excellent close-up example of positive and negative space at work let's look at the flowers in these two historic paintings below. The one on the left is *La Flambé (Garden Iris)* by the French watercolorist Nicolas Robert (1614–1685). On the right is *Vase of Flowers* by Daniel Seghers (1590–1661), a Flemish Baroque painter who was known widely for his painting of flowers.

Robert utilized dark positive space and light negative space in *La Flambé (Garden Iris)*. Since the background (the light negative space) recedes in this painting, the flower (the dark positive

Left: Nicholas Robert, *La Flambé (Garden Iris)*; right: Daniel Seghers, *Vase of Flowers*

space) comes forward. On the opposite end of the spectrum, Seghers painted *Vase of Flowers* with light positive space (the flowers) and dark negative space. In this case, the darkness of the background makes the flowers advance. In both paintings, you will see patterns of negative space that are used to create and emphasize the shapes of the petals and leaves against the background.

The negative space is an integral part of these paintings. If you were to change a form, the negative space would change. Your new positive image could be an improvement or a detriment, but both positive and negative space change together. They are a unit—one does not exist without the other. Think of the yin and yang of Chinese philosophy; together, they make a whole.

Landscape Yin and Yang

A lot of students have no trouble when asked to identify positive and negative space in a portrait

or a still life or a flower study, but they fall apart when asked to do the same in a landscape. Let's work through a few paintings so that you become comfortable with the concept.

The shape of the negative space (the water) in the lower part of *Fishing for Flounder* creates a half-circle around the figure that is the focal point of the painting. Without that half circle the strong diagonal of the bridge would dominant the painting. The bridge itself is brought for-ward by the high-value negative space of the sky. Without the blue patches separating the beams, the viewer would lose sight of its intricate structure.

In the painting of Peggy's Cove in Nova Scotia (opposite page), the negative space of the water gathers the viewer's attention at the base of the painting and leads the eye into the village (the middle foreground). The

Fishing for Flounder

Peggy's Cove

negative space at the top of the painting (the sky) outlines the buildings that comprise the village. To better understand this use of space, try to think of the sky as a pattern of color apart from the village. It takes up about a third of the painting, but more importantly, it fits atop the buildings creating a musical pattern of points, lines, and slopes.

To better understand the use and function of negative space, turn a painting upside down. You will see how the positive space stands out even though you are not relating the objects to their identities. Buildings or boats, for example, may not look like buildings or boats when upside down, but they will still stand out in the composition.

PRACTICE! PRACTICE! PRACTICE!

Practice using positive and negative space in your still-life compositions. Make the same simple painting with a dark background and then with a light background. Change the arrangement of the still life and see how it affects the viewer's perception of negative space (which of course affects the perception of positive space too).

Remember: spatial relationships in indoor paintings are a personal choice. Should there be one large object, such as in Vincent Van Gogh's *Sunflowers,* or a many faceted grouping, such as Paul Cézanne's *Still Life with a Basket*? Your choice and arrangement of subject matter is composition at work in still life painting. You will soon develop your own style.

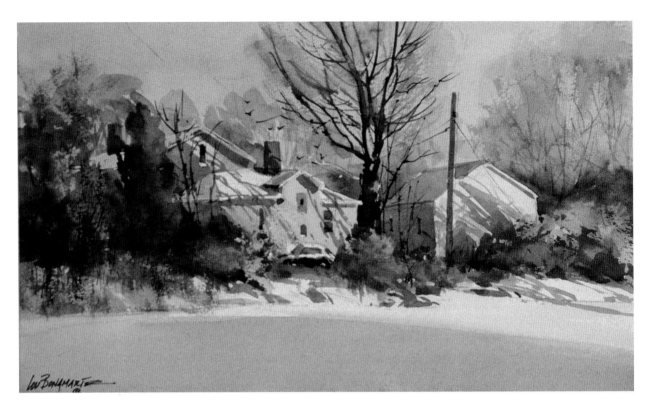

Last Light

Looking at *Last Light* you might think: "Isn't this a peaceful scene!" A contributing factor to that sense of peace is the negative space of sky and snow. In the previous two examples, the shape of the water moved the viewer's eyes into the painting. However, in *Last Light* the negative-space snow is a stabilizing horizontal shape. Now look at the sky. It too is a stabilizing, horizontal negative space; the haze of trees softens its edges. The shape of these two negative spaces complement the focal area (the houses) and complete the painting by balancing the top and bottom areas and emphasizing the middle third of the painting.

Indoor Art

Okay, now let's head indoors. Positive and negative space is very important when creating a still life composition. Because there is no sky or background distance, we can't use the major planes theory of landscape painting. Instead, the artist must carefully study the patterns created by object values and consider how those patterns relate to each other. Negative space can then be an organizing tool; its pattern can actually hold a composition together just as the major value masses can balance and hold a landscape together. The use of negative space can also help locate the focal grouping on the picture plane so that balance and eye path will create a unified whole. In still life painting, it is always essential to paint a unified composition rather than a few randomly gathered things.

When painting a still life, the table (or whatever surface you place the object upon) is your ground plane. Its position is very important. Do not place

its edge across the middle of your painting. When the ground plane of a still life crosses at or above the midline of a picture plane, the objects being painted will be above the viewer's eye level.

Keep your composition simple. Use shadow areas and negative space to make connections between the objects on the table. Remember, negative space can be light or dark. Use value and contrast as a composition aid. Think of your background as negative space around your subject matter, holding your composition together.

Look at your arrangement of objects as a large abstract form. Is the basic form a triangle, a group of rectangles, or perhaps a curvilinear figure? In any case, it should be arranged to move fluidly across the painting or within the painting. There should be no jarring breaks. If you are painting portraits or animals, your use of negative space becomes very important to the success of your work. If you place the subject in the center of the painting, the negative space that surrounds it is more or less equally balanced, with some variations for the shapes within the subject, for example, the position of the head, the clothing, the objects being held, etc. This placement can sometimes be static and rather dull. On the other hand, if you place your positive object somewhat off center, the negative space becomes a part of the composition, directing interest and focus.

A Few Last Words

You may find studying spatial relationships a bit more challenging than some other aspects of watercolor painting because in each composition you must consider light, value, form, and color as they interact together. In other words, you have to know something about everything to get it just right.

But, then again, what is "just right"? Young apprentices who studied with the great masters often copied their compositions, making only small changes in order to call the paintings their own. But a few painters occasionally broke the established patterns. Sometimes they produced masterworks that changed the standards by which art was judged. Pablo Picasso is a wonderful example of this. He began work as a realist artist and then left the fold to help create the intensity of Cubism.

So what is "just right" for you? I suggest you strive for a painting that holds together, says what you want it to say, and is aesthetically pleasing. Not every piece of work you do will qualify. But there's a great joy in showing off one that does. Remember: the desire to create paintings that are aesthetically pleasing is the great motivator. Some say it's creating beauty. Some say it's why we paint.

WORDS TO REMEMBER

- Successful composition is often dependent upon intuition. Know the guidelines but don't be boxed in by them.
- Avoid equal divisions of space on the picture plane.
- Avoid repetition of similar objects or areas.
- Typically choose three over two; the balance is better.
- Try to simplify your subject into a few major areas that fit together first. Save the details for last.
- Negative and positive space are inseparable.
- Relationships within a space create good composition. No matter how well you paint each single object, the group does not become a painting unless the composition fits together.

TWO KINDS OF PERSPECTIVE

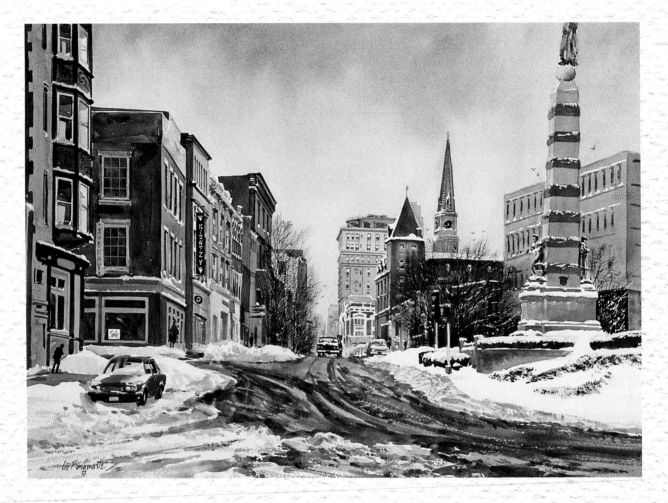

Downtown New London

> *Those who are in love with practice without science are like the sailor who boards a ship without rudder and compass, who is never certain where he is going. Practice must always be built on sound theory, of which perspective is the signpost and gateway, and without perspective nothing can be done well in the matter of painting.*
>
> —**LEONARDO DA VINCI** (1452–1519), Italian polymath

Have you ever heard of *trompe l'oeil* painting? It's been popular among wealthy households for centuries. Trompe l'oeil artists paint three-dimensional-looking illusions on blank walls. Often the illusion is of an outdoor scene, for example a casement window with a view of a garden so realistically rendered that most people would think it was a real window with a real view.

"How does this tie in with perspective?" you might ask.

Artistic *perspective* is often a magic tool used to trick the viewer's eye. Actually, there are two magical culprits, because there are two kinds of perspective: atmospheric and linear. For the realist painter, these two skill sets are the necessary tools for changing a flat white sheet of paper into a foggy day.

Most of my students resist learning perspective. They'd rather play with technique than concept. Learning perspective can sometimes seem dull and mathematical: so many rules, so many imaginary lines. But an understanding of perspective is essential to realistic painting so I continue to spend class time teaching it. I guess you might say that perseverance (sometimes called stubbornness) is part of my personality profile. So let's begin.

Learning the rules of perspective is like picking up a flashlight that saves you from fumbling around in the dark. Think of the rules of perspective not as rules of art, but as tools or guidelines for creating the illusion of distance and depth when working on a two-dimensional surface. *Trompe l'oeil* actually translates as "deceives the eye," and that is what perspective helps you do.

That sounds a little theoretical, and, well, challenging, doesn't it? Perspective is indeed somewhat more complicated than just throwing paint at paper. Leonardo da Vinci studied it for years and years, just as he studied physics. He kept minutely detailed notebooks throughout his life. He even left us methods to calculate the angles and shapes of shadows.

ARTFUL MEANINGS

- *Trompe l'oeil* is a French term used in the art world to mean a painting or a part of a painting that tricks the eye into believing a painted object is real.
- The *Merriam-Webster* definition of **perspective** is: "the technique or process of representing on a plane or curved surface the spatial relation of objects as they might appear to the eye; *specifically*: a representation in a drawing or painting of parallel lines as converging in order to give the illusion of depth and distance."
- *Atmospheric perspective* (sometimes called *aerial perspective*) is the use of size, color, form, and edge control to create the illusion of distance.
- *Linear perspective* is a geometric system based upon the artist's line of sight and the orientation of an object to the picture plane. (Don't panic if that sounds confusing—I'll explain this later.)

So how far can you and I get into perspective without committing to a lifetime of keeping notebooks? I think you'll be surprised. With a little effort, we'll go far enough to answer your questions, give you more confidence with a brush, and make your artistic life a little less complicated. Let's start with atmospheric perspective; it's easier to understand than linear perspective.

Atmospheric Perspective

As I mentioned in Lesson 3, the air is full of particles of dust and moisture that catch, reflect, and diffuse light. As our viewing distance from an object or geographic form increases, these particles effectively change the size, color, and value of what we perceive. By recognizing and reproducing these changes, we can paint the illusion of distance.

Here are the key points of atmospheric perspective:

- Objects appear smaller as their location becomes farther from the viewer. This phenomenon is called *diminution*.
- Small objects close to the artist will appear bigger on the picture plane than large objects in the distance.
- Values in the distance are higher and the contrasts are generally closer together.
- Details disappear as objects move into the distance.
- Colors become more neutralized and intensity diminishes in the distance.
- Edges in the distance become softer.
- Forms in the distance can lose their definitive shape.

DOWNTOWN NEW LONDON

Let's look at the effects of atmospheric perspective in the painting *Downtown New London* (page 180). (That's New London, Connecticut, the town where I was born.) The diminution is obvious: the buildings become smaller as they become farther from the viewer. The buildings at the center and on the right side of the painting are not only smaller because they are farther away, they are also grayer than the closer buildings on the left side of the painting. Also notice that the snowbanks in the foreground are taller than a full story of the building in the very back of the painting.

The darkest values and strongest contrasts of value are in the foreground and middle ground (the snowbanks and the yellow building). The distant buildings fade away, barely distinguishable one from the other. Windows and doorways

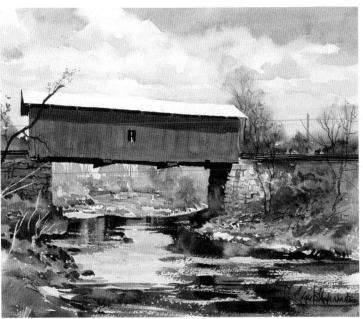

The Red Bridge

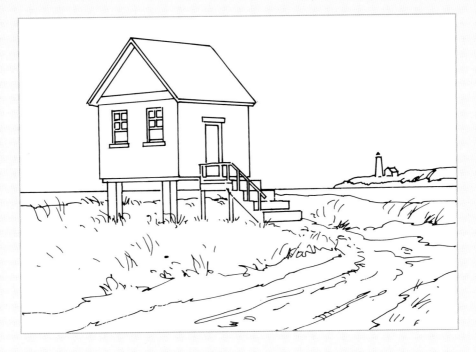

A sketch of a cottage on stilts.

Try your hand at atmospheric perspective by copying the image above. Working with any colors you choose, use value, size, hard and soft edges, and detail to try to paint the scene so that the viewer can *feel* the distance. Don't forget to indicate your light source.

are clear and reflective in the areas closest to the viewer, but almost imperceptible in the distance where they become merely shades of gray. The monument on the right and the corner of the red building on the left are the most distant objects where detail can be seen. They are both a part of the middle background.

IN THE COUNTRY

The same atmospheric perspective rules apply in rural settings, but the illusion is often of greater distance because structures are not as likely to block our view. Let's take another look at *The Red Bridge*, which you saw in Lesson 3. The distant background in this painting is seen below the bridge. On the paper, the amount of space allocated for this far view is just a small rectangle. Yet we, the viewers, see that space as moving away from us into the far distance.

Notice how the colors below the bridge are lighter, cooler, and more neutralized. Tree-leaf silhouettes and rock shapes are barely differentiated and detail has disappeared. Values are all within the 7 to 8 range. The trees and rocks here appear smaller than the same objects in the foreground.

Now look at the outlines of the shapes in the foreground. They all have distinct, hard edges. The roof, the walls of the bridge, the window, and the stonework leave no question about boundaries. You may be wondering, however, why the banks of the river appear to have less detail than the bridge, even though they're closer in perspective to the viewer. This is a case where I used some artistic license to make the bridge the focal point of the painting. And of course, the most intense color in the painting is the rectangle of red.

Linear Perspective

Each of our eyes sees form, value, and color, but not depth. The brain melds the separate images from each retina to perceive depth. The brain then connects names for objects with what we are seeing. When we paint, we also use the brain to transfer what we perceive in three dimensions into recognizable objects on the two-dimensional picture plane.

This is where geometry comes into play. To create the illusion of three dimensions on the flat picture plane, we must understand that we are making a mental transference from three dimensions to two dimensions. You need some*thing* to look at in the subject and some*place* to put it on the paper. The perception is then a "given"; it is that which you want to represent through illusion. The paper is your other "given"—where you want to put the illusion. Now you need imagination, determination, and practice to decide where you want to situate the imaginary dots that represent where parallel lines recede from the object plane to a point in the far distance.

Artists call these imaginary dots *vanishing points*. Once we establish the vanishing points, we must imagine lines that start from planes of the objects and gradually converge to meet at the vanishing points. In reality the lines are parallel, but in realistic art they are not. Keep reading and I'll explain.

Remember, the vanishing points and lines of perspective are just tools. Let them help you create an illusion, but don't let them stop you from using a little artistic license to add or subtract elements from the scene you are viewing. No one will ever see these lines; they exist only in the mind of the artist.

VANISHING POINTS

Sometime in grade school art class some art teacher must have mentioned vanishing points to you. Many of us probably just accepted what the teacher said without question because it worked, even if it seemed a little mysterious. Consequently, there can be a lot of confusion whenever anyone tries to teach perspective to adults. One of the most common mistakes of the beginning artist is thinking that each painting is done with either one or two vanishing points, as your grade school art teacher probably taught you. This isn't necessarily true.

In a particular painting, there may be only one vanishing point or there may be many different vanishing points, one for each object that is in a different relationship to the artist's station point.

ARTFUL MEANINGS

A **vanishing point** is an imaginary spot on, above, or below the horizon where receding "parallel" lines would converge.

Remember that *imaginary* is a key word in that definition. Vanishing points do not exist except in the world of perspective art. If you, the artist, are off a bit, the world you are painting will not disintegrate.

PARALLEL LINES

By definition, parallel lines never meet.

"Wait," you say. "I just read the Artful Meanings sidebar and you said the vanishing points are where the parallel lines *would* meet. Something has to be wrong here."

Yes, this is another point of confusion regarding perspective. In reality, parallel lines never meet. A line through the top story of a house should be (and usually is) parallel to the foundation line. In the same way, imaginary lines over the top and under the bottom of a picket fence set on a flat surface would be parallel. But does the artist painting a house or a fence on paper actually *see* parallel lines?

If one corner of the house is farther from the eye of the artist than the other, the farther wall will *appear* slightly shorter. The posts of a fence that moves from the foreground toward the background will appear to get smaller. So the lines of the top and bottom of the house or of the top and bottom of the fence—lines that are parallel in real life—appear to converge in the illusion of the eye. That degree of convergence is established by a vanishing point.

Look at the telephone poles in *Atmosphere*, below. We know that all telephone poles are cut to the same height. They *look* shorter, however, as they become more distant from the viewer. If

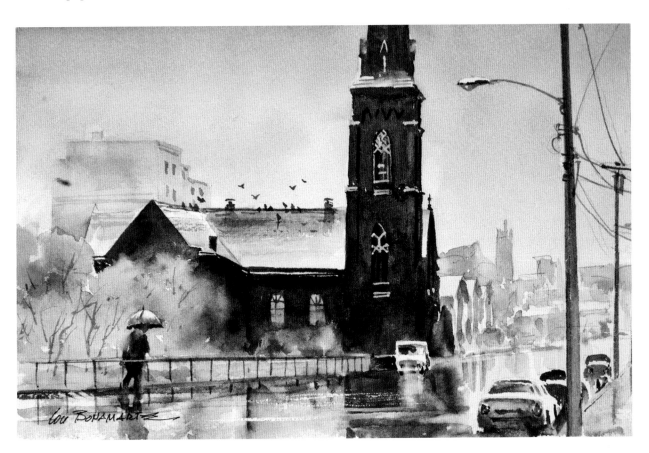

Atmosphere

the poles were established on a flat surface—for example, if we were looking at all of them straight on, so they're on the same plane—lines connecting all the tops and all the bottoms *would be* parallel. But the eye sees the objects as getting smaller as they recede into the background and, therefore, imaginary parallel lines connecting their tops would appear to converge. That's how you get parallel lines that meet at a vanishing point. It's an illusion.

To establish the vanishing point, draw a line between what you see as the tops of the first and the second pole, and then do the same between the bottoms of the two poles. Maintaining the angles of the lines, project each line out. Where those two "parallel" lines meet is the vanishing point. These lines determine the size of all other visible poles—the top line shows where the top of subsequent poles will end, and likewise with the bottom line. When painting buildings, those two lines determine the tops and bottoms of rooflines, basements, windows, and doors.

Different sets of "converging parallel lines" in a painting can have different vanishing points depending on the plane on which they're located. Fence posts along a road that goes directly from the foreground to the background will have a single vanishing point on the horizon. Fence posts surrounding a pasture will have different vanishing points depending upon their orientation to the picture plane and the artist. In *Atmosphere*, all the telephone poles have one vanishing point. The fence posts in the foreground near the church, however, are at a different orientation to the artist and have a different vanishing point.

Time Out

The atmospheric part of perspective is pretty straightforward, with a lot of good tips for improved illusion. But the linear stuff can seem like just a lot of theory and jargon about angles and hypothetical parallel lines that converge at some imaginary point. Eventually, with practice, perspective will become second nature to you. In the next lesson, we will explore some more guidelines for getting the angles you want for your painting.

PERSPECTIVE WITH POINTS

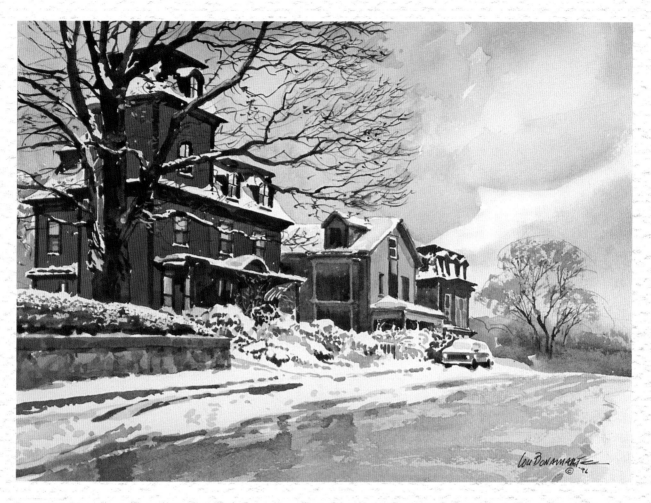

After the Storm

Without freedom, no art; art lives only on the restraints it imposes on itself, and dies of all others.

—**ALBERT CAMUS** (1913–60), French-Algerian author, philosopher, and journalist

To put the theories of perspective to good use, there must be an artist standing somewhere and looking at something. Perhaps that sounds a bit overly simplistic to you. But think about the statement before you make a judgment.

The ability to determine what the eye of the artist actually sees is essential for learning the perspective skill-set. Literally *everything*—the entire study of perspective—depends on the point of view of the artist. The artist must answer this question before starting every painting: *Where do I stand in order to see the scene I want to paint,* **as I want to paint it?**

After the Storm is a painting of a *very* cold day. Instead of standing in the street poking holes in the ice forming on my jar of water, I took photographs, returned to the warmth of my studio, and created a composition. To make a painting, I had to choose which photograph was taken from the station point that made the most interesting composition.

A station point is needed to determine the horizon line. *What did I see at eye level when I was standing in that spot?* In *After the Storm,* the horizon line is pretty obviously in the distant foliage. But in many paintings, we talk about a horizon

ARTFUL MEANINGS

- The **station point** represents the position and angle of view of the artist in relation to the objects in the composition. Are you looking head-on at an object—let's use a cube as an example—so that you see only one full side, or are you looking from an angle so that you see a corner and two sides? Where an artist stands can result in very different works of art from the same reference material. The series paintings of Claude Monet are excellent examples of how station point can make a difference in an artistic composition. He painted a series of haystacks at various times of day in different seasons, changing his station point with each painting. Much has been written about the changes in light and season in these paintings, but you can also pleasurably study the differences created as a result of station point.
- **Eye level** (also called the **horizon line**) establishes the level of the artist's line of sight. (The more universal term is **eye level**; **horizon line** is more commonly used in landscape watercolors.) If you

are unsure of your eye level, take a pencil and hold it across your nose just under your lower eyelids. That's your eye level, or horizon line.

- The **imaginary picture plane** stands at the back of the scene you are painting. To grasp this concept think of your working surface (paper) as though it were standing behind your subject matter. It is important to understand how the objects in your painting relate to this imaginary picture plane. Are they parallel to it? At an angle to it? Forward or distant? An important part of good composition is the delineation and limitation of your subject matter to fit appropriately into your picture plane. If you were painting a portrait, you would not limit your subject to the top right quadrant of your picture plane. If you were painting a vase of flowers, you would not paint it on a six-inch by six-inch square in the center of the picture plane. If you were painting a seascape, you certainly wouldn't want to paint the entire visible coastline.

line when there is no horizon to be seen. Where is the horizon line in a still life, for example? To do a realist painting it is essential to know what is above, below, or at the artist's eye level because that view determines the angle of the "parallel" lines that go to the vanishing points. For example, in doing a still life, if the artist is seated so that eye level is the back of the table upon which the subject matter rests, two vanishing points will be located at either end of an imaginary line that extends from the back of the table out beyond the picture plane. A book lying on the table would be painted so that the covers are slightly angled toward the vanishing points. A doll house standing on the table, however, would have imaginary perspective lines both above and below the table edge. The lines of the roof and tops of windows of the dollhouse would converge toward the same vanishing point.

Ground Plane

We talked about *ground plane* way back in Lesson 1. It is the surface upon which the objects in a painting stand. It is usually a line parallel to and below eye level. The ground plane can be different from the station point upon which the artist is standing. For example, if the artist is standing on a knoll looking down at the village green, the ground plane is below his or her eye level.

In simple terms, the ground plane is where the walls of a building meet the earth. If the artist is looking directly at the windows of the first floor of a building, the horizon line passes through the windows. Perspective lines for any horizontal planes below that eye level will slant from the vertical lines of the building's wall or corner *up*

to the vanishing point(s). Perspective lines for any horizontal planes above eye level will slant from the vertical lines of the building *down* to the vanishing point(s).

In the stairway illustration below, you can see the five factors that influence perspective. The point formed by the corner of the double line at the bottom of the drawing is pointing to the artist's *station point*. The dark line across the middle is the artist's *eye level*, or *horizon line*. The surface upon which the object stands is the *ground plane*. The three *vanishing points* are imaginary dots that determine imaginary (almost) parallel lines that make things look three-dimensional. The orientation of the object to the artist's viewpoint is turned 90 degrees from the *imaginary picture plane* behind it.

Can you name five factors that influence perspective?

That last sentence can be slightly confusing. To better understand, think of the building as a cube. Is one surface of the cube parallel to the picture plane? If yes, you, the artist, would see only one side of the building. Is the cube at an angle to the picture plane? If yes, you would see a corner and two sides of the building, as is the case in the illustration.

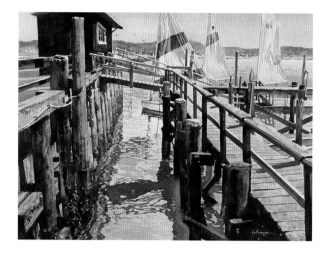

Wellfleet, Cape Cod – One-point perspective at work.

If you can relate the objects in your painting to these five factors (station point, horizon line, ground plane, vanishing points, and imaginary picture plane) you can use perspective to help turn what your brain perceives into a piece of art. The magic that makes it happen is in the *vanishing points*.

One-Point Perspective

One-point perspective (also called *parallel perspective*) uses only one vanishing point. It is appropriate to use one-point perspective when one surface of a cube is parallel to the picture plane and to the artist's station point. (For example, the short edge of the center table in the illustration in the exercise sidebar to the right.)

One-point perspective will help you determine the height of receding electrical poles or trees alongside a road. Just remember that verticals in a painting always remain vertical, but they diminish in size as they move away from the viewer. One-point perspective will also help you depict the size of the buildings on either side of a street when your station point is in the middle of a road.

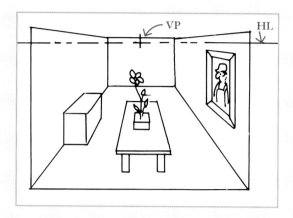

One point perspective uses only one vanishing point.

Look at the drawing above. To do this exercise, you must willingly suspend your disbelief. You *know* that the painting on the right-hand wall is rectangular, for example. But if you draw it as a rectangle, it won't have the appearance of hanging on the wall. So you use perspective to determine the converging parallel lines at the top and bottom of the frame. Remember: we use perspective to keep our minds' logic from overruling what our eyes are seeing.

Try it out. Copy this illustration. Where is the artist standing? Note the horizon line (labeled "HL" in the illustration). The artist must be on a balcony because he or she is looking down. Having established the station point, take a straight edge and put it on the vanishing point (labeled "VP"). With colored pencils, draw lines from the vanishing point over the lines indicating the horizontal surfaces that move from front to back. You'll indicate the top and bottom of the painting on the wall, the side edges of both tables, the flower box, the ceiling, and the floor.

Two-Point Perspective

Two-point perspective (also called *angular perspective*) uses two vanishing points on either side of an object and at some distance apart on the horizon line. This system is appropriate when the cube is rotated so that none of its four planes are parallel to the imaginary picture plane behind it. In other words, when the artist is looking at the corner of a building or other object. (Look again at the stairway drawing on page 189.)

As I mentioned in the last lesson, two-point perspective vanishing points are determined by taking two "parallel" horizontal lines as you see them on the top and bottom of a building (cube) and extending them out toward the horizon. Don't let all the lines and points confuse you.

Be aware that:

• A hypothetical vanishing point might be beyond the end of your paper.

• The vanishing point for parallel horizontal lines on one side of a building may be a different distance from the building than the vanishing point for parallel lines on the other side of the same building. (Look again at the stairway drawing for an example of this.)

• Perspective is a tool, not a rule. Sometimes art is intentionally out of perspective. For example, Pablo Picasso and the Cubists skewed perspective by using multiple viewpoints to paint a single object. Surrealist artists such as Salvador Dalí would intentionally distort perspective in order to make their work more surreal. And, of course, the twentieth-century Expressionists disregarded perspective and focused instead on capturing emotion and personal interpretation rather than the objective reality of a scene.

PRACTICE! PRACTICE! PRACTICE!

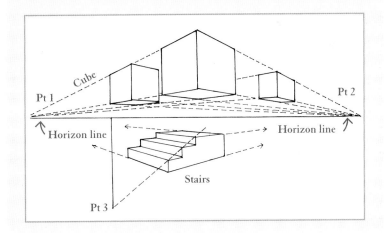

Can you find the vanishing points in this drawing?

Copy this drawing and find the vanishing points. Hint: two are on the horizon line but the third is below it.

Three-Point Perspective

Three-point perspective is used to help draw objects from above or below (bird's-eye view, or worm's-eye view, respectively). When using this system, vertical as well as horizontal lines converge to vanishing points while lines parallel to the picture plane remain parallel.

Does that sound complicated? It can be. In fact, three-point perspective is rarely used. One of the problems in teaching this system is that the third vanishing point must be determined by trial and error. Once you get a point that seems "right" you can use it as a guideline for related lines.

Is this going too far for you? Don't worry. One of the risks of perspective drawing is *too much of a good thing*. We admire artwork that paradoxically appears both studied and spontaneous, but a painting done entirely and only by the rules of perspective becomes draftsman-like in its precision. Everything looks stiff. If stifled by too many imaginary grids, watercolor can lose the luminescence that separates it from even the very best photography.

After the Storm

Let's end this lesson by looking again at my painting *After the Storm*, from the beginning of the chapter (page 187). In it, I used both one-point and two-point perspective. One-point perspective applies to the road and the wall in the foreground. Two-point perspective applies to the three houses.

The one-point vanishing point is on the horizon line to the right of the tree. You can see the parallel lines of the left side of the road, the wall (top and bottom), the top of the hedge, and the piled snow, all converging toward the vanishing point. The right side of the road is virtually directly below the vanishing point so it shows very little angle.

The horizon line remains the same in regard to the houses, but the buildings require two vanishing points because the cubes that compose them are at an angle to the picture plane. These vanishing points for the two-point perspective are different from the vanishing point for the one-point perspective. On either side of the houses, the two-point vanishing points are set on the horizon line beyond the width of the painting.

The three buildings in the painting all face the station point at approximately the same angle and are at the same angle to the picture plane. On the right side of each building, the roof edges and window tops are on parallel lines converging toward the right vanishing point. To the left, the intersection of the corner of the red building and its roof edge is close to a 90-degree angle. Therefore, the resulting vanishing point is farther from the house, far beyond the edges of the painting.

If you feel overwhelmed, don't give up! It gets easier to understand perspective the more you use the system. Remember, it's designed to help you, not make you crazy!

There are thirteen lines projected from VP1. There are eighteen lines projected from VP2. Can you find them?

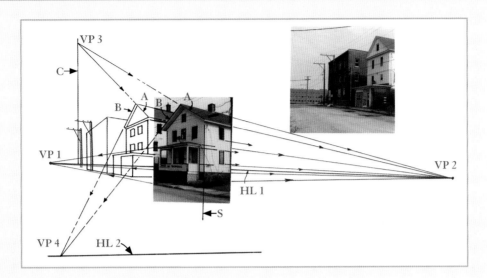

An example of a line drawing made using 4-point perspective and the photo the artist used to establish vanishing points.

Spontaneity may be beneficial, but sometimes the watercolor artist aims for more accuracy. Photographs and perspective can help capture correct detail. Here's a photo that has been transposed into perspective-determined guidelines for a painting.

To do this, I cut one building from the original photo and used it to obtain the parallel guidelines I needed to establish vanishing points. From those guidelines to the drawing was a matter of artistic selection. What details would be important? What was better left out? How should this group of buildings be placed in a composition?

Try it yourself. Take some photos of ordinary buildings, make photocopies, cut them up, and then use a portion to determine vanishing points. What can you do artistically with this method? It's all up to you.

WORDS TO REMEMBER

- Linear perspective creates the illusion of three dimensions by using the artist's station point, eye level, the ground plane, vanishing points, and an imaginary picture plane as determinates for the angles of horizontal lines.
- There are several types of linear perspective. The most commonly used by both landscape and still life painters are one-point perspective and two-point perspective.
- Three-point perspective can help in depicting objects seen from above or below.

- There can be several instances of one-point, two-point, and three-point perspective in a single painting.
- The ground plane is usually parallel to the horizon line. Two objects on two different ground planes will have different vanishing points, but those points will all be on the same horizon line.
- To use perspective effectively, paint like the writer writes. A writer must thoroughly know and understand all the rules of grammar but he or she does not write with a grammar book in hand.

LESSON 23
FOCAL POINT

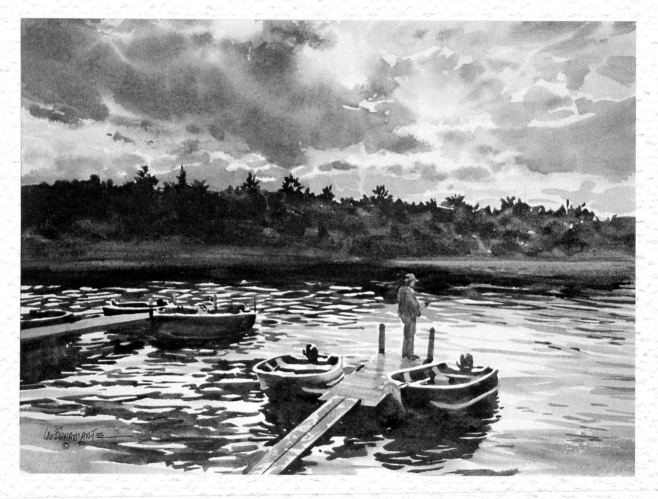

Pockomoonshine Lake

People often say that "beauty is in the eye of the beholder," and I say that the most liberating thing about beauty is realizing that you are the beholder. This empowers us to find beauty in places where others have not dared to look, including in ourselves.

—**SALMA HAYEK** (1966–), Mexican actress

There is a classic cartoon of a little old lady tapping the shoulder of a museum guard at a contemporary painting exhibit. The caption goes something like: "Excuse me, sir. Where is the 'Today's Art' show?" She can't see any *art* in the modernist paintings hanging all around her!

Perhaps the greatest difference between abstract art and traditional realism it that realist paintings have a focal point and recognizable subject matter.

Where Should the Focal Point Go?

As a traditional watercolorist, it is essential to know your focal point before you begin your painting. Ask yourself, "What is this painting about? Why do I want to paint it?"

When you know what you want to paint and why you want to paint it, the next logical question is how you want to present it. In other words, you must decide where to locate your center of interest, or focal point, for maximum effect on your picture plane. Fortunately, there are some artful answers—or perhaps we should call them "helpful hints."

ARTFUL MEANINGS

In the painter's world, **focal point** means the center of interest. It is very rarely a single point, however. Usually *focal point* refers to an area that presents the painting's subject or carries its visual or emotional impact. Among *Merriam-Webster*'s definitions of **focus** are: 1) A center of activity, attraction, or attention, 2) A point of concentration.

Over the centuries, most landscape paintings have been in either a horizontal or vertical rectangular format. Portraits and still-life scenes generally follow the same pattern, but also commonly occur in oval and square formats. Many artists, art critics, and art teachers have written about formulas for successfully dividing the working surface and placing the center of interest for maximum effectiveness. Here is a sample of the most widely accepted theories:

- Don't put your focal point in the exact center of the painting. It tends to make the image static and the viewer's eye less able to move across the painting.
- Don't divide your painting into two equal parts. If you set the horizon line across the middle of the picture plane, it divides the painting into top and bottom and thus makes for a static composition. If a vertical line runs along the center-line of the picture plane (a tree, a mast, a telephone pole, a tall building) it almost divides the painting into two paintings, a left half and a right half.
- Use the rule of threes. Many artists divide their paintings either top-to-bottom or side-to-side roughly into thirds. Often they locate the focal point about one-third of the way in from either the left or right side of the painting. This is *not* a hard and fast rule, but it does give you a starting point, or at least a thinking point.

Think of your painting as a jigsaw puzzle. All the pieces (value, mass, form, perspective, and color) must fit together to form a unified composition. The focal point is the most important piece, but, at the same time, the puzzle is comprised of elements from all the other pieces. So shift your position a bit and think of yourself not as an artist who must obey "the rules" and conform to the cut pieces, but as one who *creates* the "puzzle," or painting. All puzzle pieces need not be alike and you can make necessary adjustments. It is your job as an artist to put the puzzle together with the focal point dominant over all other parts of the composition.

- Be careful not to compose with equal parts. A painting in perfect thirds is almost as boring as a painting divided in half.
- Use the concept of major masses. Vary major masses and values artistically to draw the eye of the viewer toward the center of interest.

The Dominant Center of Interest

If you just read the last sentence in the Tip Box above, you probably have a question: "How am I supposed to ensure the dominance of the focal point in my painting?"

I'll share with you the *modus operandi* that I've been using for more than forty years.

- I usually start by choosing my focal point and indicating where on the picture plane I want to place it.
- Next I think about how to arrange the major shapes and value masses so as to bring the viewer's eye to the center of interest.
- In most cases, I place the strongest value contrasts and the most intense colors within the focal point area.
- I keep the ground plane as simple as possible.
- I put the most detail into the center of interest and avoid excessive detail in other parts of the painting.

Detail is often a stumbling block for talented students. They put in too much because they *can*. An object with hard edges and clear detail tends to advance toward the viewer. So you don't want a background tree to have every gnarl and broken branch carefully painted. On the other hand, you may want to show the peeling paint on the eaves of the dominant farmhouse. That kind of detail is good for the focal point because you want your center of interest to stand out.

If you put too much detail into other parts of your composition, those objects will compete with the center of interest for the viewer's attention. In fact, putting too many other objects (detailed or not) into your painting can also detract from the power of your focal point and subject matter. Your painting can look overcrowded or just too busy. Don't be afraid to leave some open space. Some subjects just need room to breathe.

Creating a composition, like choosing colors, is a very individual matter, different for each person. Combine your knowledge of art and its time-tested principals with your personal vision to create each painting. Over time, you will develop a style that is uniquely your own.

Some Focal Points at Work

Let's talk about a few of my paintings so you can get a feel for focal points at work. Then, if you are adventurous, you can go through the whole book and pick out the center of interest in each painting. If you're really determined, you can write down what makes each focal point work. Then you can compare your notes and see how many times I rely on each of the principles and practices we've just discussed.

The focal point of *Pockomoonshine Lake*, shown at the beginning of this lesson on page 194, is obviously the fisherman. He is positioned a little more than a third of the way into the picture plane from the right side and a little below a third of the way up from the bottom. The ground plane of the painting is the lake, which has a lot of movement but is totally abstract. On either side of the fisherman are two boats, with the darkest darks against the whitest whites. Note, however, that there is also an area of the highest value of white in the sky. This high value represents the light source and emphasizes rather than detracts from the lone figure.

The fisherman himself is a middle value. So do you think perhaps that the boats are the *real* focal point? They certainly are a part of the center of interest, but notice the color in this area: The entire painting is almost a monochrome of blues. The fisherman's jacket, however, is another primary color, red. It is warm against the cool blues. You can't help but look at it. This strong central appearance of another primary color helps the fisherman stand out as the focal point of the painting.

Just in case you did some-how miss the importance of the red jacket, notice that the surfaces of the two docks are painted in a neutralized but still warm orange-brown that also contrasts with the predominant cool blues all around. And don't overlook the bit of a red gas can poking up in the boat on the right. This is a painting where color is a definite contributor to establishing the center of interest.

Do your remember *Central Park in Winter* from Lesson 1 when we were talking about light? Now let's consider this painting, on the next page, again, this time in terms of focal point. Look at it steadily; look particularly at the girl. Keep looking. Can you keep your focus there?

Be honest: How many of you peeked up to look at the triangle of buildings that occupies the center third of the painting?

Don't worry, everyone does it because the girl is *not* the focal point of the composition. The lightest lights and darkest darks, the sharpest edges and the most detail are in the clock-tower building. Its façade stands on a dark base and adjacent to that is the dark base of foliage. The low, dark building adjacent on the left rear side stands against the two light towers in the background. The gazebo placed at a point that creates an almost perfect triangle of central interest balances this large central form. To see the aesthetic triangle, imagine a horizontal line moving to the left from the base of the clock tower, where dark and light meet, to the trunk of the main tree just beyond the gazebo. From that point, imagine a line to the top of the clock tower. The third line of the imaginary triangle goes from the top to the bottom of the clock tower along the shadow line.

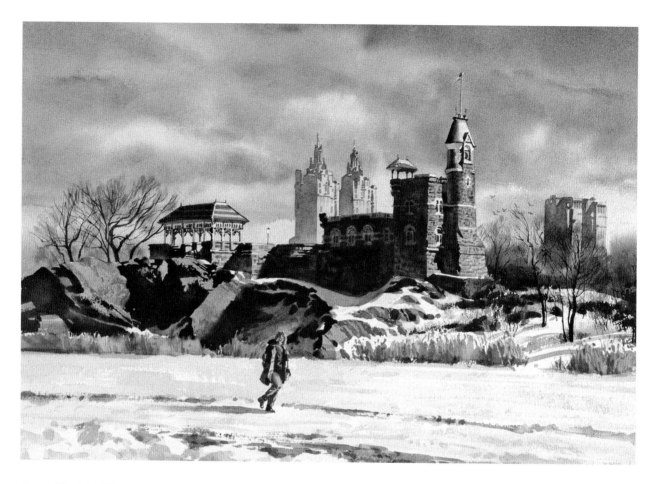

Central Park in Winter

The girl and the grasses along the edge of the foreground are closer to the viewer than the buildings, yet we can see the stones in the clock tower but not the details of the girl's clothing. The middle third of this painting is definitely the dominant plane. The focal point in this painting is thus created using value contrasts and detail.

Of course you remember *Sunrise on Kennebago* from Lesson 6. And I'm sure you're going to say the focal point in this painting is the fishermen in their boat. That seems pretty obvious, the darkest dark against the lightest light.

"But wait," you say, "why are the men and the boat so small, and only silhouettes at that? There's no detail. And the boat is located almost dead center. And the figures and the boat are dark and neutral, with no color."

Good observation! The fishermen in the boat add scale and dimension to the scene but they alone are not the focal point of the painting. And they are *not* mid-center. It just seems that way because the figures are so dominant in the landscape.

Now look at the whole painting. The whitest white is actually the sun rising over the trees (again, just off center, about a third of the way from the top). This intense light is reflected in the water extending just into the bottom quarter of the painting. Together, the sunrise, its reflection in the water, and the silhouette of the fishermen in the boat create the focal point. This center of interest is in a vertical area just left of center.

Except for the focal area, everything else in the painting is horizontal. Horizontals in a composition usually create the feeling of stability. In this painting, masses of horizontal alternating values (sky, hills, fog, and water) are "broken" by the visual vertical focus of sunlight and fishermen. Yet the silhouette of the fishermen in their boat is actually horizontal and serves to unify the vertical perception of the focal point with the horizontals of the painting. Without the men and boat, this could be seen as a serene abstract painting; with them, it is a captured moment of our life in nature.

Some people might argue that this painting seems to break the rules of focal point and composition. Actually it *uses* the rules. Everything in this painting takes the eye back and forth horizontally, but the central shaft of light is a strong vertical. It's really a very good example of what I said earlier: *Understand the rules but don't be chained to them.*

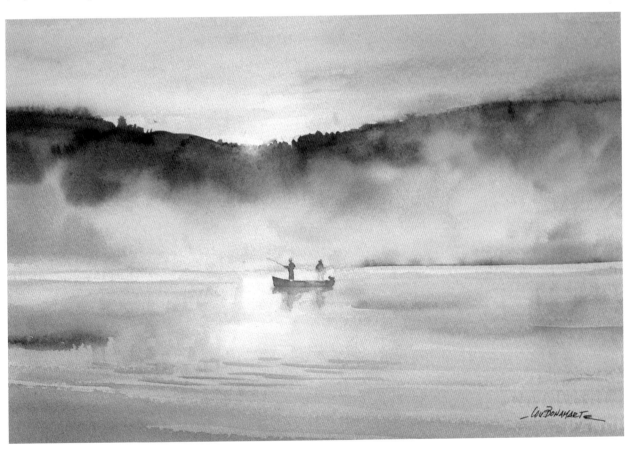

Sunrise on Kennebago

Use these photographs as the basis for some painting exercises.

Here are two photographs. Choose one (or both if you feel ambitious). Now try to create three paintings from the photo you have chosen. Do so by changing the focal point, format, and scene parameters. In other words, you can take pieces out of these photos and make them into paintings. Using the photos as reference material, you can change the sky, weather, foreground, anything you want in order to create your paintings. But remember that the most important part of this exercise is to change the focal point in each painting you create.

For example, there are two interesting pathways in the seaside photo, and of course, there are two possible paintings of cliffs and water. In the farm scene photo, there is a bird that might be moved or focused upon, as well as an interesting tree that could make a good focal point.

WORDS TO REMEMBER

- Realist paintings have recognizable subject matter.
- The focal point is the center of interest in a painting.
- There are time-tested guidelines for locating the focal point.
- All other parts of the composition are subordinate to the focal point.
- Most often, the lightest lights and darkest darks are at or near the focal point.
- Use artistic guidelines but do not be controlled by them.

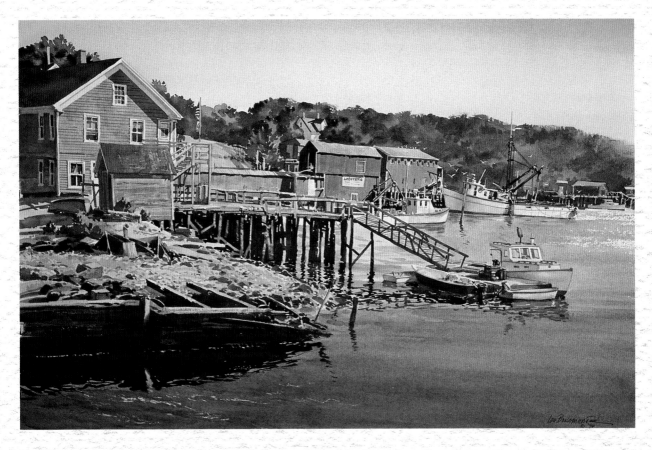

Fishing Port in South Bristol, Maine

Conception, my boy, fundamental brain work, is what makes all the difference in art.

—**DANTE GABRIEL ROSSETTI** (1828–82),
British poet, artist, and translator

n the art world, the term "caught my eye" is often used in reference to a focal point, or a particular detail, or the use of color in a particular area of a painting. In art education and art criticism, you'll often hear a similar phrase: *eye path*. The eye path of a painting is a figurative journey within the picture plane. What catches your eye first? Where do you look next? Where is your eye likely to linger? And, of course, the ultimate question: Why?

Different Paths for Different Eyes

Different viewers may take different eye paths through a painting. For example, when viewing *Fishing Port in South Bristol, Maine* (at the beginning of the lesson, page 201), my coauthor immediately sees the red fish-processing buildings and the adjacent white boats in the middle distance. Her view then takes the eye path to the right along the boats and almost out of the painting. But light catches her eye with its sparkle on the water. Her eye path then moves down to the foreground boat group. It jumps to the raft, then up the wooden ramp and across the pier to the blue house with the red roof. Enticing as that house is, her eye doesn't stay on it because the lure of the red buildings in the almost-center of the painting is too great. So her eye path continues along the low blue work shed and back to the two red buildings. My question to her is: How did you choose that focal point? Why did your eye decide to start its eye path right there in the middle ground?

Other observers begin their eye paths at the blue house on the left. Notice the peeling paint on the shed, the visible boards of the siding, the windows with shades, all carefully detailed. Notice also that this building and its roof are painted in two primary colors, with a strong contrast of warm and cool. (I'll discuss warm and cool hues in the next section.)

Examples of two different eye paths a viewer could follow in the same painting.

Viewers who take this eye path look first to this strong foreground structure, the blue house with its red roof. But they don't stop there because there is so much more going on. The red roof of the shed standing in front of the blue house

creates a kind of tension that forces movement. The only place for the eye to go is along the small blue shed, which leads to the warm, red central building standing against the green hills with the bright white boats in front of both the building and background.

Having traveled those two eye paths with me, do you see what color and form is doing in this painting? The eye is attracted to the high chroma contrast of red and blue, then it moves along the low blue form to another red form. From there, the white boats and highlights in the water swing the eye around and back toward the foreground. The eye path is stopped momentarily at the small gathering of boats around the raft. There's nowhere to go but up the ramp and over the pier back to the blue house and red roof.

Look closely. What color are the ramp and the pier? And if you escape that strong temptation, what color are the lit surfaces of the planks in the foreground? And the rocks and the unpainted corner of the house? The complements of dominant colors are often strong eye path indicators.

Be aware that neither eye-path A nor eye-path B is "right" or "wrong." This painting holds together with either route because there are visual connections through its composition, including value contrasts and color choices.

How and Why

We've studied all the elements that hold a composition together and create a continuous eye path in a painting. Studying eye path, however, is a bit like watching a ballet or modern dance performance. No one can actually *see* the lines of the choreography, but they have been worked out and they are very much a part of the beauty of the performance.

Movement in and through a painting is created by:

- Value masses
- Contrasts of light and dark, cool color and warm color
- Forms (think of objects on various planes, one behind another)
- Shadow, often connecting one object to another on the ground plane
- Atmospheric perspective that deceives the eye with the appearance of depth
- One-point perspective (think of roads or telephone poles going into the distance)

- Two-point perspective (think of buildings getting smaller to a vanishing point)
- Detail and subject matter; some things will just naturally "catch the eye"

I must admit that *Fishing Port in South Bristol, Maine* has a rather complex eye path. Many paintings are much simpler. In fact, whether the subject matter is a dark and stormy day at sea or a bell, book, and candle on a windowsill, the eye path in most still life paintings moves smoothly around an oval or triangular pattern within the picture plane. As a demonstration, let's look again at two paintings you've already seen, *Eastern Point Lighthouse* and *Tea for Two*.

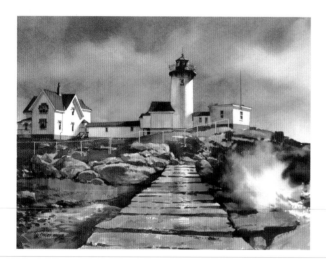

Eastern Point Lighthouse

A DARK AND STORMY DAY

Eastern Point Lighthouse is an example of a painting with an obvious eye path. Who could possibly miss it? Its entry into the painting is literally a path! Not only a path, but a path with the white reflection of the focal point—the lighthouse—on it. It seems that your eye can go nowhere else but across the granite slabs to the lighthouse. But then where do they go?

The lighthouse, located just to the right of and above the center of the painting, contains the lightest lights and darkest darks. The reflected light that colors the tower's left side, the detail on the railing, the roof, and the window seems almost comforting to the eye at the top of that strong lead-in and therefore holds its attention. Thus vertical movement dominates the entry into the picture plane.

But if the movement in an artistic composition was supposed to help unify the composition, it would follow that no one direction should dominate completely. In other words, the viewer's eye simply can't stay pinned in one spot at the top of the lighthouse. So what else is at work in this composition that helps the viewer's eyes see the whole painting?

Subordinate to the lighthouse but providing strong balance, the lit side of each building on either side of the focal point repeats the intensity of the white light. That repetition causes the eye to move back and forth among the buildings. The repeated parallel lines of the dull blue-gray foundations and the warm red roofs repeated horizontally across the middle ground support this movement.

So the middle ground focal point is unified. But to remain among these buildings without other areas of interest would be rather boring. The lighthouse grouping may be the subject matter, but the painting as a whole depicts a moment in time and place with almost poetic ardor. The gathering of the storm clouds, the spray of the breaking wave, the light caught reflected from

the tops of the boulders, and of course the seemingly fragile blue fence keep the eye path moving. A strip of green grass—the only green in the painting—anchors and stabilizes the buildings.

HERE'S A TIP

There is always a color change in a reflection. Dark objects reflect lighter; light objects reflect darker. Look at the reflection of the lighthouse on the pathway. You can see an upside-down lighthouse, but it's definitely *not* light or bright enough to distract from the movement into the painting. Now look back through the earlier lessons in this book to find other reflections. Notice the color and value changes. Consider how these reflections affect the eye path in each painting.

QUIET AND COZY

Now let's look at a rather different example of eye path in a painting. Because still life paintings lack the atmospheric depth of landscape art, composition and eye path become even more important in the creation of a unified work of art. Unless the objects in a still-life arrangement are connected to one another in some way, the painting becomes a grouping of individual forms. Shape, shadow, light, and color must take the eye into and around the composition.

Notice the pieces of lemon peel in *Tea for Two*. They weren't dropped into the painting accidentally. The two small pieces of bright yellow peel catch the eye and move it into the painting. From the bright yellow, the red-pink of the flowers moves to the red-orange in the vase. The highlighted green lip at the top of the vase points the

Tea for Two

eye toward the handle of the teapot. The handle curves over to the spout, and the spout's curved structure takes you down to the yellow of the lemon with the white parts pointing directly back to the pieces of rind. And then you can start the oval all over again!

It's a nice path, but the leaps of color and shape are not the whole story. Look carefully now for the shadows. You will see an object, then its shadow again and again as your eye moves through the painting. The shadows connect the objects to emphasize a continuous oval. The painting is quiet and still, but within that peacefulness there remains a feeling of life and movement.

How Does Your Garden Grow?

Creating an eye path is a lot like planning a garden. You can find lots of books that will tell you what a plant needs and when it will bloom. Some plants need sun, some need shade; some need moist soil, some need sandy and dry dirt. But even while staying within these stated needs, you can choose plants that will vary colors, heights,

textures, and blooming seasons to create an ongoing feast for the eye. It's the same for the eye path of your paintings. There are guidelines, but you also have a lot of choices.

Just as we followed two possible eye paths in *Fishing Village in South Bristol, Maine*, we could discuss the possible alternative eye paths that might somewhat change our responses to many other paintings. Eye path is a guideline to composition. There are no hard and fast rules. In fact, you should be no more aware of the existence of eye path plans than you are of the bass and treble clefs and the musical notes upon them while you are listening to a symphony or favorite song. Creating a working eye path is where skill and style come into a composition. Let's look at a few more paintings with eye paths that are a little "different."

Connecticut may be a neighbor to Massachusetts, but *Guilford Dock* is a long way from *Eastern Point Lighthouse* artistically. The mood of this painting is still; there is no stormy unrest. Like the lighthouse painting, the focal point in this dock painting is a

The Mikado

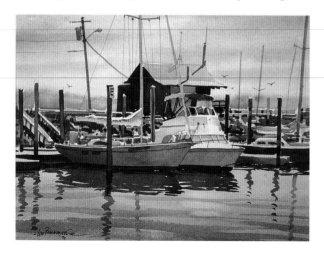

Guilford Dock

horizontal across the middle third of the painting. But there is no dramatic slate pathway to that focal point; you are brought to the subject of the painting by repeated and subtle horizontals in the water and the sky.

So why doesn't this painting *feel* sedate and staid? You certainly don't travel through it in a circular eye path. Instead, you have broken lines. The repeated verticals in the masts and pilings and their reflections create a tension against the strong horizontal of the composition. The movement in this painting is almost staccato, the horizontal sweep broken by thin lines of verticals.

There can be no question or confusion about the focal point of *The Mikado*. The painting is about an engine. The eye path starts at the lower right corner and takes you on the tracks to the nose and smoke stack. The use of one-point perspective with the vanishing point to the left creates depth and movement along the body of the engine. The bit of shadow area in the left foreground and the roof and walls of the station keep the eye from racing back into the distance. You see

the whole engine and/or you see bits, pieces, and details of the engine. But your eye is always on the engine. There is nowhere else to go in this painting.

Blue Water has strong lines of movement, but the eye can't easily follow a single path. This creates a dramatic tension that is almost electric. The three boats are painted in a very high value and each point into the painting. But those three boats meet the strong, dark diagonal line of the side of the dock in shadow. The shadows under the boats also point toward the dock and emphasize the light inside the boats. Crossing those lines, almost like a slightly off-center X, is the shadow of the railroad bridge above. That dark shadow leaves the painting at the upper right corner, only to re-enter at the lower left. The dock itself is a large mass of light value that moves into the painting from the upper right.

So many lines, so many directions! It's no wonder if you are puzzled when asked *what is the eye path of this painting*? If this were a classroom situation, several very different essay answers could each get a grade of A. And that diversity

Blue Water

(some would say confusion) is the story of eye path in *Blue Water*. The fact that there is no easy "right" answer is exactly what generates the excitement of the composition. The painting holds together and breaks apart at the same time. This is a tricky effect to achieve. *Blue Water* shows very plainly that eye path is only one element in a good composition. It's a very good example of why art is *art*, and not like a prescribed geometry theorem.

PRACTICE! PRACTICE! PRACTICE!

If you have access to a copy machine, make black-and-white copies of some of the paintings in this book. Sit down with a colored marker and circle the objects or area that you notice first in each painting. Then, using dotted lines, trace what you think is the eye path in the painting. Do you return to your starting point or nearby to it? Could or would you do the same path again? Is the starting point the focal point of the painting? Is the movement primarily horizontal, vertical, diagonal, or circular?

If you can't get to a copy machine, you might try using tracing paper. Or you can just go through this book with a notebook in hand examining the paintings, making notes as you go.

WORDS TO REMEMBER

- The eye path of a painting is a figurative journey within the picture plane.
- Different people might take different eye paths through the same painting.
- Eye path is determined by value masses; light and color contrasts; forms; shadows; atmospheric perspective; one-, two-, and three-point perspective; detail; and subject matter.
- Shadows are a connecting device in both still life and landscape painting.
- In some paintings, there is no discernible eye path. Beauty then is truly in the eye of the beholder.

UNITY, BALANCE, AND ALL THAT JAZZ

Engine in Autumn

Know the limits of your medium. The secret of freedom is to see what's possible within the given limits.

—**JAMES G. CRANE** (1927–), American multimedia artist and
former chairman of the art department at Eckerd College

W hat holds a work of art together? The answer to that very important question is spread throughout the lessons we've done so far: a unity of light, a balance of value masses and forms, color, perspective, focal point, and eye path. This lesson is a summation of artistic composition with a focus on balance.

As you're reading through this lesson, however, I'd like you to think about the paintings you've done and, perhaps more importantly, the paintings you'd like to do. Do you prefer peaceful or dramatic, traditional or surprising, panoramic or closely focused, objective or subjective vision? To achieve your goals, you must have an understanding of the principals of art, but you need not necessarily stay within the lines. In other words, use the knowledge you have acquired to create works of art that are uniquely yours.

The Trouble with Two

In virtually every art instruction book ever written, including this one, you'll read advice about avoiding balanced, equal pairs of objects, masses, color areas, or lines (i.e. symmetry). Two of anything, they say, is static and boring. Three of anything encourages movement and interest.

"But," you ask, "isn't that a painting of two equal and alike tug boats?" *Thames River Tugs* is indeed a painting of twos. Two tugboats, two red cabins, two piers, two pilings on the nearer pier, four on the farther pier, two tires on the front boat. So what holds it together? Why isn't it boring?

Remember that I said composition is like a puzzle—all elements must fit together. In this case, the excitement in the painting is not created by the subject matter of the two boats, but by the angles, major planes, perspective, and color.

This painting has a foreground (the water), the hint of a far distance (the horizon), and a sky. The

- **Symmetrical** means aspects similar in size, shape, and relative position on opposite sides of a dividing line or median plane or arranged about a center of axis. **Symmetrical balance** in art is the recurrence or repetition of like objects, masses, values/colors, and linear movement.
- **Asymmetrical** means not symmetrical. In other words, similar objects, masses, values and colors, and linear movements are not repeated on two sides of an imaginary line. **Asymmetrical balance** is the achievement of stasis or equality by manipulation of space, weight, intensity, size, and linear movement, often in opposing positions. Think of a seesaw with an adult on one side and a child on the other. To achieve balance the adult must move closer to the center support. The movement achieves asymmetrical balance of unequal forms. A big red circle in one corner of a painting could be balanced by an open space, a few short lines, and two small yellow circles in the opposite corner. (Think about the works of Kandinsky and Mondrian.)

Thames River Tugs

subject (the boats) consumes the middle ground of the painting. The major planes are not equal. The top of the far horizon line leaves a little less than half the painting to the sky. The middle area (boats and docks) is dominant in color and size of objects. The foreground (the water) is less than a quarter of the picture plane, but its reflections strongly take you into the scene.

Trace your finger over the water line starting at the pier on the lower left and moving along the hulls and then out of the painting on the right. What kind of path did you make? A strong zigzag, right? The section between the boats is shaped like an arrow. It points the eye into the painting. (It's also the lightest value in the water.)

Now look at the perspective. The tugboats are *not* side-by-side and the images of them are *not* equal. The foreground tug appears larger to the eye. Its colors are stronger, the white trim more intense. There is also more detail—just compare the windows of the two cabins.

The almost-square picture plane has a vertical feeling to it because the wooden piers on the left and right sides cut off space and lead the eye inward and upward to the boats. The prow of the boat nearer to the viewer is so detailed that it seems to pop out of the painting. There is a vertical line of light along the front bumpers of both boats, but these bumpers are not the focal point. The lightest light of the painting is in the foreground cabin's trim and roof. The colors are intense. The darkest dark is between the dock and the boat. The second boat is almost like an echo of the first one.

The balance of this painting is actually asymmetrical. The focal point is to the left and above the center point. The second boat is smaller, quieter, and actually more centered. In other words, the boats are not equal and the lines and masses of the painting are not symmetrical, even though they may seem to be at first glance.

PRACTICE! PRACTICE! PRACTICE!

Look around your home or workplace or go outdoors and gather a pair of objects. For example, two apples, two shoes, two pinecones, two books, or anything you can find that makes a similar pair. Now try to make a painting with your pair as the subject matter. Use arrangement, viewpoint, light source, shadows, color, perspective, and everything else you've learned to create a work with asymmetrical balance.

The Joy Of Three

Three objects, three planes, three value masses, three colors: as I've said before, three is art's magic number. If you think in threes, you will increase your likelihood of achieving a good working composition. It even works when the balance is somewhat symmetrical. Let's look at the threes in *Morning Light*.

The obvious focal point is the three major trees. Each one is unique. They are not quite equidistant from each other. The major planes in the painting are also obvious. The snow is the foreground, the burnt sienna triangle of brush is the middle ground, and the sky is the third plane. The three fence posts balance the trees (asymmetrically) and stop the eye path from leaving the painting. The three tree shadows (each one different) lead the eye into the painting. And finally, color adds to the interesting three-beat rhythm. The warm, pink-tinted snow plays nicely against the cool blue shadows, as do the light siennas against the dark umbers.

In this painting, nothing conflicts, yet there is individuality, interest, and movement.

Morning Light

The Music of Art

At this point, you may be wondering why I chose to open this lesson with the painting *Engine in Autumn* (page 209). You might be thinking, "This is a chapter on balance and unity, but that painting has only one thing in it, the engine."

Yes, the only object in this painting is an engine, but have you considered the composition? It has three major planes: the grassy foreground, the middle ground where the engine runs across the whole middle third of the painting, and the sky. Now you may say, "But three planes and three values don't necessarily make an interesting piece of art."

You're right about that. But now I'm going to take you to the next step. Don't think of the engine in this painting as its subject, think of it rather as the focal point—as an *abstract* focal point. This will help you see the art within it, the music of color and value, size and line.

You have a flat train bed with forms upon it: a cube, a rectangle with a rounded roof, and a cylinder. You are led into the painting from the left side by a truncated rectangle that looks vertical. Then the first cube has two values with a light rectangular panel. The second cube has the same shadow side, but a lighter sunlit side and more highlighted areas. The three windows create a repetitive pattern that moves along toward the cylinder. The highest lights are in this left middle section of the painting, nearest to the darkest shadow areas. The cylinder of the engine housing is more neutral in color and slightly darker in value. But look at the engine vents. These repeated rectangles race along like staccato notes in music, bringing the eye path with them.

So the movement across the middle third of the painting is: Enter left with a neutral vertical rectangle, space, cube block of color and shade, larger cube of color and shade with highlights and a repetitive window pattern, cylinder of neutral color moving quickly forward, stop at vertical rectangle, and then neutral color bare trees.

Now look at the pattern of the mechanical elements below the train. Here is a careful alteration of dark and light, cool umbers and warm siennas. With the exception of the blue sky, there is very little strong color in this painting. It is a harmony of neutralized greens and browns, but it comes alive because of the play of light and dark, warm and cool. Look next at the lines in the painting. The flatbed is the strongest line, stabilizing the whole painting. But look carefully at the railings on the engine; curves and bends and straight lines lead the eye along the object.

Now look at the painting as a train engine again. It's not likely that you will be able to see just an engine. Along with that recognizable form, you'll see the dance of color and shape. Many artists believe that you can appreciate any painting (no matter its "style") in terms of abstract forms of mass, value, color, and line. And it usually works. Which shows, I think, that it's not what you paint, it's how you paint it.

PRACTICE! PRACTICE! PRACTICE!

You've created a composition with two objects and asymmetrical balance; now try painting a composition with a single object. Position your object on the picture plane so that space is not divided equally. Light it for maximum drama. Then paint it so the values, planes, masses, lines, and colors work together to form a painting that could be considered as an abstract composition.

WORDS TO REMEMBER

- Use the knowledge you have acquired to create you own compositions. You don't necessarily have to "stay within the lines."
- Symmetrical and asymmetrical balance both play a role in good composition.
- If your focal point is composed of only two objects, put them together in an interesting way using perspective, overlap, value, lighting, and color to keep the eye of the viewer moving around the composition.
- It is easier to work with groups of three in every aspect of art.
- Take the time to look for abstract patterns in every painting.

ACKNOWLEDGMENTS

LOU BONAMARTE would like to thank all those who helped bring things together: Melonie Tooker for her critiques, Mark Muto for his photographic expertise, and Mary Muto for guiding him through using the computer. Thanks also to Barbara Berger, Sasha Tropp, and Jeanne Fredericks, for their confidence and patience.

CAROLYN JANIK would like to thank her agent, Jeanne Fredericks, for her loyalty, perseverance, and patience. And a BIG thank you to her editors at Sterling Publishing, Sasha Tropp and Barbara Berger, for their meticulous care at every line. They both contributed significantly to the quality of this book.

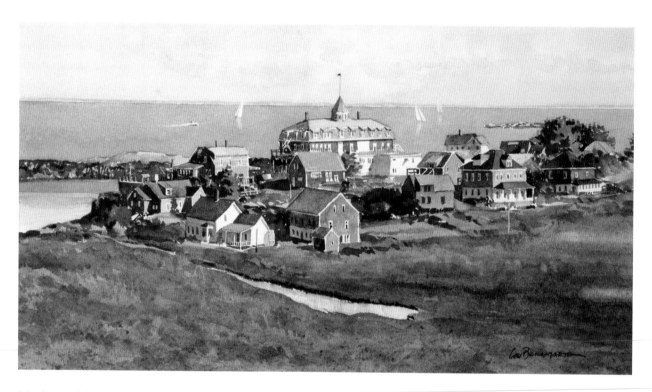

Monhegan, Maine

GLOSSARY

A

Abstract art is nonrepresentational art. That is, art that does not attempt to create the realistic illusion of recognizable objects.

The term **abstract expressionism** describes spontaneous, personally expressive art with an emphasis on movement and it is often large-scale, such as the work of Jackson Pollock or Willem de Kooning.

Areas that **advance** seem to come forward in the painting; in other words, they seem closer to the viewer.

Aerial perspective: see **atmospheric perspective**.

An **analogous color palette** is a palette limited to colors on only one side of the color wheel.

Asymmetrical means not symmetrical. In other words, similar objects, masses, values and colors, and linear movements are not repeated on two sides of an imaginary line.

Asymmetrical balance is the achievement of stasis or equality by manipulation of space, weight, intensity, size, and linear movement, often in opposing positions.

Atmospheric perspective (sometimes called **aerial perspective**) is the use of size, color, form, and edge control to create the illusion of distance.

B

Background: see **horizon**.

A **backlit** composition occurs when the light source is behind the subject matter.

C

A **cast shadow** is created when an object blocks the light source from hitting another surface. Cast shadows are usually darker than object shadows.

Chroma (sometimes called **intensity** or **saturation**) refers to the strength or weakness of a color. The more pure and unneutralized a color is, the higher the chroma. Variations result in changes in the intensity that the viewer perceives. You can see a hue of blue, for example, that is so bright that it is almost hard to look at it or a hue of blue so neutralized that you can hardly separate it from gray.

Cold-pressed paper is rough paper that has been weighted down during the drying process. This step smooths out the texture to some degree.

A **complement**, sometimes called an **opposite**, is the color opposite a primary on the wheel. It is always a secondary color, never another primary. The complement of yellow is purple; the complement of red is green; and the complement of blue is orange. Mixing a complement into a primary neutralizes it. Placing a complement next to a primary in a painting calls attention to the area.

Compound wash and **glazing** are terms used interchangeably in watercolor painting. To do a compound wash, the artist lays down a color and waits for it to dry. Then he or she covers that color with another color, producing a third color.

D

A **diagonal plane** is at an angle to a vertical or horizontal plane.

Diminution is a phenomenon in which objects appear smaller as their location becomes farther from the viewer.

The **dome of the sky** refers to the upper atmosphere or expanse of space that constitutes an apparent great vault or arch over the earth.

E

Eye level (also called the **horizon line**) establishes the level of the artist's line of sight. (The more universal term is **eye level**; **horizon line** is more commonly used in landscape watercolors.)

Eye path is the way you view a painting—some people would say the "flow" of the eye. It usually starts and ends at the focal point.

F

Fan brushes are shaped just as their name implies, with the bristles forming a semicircle.

Far distance: see **horizon**.

The hairs of a **flat brush** have a square or rectangular shape.

The **focal point** is what the painting is about—the center of attention. It is often where the colors are strongest and the darkest darks meet the lightest lights. It is very rarely a single point, however. Usually focal point refers to an area that presents the painting's subject or carries its visual or emotional impact.

Among *Merriam-Webster*'s definitions of **focus** are: 1) A center of activity, attraction, or attention, 2) A point of concentration.

The **foreground** is the area closest to the viewer.

G

Glazing: see **compound wash**.

Granular color refers to the amount of sediment in a pigment. In varying degrees of different hues, granularity reduces the ability of the paper to reflect light through the pigment.

The **ground plane** is the surface upon which the objects in the painting stand.

H

The **horizon**, **far distance**, or **background** is the farthest surface area the viewer can see.

Horizon line: see **eye level**.

A **horizontal plane** is parallel to the ground.

Hot-pressed paper is rough paper that has been hot pressed. The resulting paper surface is very smooth.

Hue is the name for a gradation of a color.

I

The **imaginary picture plane** stands at the back of the scene you are painting. To grasp this concept think of your working surface (paper) as though it were standing behind your subject matter. It is important to understand how the objects in your painting relate to this imaginary picture plane.

Intensity: see **chroma**.

L

Linear perspective is a geometric system based upon the artist's line of sight and the orientation of an object to the picture plane.

Local value-areas refer to the perceptual creation of three dimensions when relative value changes are used to create form or atmosphere (sometimes intangible) in a space rather than on an object.

Merriam-Webster defines **luminosity** as "the relative quantity of light" or the "relative brightness of something." In watercolor painting, luminosity is created by the whiteness of the surface upon which the work is done since that whiteness shows through the transparency of the pigment.

M

Major value plane: see **value mass**.

Middle distance: see **middle ground**.

The **middle ground** or **middle distance** is usually the middle third of the painting and often the location of the focal point.

The **mop brush** is similar to the round brush, but thicker.

N

Negative space is the area (often something intangible such as liquid or air) around an object or between it and another object.

O

Object shadow is a surface of an object facing away from the light source. This is an area often spoken of as "in shadow."

Object value refers to the relative shades of light and dark that are created by the angle and amount of light falling upon the surfaces of an object.

According to *Merriam-Webster*, **opacity** is "the quality or state of a body that makes it impervious to the rays of light." In watercolor words, opacity is the ability to mask the color beneath it. Different pigments have different degrees of opacity.

Opposite: see **complement**.

Overlapping shadows occur when a still life or other subject is situated near a window and then lighted from the opposite side with artificial light. They also occur when more than one source of light is used. In each case, two sets of shadows are cast. They usually overlap in arcs.

P

The *Merriam-Webster* definition of **perspective** is "the technique or process of representing on a plane or curved surface the spatial relation of objects as they might appear to the eye; specifically: a representation in a drawing or painting of parallel lines as converging in order to give the illusion of depth and distance."

The **picture plane** is the two-dimensional surface upon which you are painting.

Pigment refers to the material, either natural or manmade, unified with a binding substance to make paint.

The **Pike Palette** has twenty wells arranged around three sides of a rectangle (for a visual example, see page 23 in the Tools and Supplies section).

A **plane** is a flat surface.

Plein air (pronounced "plane air") is French, meaning, "open air." In the art world it is a term that refers to landscape painting on site, in the

open air instead of in a studio. Plein air can also refer to a style of painting that emphasizes the impression of the open air and of spontaneity and naturalness.

Positive space is an area in a painting that is occupied by an object.

Primary colors are red, yellow, and blue. These colors are called primaries because they cannot be made by mixing together other colors. However, all other colors can be made by various mixings of these three primary colors.

R

Areas that **recede** appear to move back into the painting; they seem farther from the viewer.

Reflected light is light that radiates from another object or surface that is being lit by the light source.

Related colors, or **relative colors**, are those having a relationship or mixing connection with each other. They are usually in the same area of the color wheel. They may be a different manufacturer's hue, they may be more or less neutralized, they may be of a different value, or they may be colors mixed from adjacent colors.

Relative color is an area of pigment considered in relationship or proportion to something else. Relative color also refers to the *appearance* of a color in its surroundings. The exact same color can appear warmer or cooler, darker or lighter depending on the adjacent colors.

Relative value is defined by *Merriam-Webster* as "the relation of one part in a picture to another with respect to lightness and darkness."

Round brushes are bulbous in shape, come to a point, and hold a lot of water.

Rigger brushes have very long bristles, but very few of them. It holds a large quantity of paint for its size and is used for making long, fine lines.

Rough paper is highly textured, meaning it has many bumps and indentions.

S

Saturation: see **chroma**.

Secondary colors are orange, green, and purple. Each hue can be made by mixing two primaries in approximately equal amounts. Orange is made from red and yellow; green is made from yellow and blue; and purple is made from blue and red.

A **shade** is produced by darkening the color you start with. Most watercolor artists recommend using the color's complement or near complement to create a shade. Black will also do the job, but the color will lose some of its luminosity since black blocks the reflection of light from the paper. However, keep in mind that black can make some beautiful low-key colors, such as maroon (which is red mixed with some black).

Sizing is a substance added to papers, textiles, and brushes to act as a protectant.

The **sky** can comprise most or even all of a painting. Or not. The artist chooses how much sky appears in each painting. It is imagined and it is always influential.

Sky blue is defined in the dictionary as a pale to light blue color. It is the color of our atmosphere.

In discussing art, the term **spatial relationships** denotes the relative amount of space accorded to various elements of the painting and how those elements interact in the composition.

Staining color refers to the degree that the pigment will permeate and remain on watercolor paper. A staining pigment cannot be easily washed out, even when the paper is scrubbed.

Station point is a term used to denote the place where the artist is standing in order to view the scene or objects to be painted.

A **study**, in the language of artists, is defined by *Merriam-Webster* as an "artistic production intended as a preliminary outline." Artists often do several studies before they paint what they consider to be a finished work.

Sun-color theory is a little like perspective because it is a tool that will help you make your paintings look "real." But it is not nearly so complicated as perspective. Using the knowledge you have, it is a method of thinking that will enable you to use color effectively to unify a painting and make it exciting.

Symmetrical means aspects similar in size, shape, and relative position on opposite sides of a dividing line or median plane or arranged about a center of axis.

Symmetrical balance in art is the recurrence or repetition of like objects, masses, values/colors, and linear movement.

T

Tertiary colors are made by mixing a secondary color with additional pigment from an adjacent primary color. For example, green is a secondary color. Mix it with more yellow and you have spring green or yellow-green. Mix green with more blue and you have aqua or blue-green.

A **tint** is a lighter version of the color you start with. In watercolor painting, a tint is produced by adding clean water to the color.

Tone is a term used loosely in the art world. Most often it refers to the relative value of a color. Sometimes, however, it is used to discuss the intensity of the color. Tone is achieved by adding gray to the color you want to neutralize.

The *Merriam-Webster* definition of **transparent** is "fine or sheer enough to be seen through." In watercolor parlance, transparent (or sometimes translucent) means that an underlying color, shape, or line can be seen through the pigment painted on top of it.

Trompe l'oeil is a French term used in the art world to mean a painting or a part of a painting that tricks the eye into believing a painted object is real.

V

Value refers to the relative lightness or darkness of an object or a surface.

A **value mass** or **major value plane** is a large portion of a painting attributed to one value in the structure of the painting. It is essentially abstract and does not include objects, details, or the shadow effects of the light source.

A **vanishing point** is an imaginary spot on, above, or below the horizon where receding "parallel" lines would converge.

A **vertical plane** is perpendicular to the ground.

W

Wet-on-wet is a watercolor technique that creates soft edges and melded colors. Using damp paper, the artist puts down one color into appropriate areas. Then he or she adds one or more other colors, again in areas that seem appropriate. The colors run together, the edges blend, and new colors are sometimes created. Sometimes water patterns and stains are created too, which the artist may or may not like.

Atmosphere

INDEX